DRESSING *Barbie*™

DRESSING *Barbie*

A Celebration *of the* Clothes That Made America's Favorite Doll, *and the* Incredible Woman Behind Them

CAROL SPENCER

as told to Laurie Brookins

HARPER
DESIGN

An Imprint of HarperCollinsPublishers

Published in 2019 by
HARPER DESIGN
An Imprint of HarperCollins*Publishers*
195 Broadway
New York, NY 10007
Tel: (212) 207-7000
Fax: (855) 746-6023
harperdesign@harpercollins.com
www.hc.com

Distributed throughout the world by
HarperCollins Publishers
195 Broadway
New York, NY 10007

ISBN: 978-0-06-280244-6

Library of Congress Control Number: 2018948776

Book design by Raphael Geroni

Printed in China

First Printing, 2019

I dedicate this book to the
child in all of us as we play,
dream, and evolve.

Enjoy!

Contents

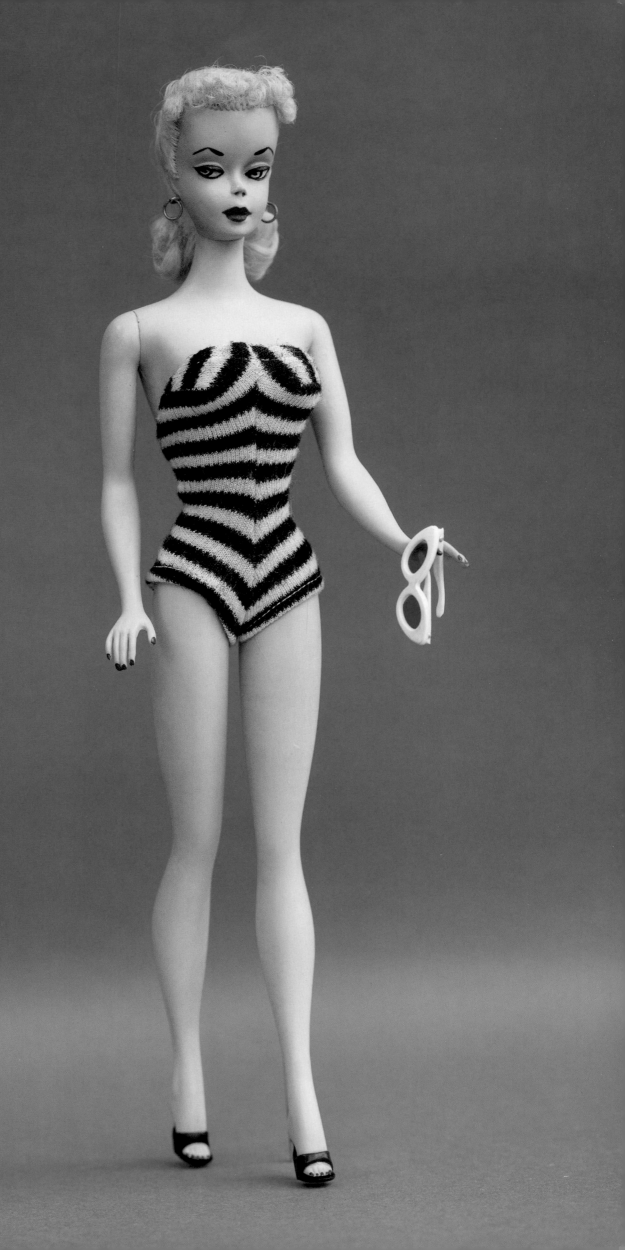

INTRODUCTION

What a Doll

BARBIE QUITE SIMPLY CHANGED MY LIFE. Since 1959, millions of children around the world have fallen in love with the most popular fashion doll ever created. Barbie wasn't only a stylish toy, she also nurtured imaginations, which was what Ruth Handler had envisioned when she created the eleven-and-a-half-inch "teenage fashion model."

Of course I was aware of Barbie when she debuted in 1959. You couldn't miss her. Ruth Handler and her husband, Elliot, had done a masterful job with Barbie's launch; in magazines, newspapers, or on television, someone was always talking about Barbie. I went to a toy store to check her out, and I can still recall my first in-person glimpse of her, with her sideways glance, wearing her now-iconic black-and-white-striped bathing suit and heels. I remember thinking Barbie looked important.

That turned out to be quite the understatement. Over six decades, Barbie and her friends have spawned an incredible wealth of adventures— many originated from her design team, who created a universe that included an ever-expanding roster of professions, dream houses, modes of transportation, a wide-ranging wardrobe that combined fashion trends with a liberal dose of fantasy, and so much more. Children everywhere embraced this world and enhanced it via the stories they created as they played, which was key to Barbie's success.

For thirty-five years, I was at the center of that universe as a member of Mattel's design team. It

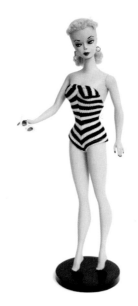

wasn't a career I had ever envisioned when I was younger, but from that moment in 1962 when I first read Mattel's advertisement in *Women's Wear Daily*, I saw my future, and it thrilled me.

Perhaps that's because Barbie's life was the polar opposite of my own: she was the ultimate California girl, while I grew up in Minneapolis, where the winters were gray and seemingly endless. Barbie could take on any profession she desired—she was an astronaut in 1965, four years before the Apollo 11 moon landing—but when I was thinking about a career in the late 1950s, the options available to women largely focused on the "expected" five: nurse, teacher, secretary, shopgirl, and seamstress. My older sister, Margaret, had become a nurse, and all my friends at Washburn High School in South Minneapolis likewise seemed to easily accept these choices. I always knew, however, that I wanted more.

The only exception? I really loved to sew and still do. In 1937, when I was four years old, my father died unexpectedly, and my mother, sister, and I moved from Dallas, Texas, to Minneapolis, Minnesota, to live with my Aunt Lena, Uncle Lincoln, and

Opposite and Above: *The first Barbie doll, 1959.*

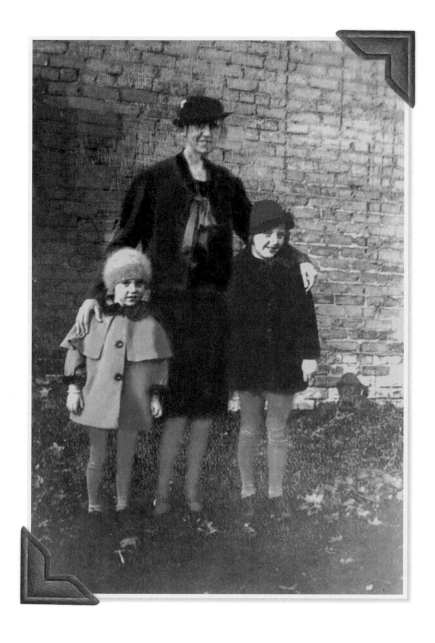

my grandmother. Getting used to the snow and cold was a big adjustment, but I quickly bonded with my grandmother, who was incredibly talented with a needle and a sewing machine, and she instilled in me a fondness for these skills. I was mesmerized by her ability to create a beautiful dress from pieces of fabric, and as I watched her, my face would inch ever closer to the sewing machine. I can still hear her say, "I will stitch your nose to the garment if you don't move farther away."

Aunt Lena and Uncle Lincoln, who had no children of their own, truly became surrogate parents for Margaret and myself when our mother passed away from a stroke while we were in high school. Eventually the four of us were very happy in that Minneapolis home.

As my high school graduation approached in 1950, however, those expected life choices loomed before me, and I was feeling restless. That's also because I had found myself somewhat committed to a sixth option: wife and mother. His name was Neil: he and I had dated throughout high school, and everyone around us expected the next natural step—including Neil. His family had decided we would get married after graduation and I would get a job so I could support him while he went to medical school. He had not given me a ring, and no date had been set. Yet increasingly, I didn't like the idea that my life had been planned out for me.

I want more, I thought.

One Sunday while reading the newspaper, I spied an ad for a seminar highlighting jobs in the

Above: *My sister, Margaret (right), and me with our Aunt Lena, 1937.* ∗ **Opposite:** *Modeling one of my ensemble designs for my classmates at the Minneapolis School of Art, c. 1954.*

fashion industry. I put on my best interview clothes and my bravest face, and I didn't tell anyone where I was going. The first speaker was a member of the Fashion Group International, Inc., who discussed the fashion design program at the Minneapolis School of Art. She put two words together that I had never heard of as a vocation: *fashion designer*. It was as though someone had turned on a light. Before leaving the seminar, I filled out an application—and when I returned home, I still didn't tell anyone.

I watched the mailbox every day for weeks until an envelope with my name on it finally arrived: I had been accepted! That feeling of wanting more suddenly no longer made me feel restless; instead, it was exhilarating.

It was time to tell Neil. His father used to drive us on our dates, he in the front seat, Neil and I sitting side by side in the back seat. Anything I discussed with Neil, his father would be privy to. So I shared my news, telling my fiancé how excited I was about the opportunity and suggesting that we both could go to school, but that meant I would be unable to work and help pay his tuition. But the next day, the decision was made: our engagement was over.

More than anything, I felt relieved. And I couldn't wait for what was next.

Today the Minneapolis School of Art is known as the Minneapolis College of Art and Design, and in the early 1950s, I was among just 250 students, many of whom were World War II veterans studying on the GI Bill. On most days, I was able to catch a ride with a former GI who decided to study sculpture after he had worked on the restoration of Mount Rushmore. And instead of the sweater-and-skirt combination that had practically become my high school uniform, in college I wore blue jeans most days—just like the guys.

This newfound freedom also came with challenges. I loved studying basic design, color, and painting, though when it was time to take Life Drawing, I discovered I was the only woman in the class alongside thirty older, male students—and, in the center of the room, nude models. I hid behind my drawing board the first few days, until I realized it was silly to be self-conscious. We were too busy learning about perspective, proportion, and shading to be embarrassed or titillated.

Another favorite memory was when Oskar Kokoschka, the Austrian expressionist painter, came to our school to give a seminar. My textbook called him "a giant of modern art," and I read everything I could find about him. He was in his sixties when he visited us, cutting quite the dramatic figure with his white hair and keen eyes.

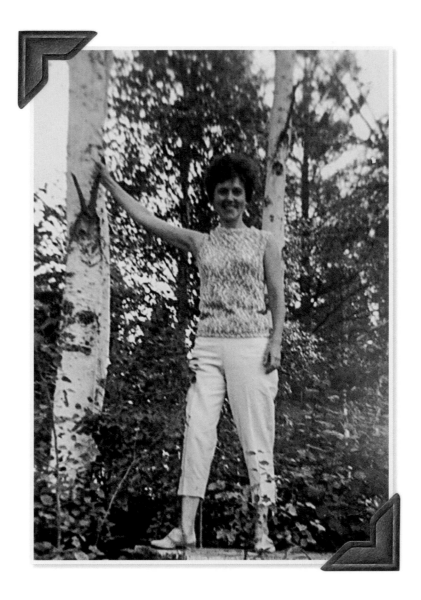

I arrived at the lecture early and sat in the front row. The title of his talk was "The Art of Seeing," and he sketched the entire time he spoke, occasionally holding up his pad to illustrate a point he was making. Toward the end of his speech, he held up a sketch—it was me! I almost didn't recognize myself, but then he turned to me and quietly said, "You are special."

The moment was more than thrilling. It felt like a blessing from someone I considered larger than life. Never before had I thought of myself as special. But Oskar Kokoschka pushed me a little further on my path; I was going to prove I was special to everyone—including myself.

At the beginning of my senior year of college, a notice was posted that the application process was about to kick off for *Mademoiselle* magazine's annual guest-editor contest. While *Vogue* was considered the epitome of high fashion, *Mademoiselle* focused more on the lifestyle of smart, independent young women; contributing authors included Joyce Carol Oates and Truman Capote. Meanwhile, the guest-editor program was truly prestigious, with an alumni list that included Sylvia Plath and, from my year, Joan Didion.

Entrants submitted four essays over the course of their senior year; but with more than thirty-seven thousand applicants and only twenty guest editor spaces, did I even have a chance? My first essay won a ten-dollar prize, and I allowed myself to hope. In early May, just prior to graduation, the telegram arrived: "We are delighted to tell you that you have been chosen as a 1955 Guest Editor."

How did I feel? Special, indeed.

Naturally I was thrilled, but also more than a little apprehensive. *Mademoiselle* informed the

Above: *On vacation in northern Minnesota, 1958.* ✦ **Opposite:** *The congratulatory telegram* Mademoiselle *sent me, May 1955.*

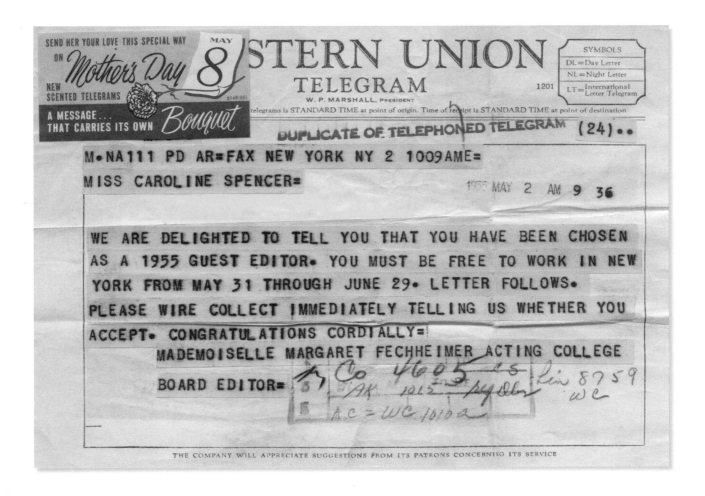

STERN UNION
TELEGRAM
W. P. MARSHALL, PRESIDENT

SYMBOLS
DL=Day Letter
NL=Night Letter
LT=International Letter Telegram

1201

telegrams is STANDARD TIME at point of origin. Time of receipt is STANDARD TIME at point of destination

DUPLICATE OF TELEPHONED TELEGRAM (24)..

M.NA111 PD AR=FAX NEW YORK NY 2 1009AME=

MISS CAROLINE SPENCER=

1955 MAY 2 AM 9 36

WE ARE DELIGHTED TO TELL YOU THAT YOU HAVE BEEN CHOSEN
AS A 1955 GUEST EDITOR. YOU MUST BE FREE TO WORK IN NEW
YORK FROM MAY 31 THROUGH JUNE 29. LETTER FOLLOWS.
PLEASE WIRE COLLECT IMMEDIATELY TELLING US WHETHER YOU
ACCEPT. CONGRATULATIONS CORDIALLY=
MADEMOISELLE MARGARET FECHHEIMER ACTING COLLEGE
BOARD EDITOR=

THE COMPANY WILL APPRECIATE SUGGESTIONS FROM ITS PATRONS CONCERNING ITS SERVICE

winning guest editors that we had to be free to work in New York between May 31 and June 29. I had never lived away from home or outside Minneapolis, at the time a relatively small city. Not until the telegram arrived did it occur to me that living in New York for a month might feel overwhelming. Then again, after all those years of feeling restless and wanting more—this was my chance.

In June 1955, instead of walking across the stage to receive my diploma, I'd checked into the legendary Barbizon Hotel for Women in New York City, living and working in a city that was overwhelming, but exciting too. While walking on Fifth Avenue, I found myself always looking up—at the green mansard rooftops of the Pierre and the Plaza, or the art deco edifices of Bonwit Teller and Tiffany & Co.

Our class of twenty talented "mademoiselles" was nothing less than a dreamlike experience. We were invited everywhere: to the home of the famed cosmetics mogul Helena Rubinstein, who devoted an entire room of her penthouse apartment to Salvador Dalí paintings, and to stand at the podium in the General Assembly room at the United Nations, which had opened its headquarters on Manhattan's East Side just a few years before. We wore our best formals while dancing with West Point cadets in the ballroom on the rooftop of the St. Regis Hotel. And everywhere we went, we were photographed as though we were debutantes or celebrities. It was about as far from Minneapolis as you could get.

Even the work was tinged with glamour. We each had to produce an article for publication, and I asked the magazine's fashion editor, Kay Silver, if I could interview Pauline Trigère, whose work I appreciated for its combination of innovative construction and clean, chic lines. To my utter delight, Kay granted my wish, and soon enough I was standing with Pauline Trigère in her workroom in the Garment District. It was my first look at a professional design studio, with its large tables for pattern cutting, mannequins for draping (Miss Trigère's preferred design process), and a live-fit model on standby. I was hooked.

AQUA

RIVER BLUE

TEAL

EACH

AB APPLE

QUER

Cable No.
70157

GOLD

Cable No.
70158

BRONZE

Cable No.
70159

BURNT ORANGE

Cable No.
70160

TERRA COTTA

Cable No.
70161

HENNA

Cable No.
70162

NIC

STEE

LIMEPEEL

MOSSTONE

Cable
701

OLIVE

Cable No.
70156

PRUNE

Cable No.
70164

EGGPLAN

JADE GR

PRIMITIVE

IRIS

LEMON YELLOW

Cable No.
70205

B

CORAL

Cable No.
70206

PARMA

PARROT BLUE

Cable No.
70207

FU

CHARTREUSE

Cable No.
70208

SCARAB GR

ORIENTAL BLUE

Cable No.
70209

NUGGET GO

CARMINE

Cable No.
70210

SAPPHIRE BLU

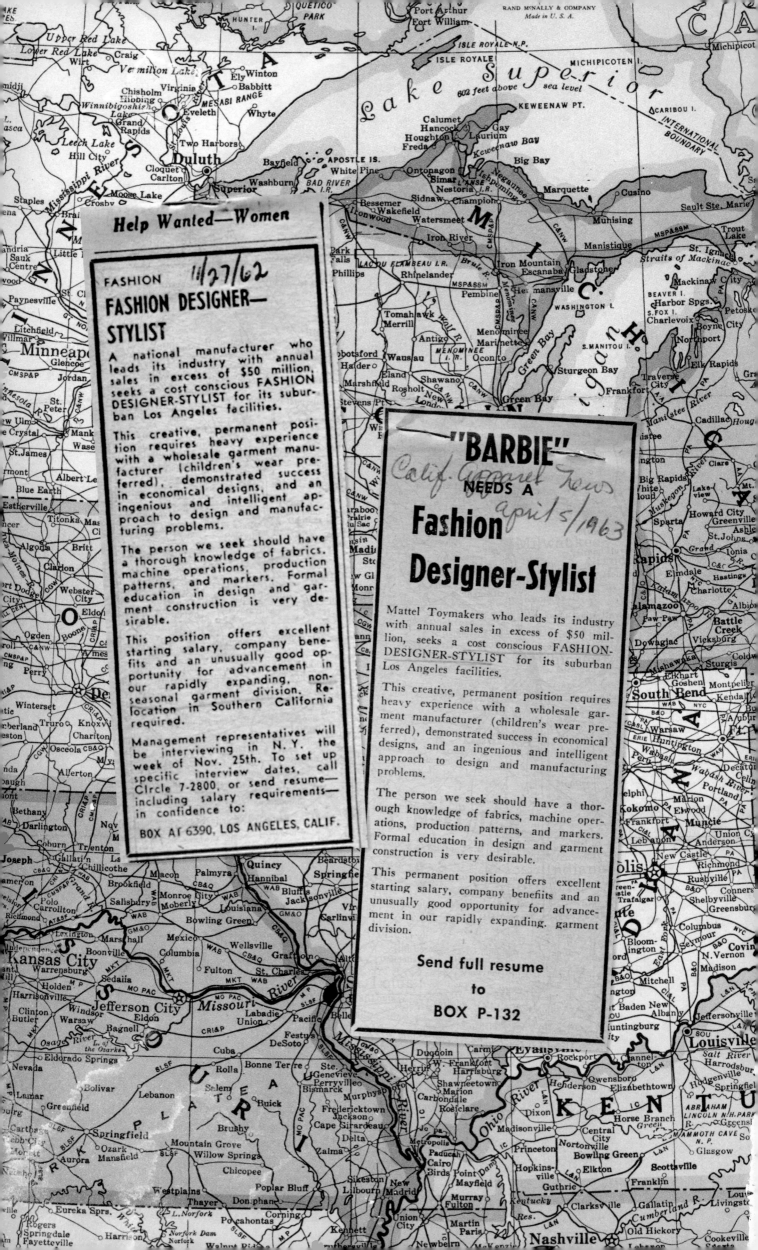

During our interview, Miss Trigère (as I always called her) dispensed terrific advice that I still follow: a pretty sketch is only the beginning; a good fashion designer also considers the execution of that design and how the personality of the fabric will play a role. No one element is more important than the others. She also encouraged me to, above all, be true to myself. Throughout my thirty-five years designing for Barbie, I never strayed from this philosophy.

That month in New York flew by, and it was time to think about a full-time job. I headed back to Minneapolis, where Wonderalls Co., a wholesale garment manufacturer, needed a children's wear designer. These days it would be impossible to think of someone fresh out of college designing a complete clothing line, but that's exactly what I did, everything from tops to coveralls and even bathing suits, for girls and boys.

After a few years at Wonderalls Co., I needed a change—not only because designing children's wear could be rather limited but also because of Jerry, the owner's son. We had dated for a while, but when he broke up with me—our religions were incompatible, unfortunately—I knew it was going to be awkward seeing him every day. I also realized that I once again had no desire to be dependent upon a man. My first priority had to be my career. I started sending out my résumé.

A Milwaukee company called Junior House needed a designer for "misses sportswear," the designation for clothes for teenage girls then. It was just what I wanted: a new job in a new city, and no more children's clothes.

Junior House was located in a big, drafty building on Milwaukee's South Side, but I quickly learned every aspect of the business, as my new boss, Lee Rosenberg, gave me a crash course on everything, from fabrics and production patterns to machine operations. I was installed in a studio above the factory, where I would sketch a design, cut and drape it on a mannequin, and then cost it out. If Lee approved, I would make the pattern and run it downstairs, where the production team would crank out my design in every size and color, a dozen pieces each. I loved watching my design go from sketch to completed garment so quickly. My designs also came in on budget and sold well, a combination every garment manufacturer appreciates.

I couldn't know it at the time, but the knowledge and experience I gained at both Wonderalls

Co. and Junior House ultimately would prove to be the perfect foundation to join Mattel as a Barbie fashion designer-stylist.

But first I had to get the job.

When I saw the ad in *Women's Wear Daily* in November 1962, it didn't mention Barbie or Mattel; rather, it was a blind ad for a fashion designer-stylist, yet I read between the lines and was able to discern both the company and product. I also realized how perfectly I matched every element the ad was seeking. "Heavy experience with a wholesale garment manufacturer"? Check. "Children's wear preferred"? That fit as well. "The person we seek should have a thorough knowledge of fabrics, machine operations, production patterns, and markers." Thanks to my experience at Wonderalls and Junior House, I was confident I could handle these tasks with ease. Perhaps best of all, two words jumped out at me: *Los Angeles*. Sunny California suddenly seemed like the perfect change from Milwaukee, and working on Barbie, already the world's most popular toy, seemed like an irresistible idea.

I sent my résumé for consideration, but didn't receive a response. In the meantime, thoughts of Los Angeles continued to beckon. One day, in a pure leap of faith, I decided a move to California was exactly the change I was seeking. I didn't have a job, but even if Mattel didn't hire me, I knew Los Angeles was a hub for fashion manufacturers. Aunt Lena accompanied me on the road trip and helped me settle into my first LA apartment—I also hedged my bets and selected a home not far from Mattel's headquarters. The sun shined every day, and the Pacific Ocean was just twenty minutes away. I was in heaven.

Before I left Milwaukee, I had asked for my mail to be forwarded, but still no word from the company advertising for a fashion designer-stylist. Then one day in 1963, I was sitting at my kitchen table in Los Angeles, reading a trade paper, and I couldn't believe my eyes: "Barbie Needs a Fashion Designer-Stylist." The ad listed all the same requirements as the previous blind ad, but this time it was no secret: Mattel needed someone to design for Barbie. Thrilled to learn more about the position, and that it hadn't been filled, I applied the same day.

And soon enough, a response. Actually, make that two responses: At roughly the same time Mattel replied to my submission to the ad in the California paper, my forwarded mail from Milwaukee also

Opposite: The ad Mattel placed in Women's Wear Daily *(left) when the company was looking for a fashion designer-stylist, November 1962. I saw the second ad for a Barbie fashion designer-stylist (right), in* California Apparel News, *April 1963.*

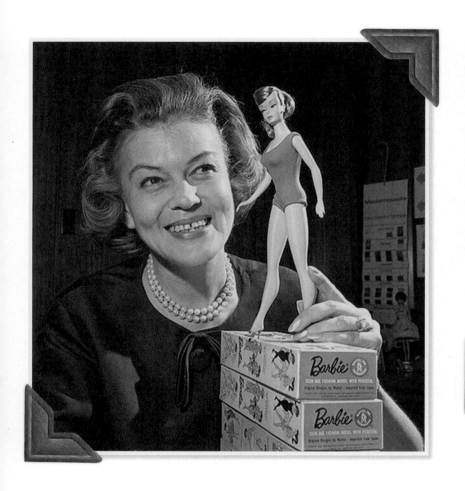

arrived, and there was Mattel's reply to the résumé I had sent after seeing the blind ad in *Women's Wear Daily*. Amazingly, both letters included the same request: Could I come in for an interview on April 12 at 11:00 a.m.?

This was fate, I thought. My decision to move to Los Angeles had paid off.

On Friday, April 12, 1963, just before 11:00 a.m., I arrived for my interview at Mattel's California headquarters. I was determined to get this job.

Jerry Fire of Mattel's human resources department greeted me in the lobby. I still remember thinking how handsome he was. We walked back to his office, he offered me a seat, and then he opened his desk drawer: inside, I saw what looked like a gun.

He saw the look on my face and burst out laughing. "This? It's a toy," Jerry said, waving it around nonchalantly and showing me that it only fired blanks.

So this is what it's like to work at a toy company, I thought.

My interview with Jerry actually was quite brief. He had heard the story of my dueling résumé submissions, and during this process Mattel evidently had decided I was more than qualified for the job. There were just two hurdles to get past: from that same desk drawer, Jerry took out two Barbie dolls, one blond and the other brunette, both sporting the same bubble-cut hairstyle. With them, he handed me a packet of instructions. I had two weeks to create a set of test fashions; the dolls should be dressed in my finished designs, and I needed to present patterns and sketches. "And be sure to keep track of your time, because we'll pay you for it," Jerry added.

Back in my apartment, I put the dolls on my kitchen table and spread out the instructions. The first challenge was how different it would be to design for a doll instead of designing for a child or young woman. Barbie had been created on a one-sixth scale of the female form, and while the math for creating patterns was easy enough, finding prints suitable for her smaller size could be difficult; even the smallest, most delicate flower on a child's dress would seem gigantic on an eleven-and-a-half-inch

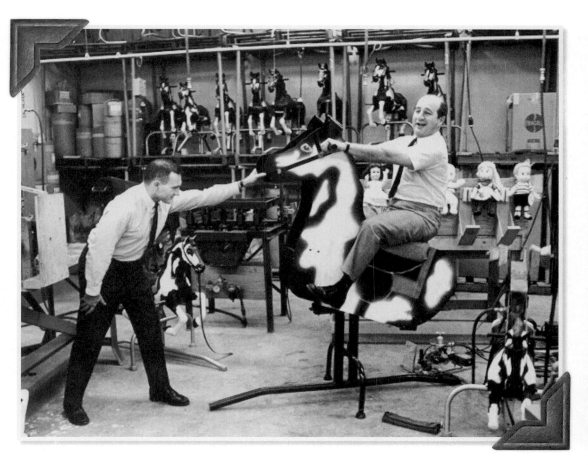

doll. I also had to take into consideration the perception of Barbie as the quintessential California girl. Whatever I designed needed to evoke that ideal.

That's when I decided that a swimsuit and matching cover-up was the answer. If Mattel had any concerns that I might not understand the California lifestyle, I would prove that wrong from the outset. I dived into my considerable collection of fashion magazines and tore out every image of a stylish swimsuit to produce an inspiration board. From there, I started sketching and created a small collection that felt chic and on trend and also more than a bit feminine. That's what I saw when I looked at Barbie, and I wanted that to come through.

As I started thinking about the fabric I would use to render my designs, I remembered a children's look I had created at Wonderalls, and I dug through boxes until I found it—I no longer cared about the clothing design, but the fabric was perfect, a beige

cotton with miniature lollipops that I had custom designed. Both the scale of the print and the feel of the fabric were perfect for the cover-up. For the swimsuits themselves, I created a one-piece and a two-piece style, both in a soft red that coordinated perfectly with a color found in the lollipop print. My finished Barbie dolls looked fun and chic, and definitely like California girls. Most important, I absolutely loved the process.

Completing the test fashions was merely the first hurdle. My follow-up meeting two weeks later was with the woman who already had become a bona fide legend in the history of Barbie. Charlotte Johnson had been a freelance fashion designer who also taught at what later became known as the California Institute of Arts. Early in 1959, Ruth Handler recruited Charlotte to work on her top secret doll project, and she ultimately played an integral role in Barbie's look. Charlotte was inspired by the runways

Above, left: *Charlotte Johnson, the manager of the Barbie design team, in 1963, the year I met her.*
Above, center: *Ruth Handler, Barbie's creator, in the early 1960s.* ✳ Above, right: *Jack Ryan* (left), *head of research and design, and Elliot Handler* (right), *Mattel's co-founder, test out Blaze, Mattel's talking rocking horse, c. 1961.*

of Paris and New York, combining that chic aesthetic with the feeling of the California lifestyle to create the twenty-two fashions that comprised Barbie's 1959 debut wardrobe. Charlotte knew the doll better than almost anyone—except, perhaps, Ruth Handler herself—and she was about to evaluate my designs. Of course, the moment was incredibly intimidating. I wore my best interview suit with a hat, gloves, and a matching bag, and I carried my finished Barbie dolls, one in each hand, somewhat nervously. Still, I knew what I had created was the absolute best of my skills and imagination.

Jerry Fire ushered me back into his office for this step in the interview process, and then Charlotte walked in and joined us. My first memory of meeting her was that she was very tall and quite stylish. I felt good about my test designs, but in Charlotte's hands, who could tell? I didn't say a word as she turned the dolls over and over, closely examining every detail—not just the styles themselves but also the construction, the seaming, even the fabrics I had chosen. After what seemed like an eternity, Charlotte

rendered her verdict: "I have no objection to hiring you," she said, her words revealing no enthusiasm for my designs. And with that, she walked out of the room.

My first thought: *What just happened?* Then Jerry Fire was beside me again, escorting me to another room to take a personality and aptitude test, the final step to becoming a Mattel employee in those early years. Once that was complete, he was shaking my hand, a big smile on his face. It took me a moment to realize that I had passed both tests—Charlotte's and Mattel's—and had gotten the job. All of a sudden, I was smiling along with Jerry.

The rest of that day was like a dream in which I sort of floated along. I couldn't stop grinning, because I had achieved exactly what that second ad had asked for: I was a fashion designer-stylist for Barbie.

People talk about fate as an abstract idea, but in that moment, I fully embraced what it meant. The two advertisements I'd responded to had serendipitously asked me to come in and interview on the same day at the same time. How could that not be destiny?

Above: Mattel as it looked in the early sixties, when I started working there. ✱ *Opposite: The inspiration board I created before I started designing the "test" outfits for the Mattel job, along with the fabric I used for the cover-ups.*

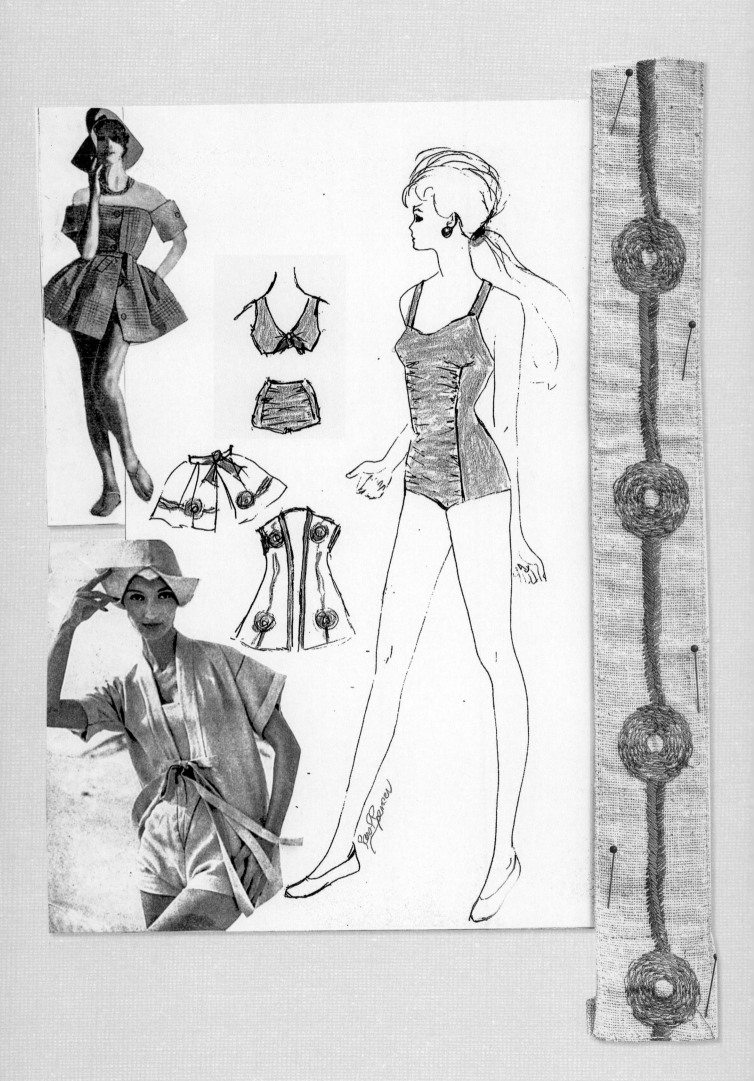

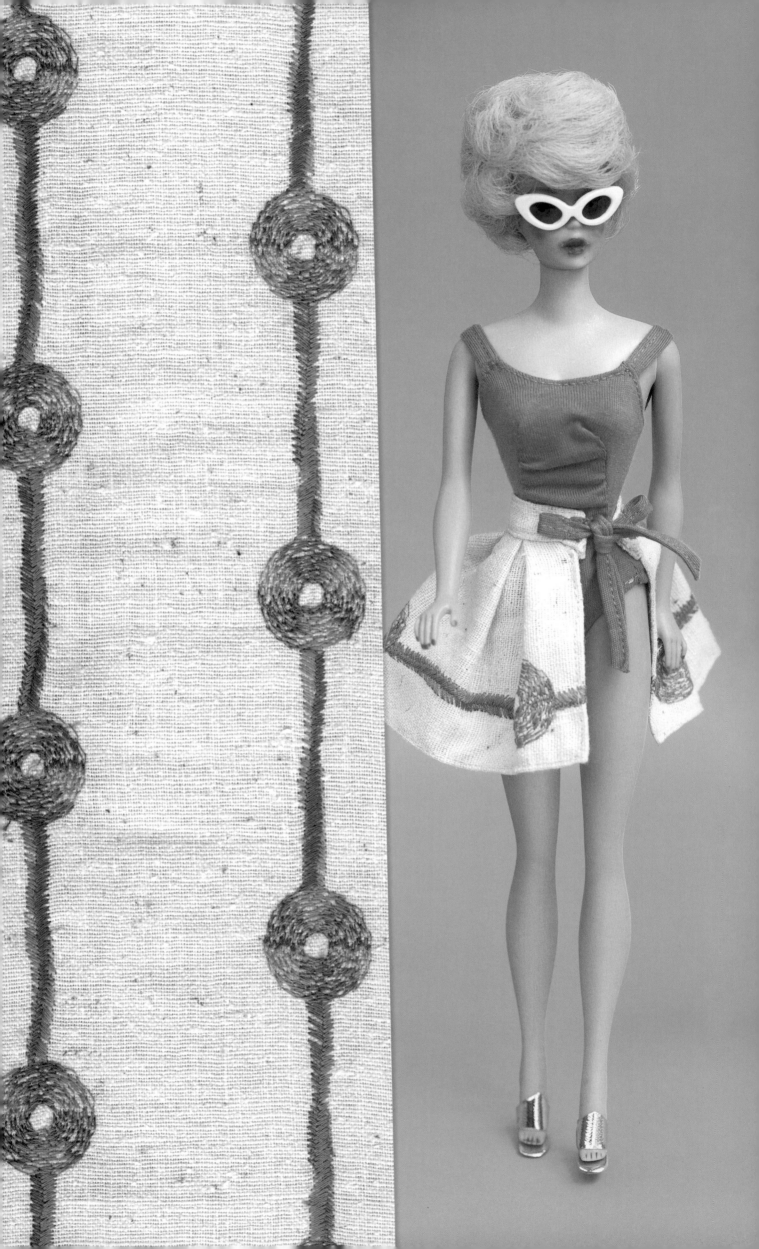

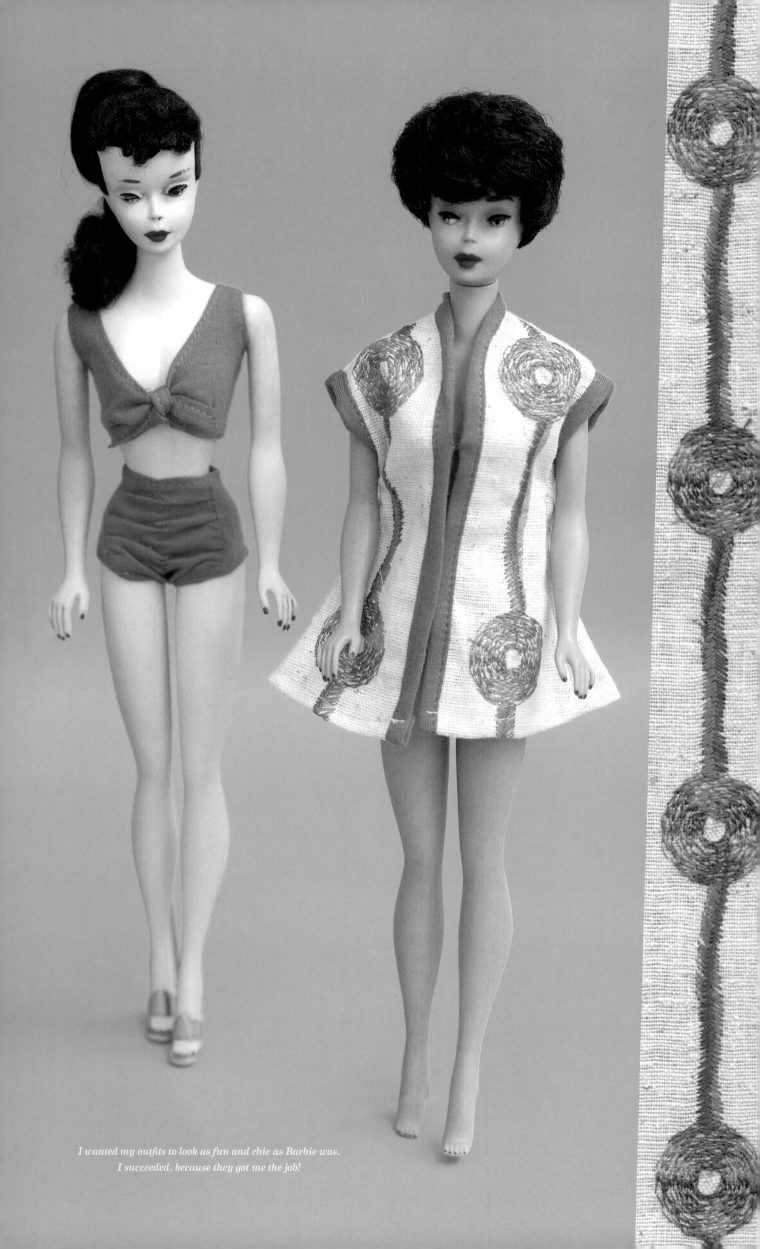

I wanted my outfits to look as fun and chic as Barbie was.
I succeeded, because they got me the job!

The
1960s

It Was Swell at Mattel

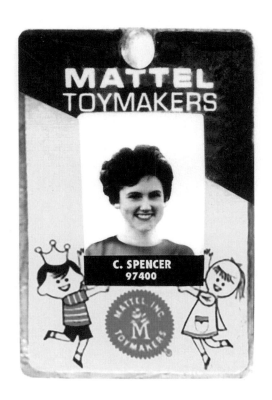

DESIGNING FOR BARBIE WAS EXACTLY WHERE I wanted to be. I understood her potential, the role she could play in our popular culture. I also felt a personal connection with Barbie, how she spoke to girls on the cusp of adolescence, that in-between time of loving dolls while also discovering their love of fashion. That's what Ruth Handler had envisioned when she created Barbie: she encouraged little girls to project their own dreams about their future as they played. Something in that message spoke to me as well.

I started work on April 29, 1963. Jerry escorted me down the hall to research and design: the nerve center of Mattel, where all new products were created. Security was tight there, with closed-circuit cameras and guards on duty. Many of the personnel who had joined Mattel at that point had at one time worked for the government.

That idea was a little thrilling. Each of us was cautioned from the beginning that everything we did was likely under surveillance—the notion of "toy espionage" might seem a little silly now, but imagine that Barbie then was similar to what Apple is today. Every new introduction was closely scrutinized by the competition and very soon copied.

My desk was in the fashion-design department, a large group space with exactly zero windows; this was my first clue that competitors spying on our work was a chief concern at Mattel. Charlotte's office

Above: My first badge at Mattel.

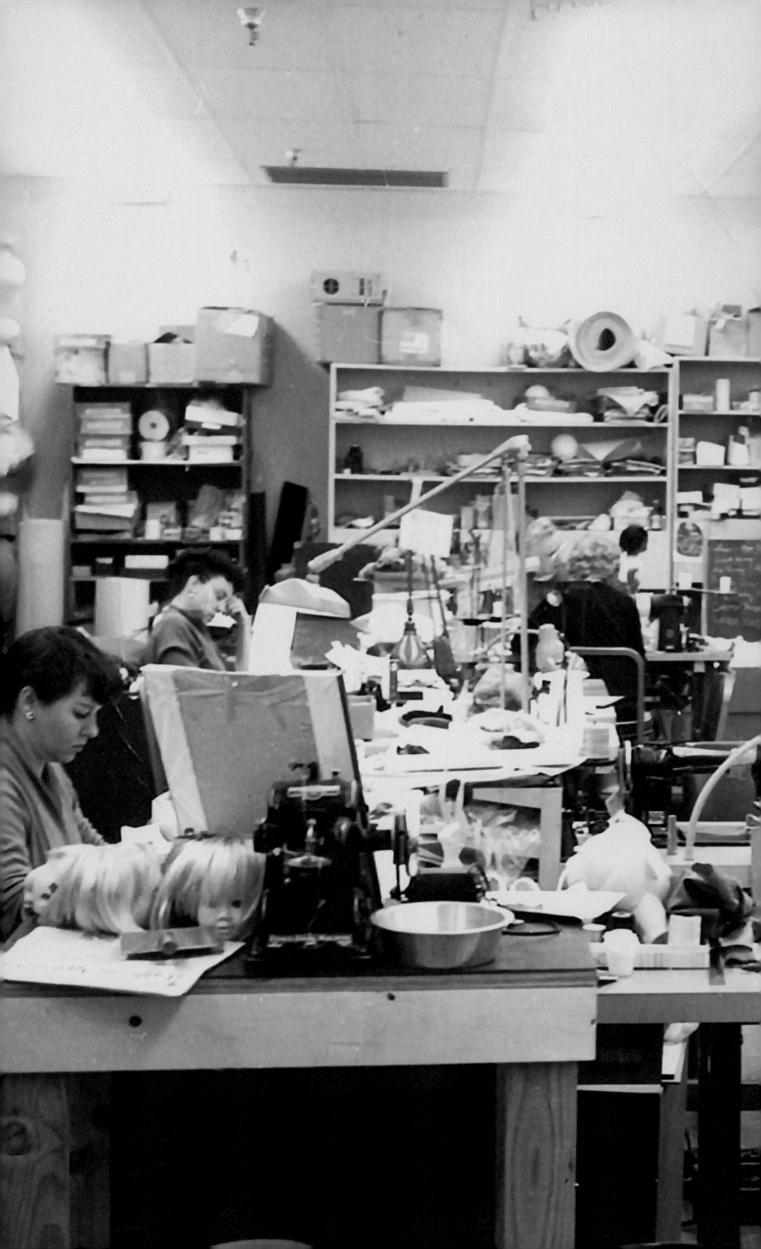

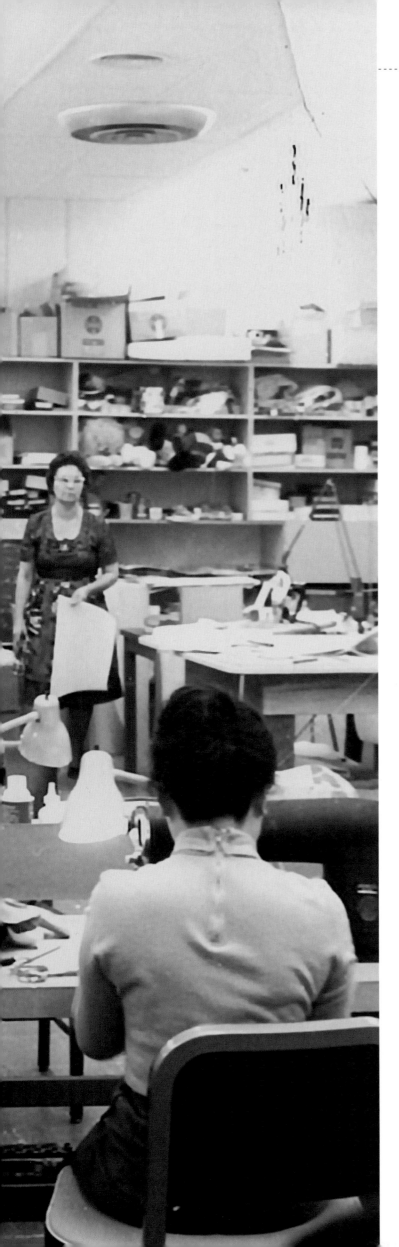

was on the left, a private room filled with stacks of art books and magazines, and multiple fashions displayed on movable pegboards. Beyond her office, in the center of the common area, was a large wooden table with doll-size fashions in various stages of development. The shelves beneath held a treasure trove of notions: buttons, zippers, snaps, ribbons, sequins—anything you might need to bring one of Barbie's fashions to life.

Each wall was lined with floor-to-ceiling shelves teeming with fabrics of every color and print. Between the center worktable and the walls were our individual spaces, a place to both design and sew (the latter task was handled by our sample makers, the professional seamstresses who served as our assistants).

I also met my fellow designers: Dorothy Shue, who had started out as a puppeteer in the movie industry; Aileen Zublin, who had made a name for herself as a fashion designer in Switzerland; and Kay Carter, who, like Dorothy, also had come from the movies, having worked under the legendary fashion designer Adrian, whose glamorous work had been made famous in films like 1939's *The Women*. Indeed, Kay was an expert with drama when it came to doll fashions; with the flick of her wrist, she could literally twirl a piece of taffeta into a beautiful doll-size gown.

Under Charlotte Johnson's direction, the four of us were responsible for creating Barbie's wardrobe. What was surely unique about our equation, and about Charlotte's influence over our group, was that each of us brought our own distinct flavor to the fashion department. Dorothy specialized in fantasy, while Aileen brought a sense of high style and haute couture; Kay contributed the drama, and me? I lent an air of practicality. American fashion has always been rooted in a straightforward, sportswear-driven sensibility, and I specialized in that idea. The pieces I designed were stylish and wearable without ever feeling too frilly or frivolous. Perhaps of all four women in the group, I excelled most at the meaning of true American design.

My badge, security clearance, and coworker introductions complete, I took my place at my new desk and immediately started work. Charlotte traditionally handed new designers a two-page list of handwritten instructions, which were to be considered as nothing less than gospel: Think of Barbie as a real person, for example, a fashion model who

Left: *The fashion design room, c. 1961.*

was eighteen years old. Barbie was stylish; she was a career girl, and she lived a wonderful fantasy life; little girls should be able to project similar dreams as they played with her. Barbie's clothes, meanwhile, couldn't be too grown-up or the closures too tricky for the children dressing and undressing her. Another key: they should evoke a sense of romance, a backstory, or a predetermined theme, yet still feel current and fashionable.

On the logistical side, each Barbie fashion designer was responsible for producing both the first and production patterns as well as the accessories. When we presented our work for review, we displayed the designs individually, with a duplicate set in its packaging, exactly as the customer would see it in stores.

Even as I started thinking about how I would succeed with Barbie, I felt Dorothy, Aileen, and Kay summing me up, wondering about the impact I might have on the group. At my two previous positions, I had been the lone designer, and it wasn't until I arrived at Mattel that I realized how unusual that was. At Mattel I was part of a team, comprised of members who were highly competitive. Only 120 fashions were sold over the course of the year, and each of us competed for those slots.

I got right to work and didn't have to look too far for inspiration. In 1963, no woman in America was considered more fashionable than Jacqueline Kennedy, and I had long admired her clean, classic look. Combined with my own wardrobe, which had become rooted in sleeveless dresses well suited to the California lifestyle, I envisioned a chic set of separates for Barbie: a white blouse with red buttons and a scarf of red and white polka dots, paired with a red pencil skirt that reached below her knees. Matching white gloves, open-toed white pumps, and a handbag—white with a red handle—rounded out the ensemble. The result was a look that Jacqueline Kennedy might have worn in the summer of 1963, and if so, surely it would be copied by stylish girls all over the world.

Above: Barbie's clothes were meant to evoke a sense of romance and fantasy—and the illustrations on the packaging and the booklets that came with the dolls in the 1960s conveyed that.

From Idea to Finished Product

The Design Process in the Sixties

Getting a design approved was no small feat, and the process was quite rigorous. It started with ongoing reviews by Charlotte Johnson, who oversaw the department and supervised our work. Throughout the process, Charlotte would stop by our desks and ask to see every design, whether it was in early stages or nearly done. This hands-on approach was extremely helpful, because it ensured success down the road; if Charlotte didn't care for a fabric or even a minute detail, it was changed immediately. As someone whose vision was instrumental to Barbie from her very first fashion collection, Charlotte's opinion was simply unparalleled and respected by everyone.

The Handlers relied on Charlotte's sophisticated taste and design sense, though Elliot still stopped by every day around 3:30 p.m. to check out our work. He was a respected figure in the toy industry—among many iconic products, Elliot was responsible for introducing Chatty Cathy—and he never failed to offer bits of helpful advice as he toured the design studio. I always enjoyed it when he stopped by my desk (he'd announce his arrival with "On, Wisconsin" playing over the Muzak PA system as an affectionate nudge to my former state). His style was easygoing and cheerful, and he liked to ask questions—he seemed to care how we had arrived at our decisions. I like to believe that his sense of fun, and the interest he took, always came through in the fashions we created for Barbie and her friends.

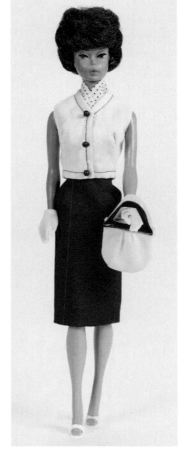

The process culminated in a lineup that was presented upon the deadline of our yearly design cycle. This was our chance to present finished designs for Charlotte and Elliot's final review—and for Ruth's approval as well. With so many aspects of Mattel under her purview, Ruth typically didn't view our efforts until the final stages. Charlotte also positioned the lineup according to her favorites. If Charlotte loved a design, Ruth and Elliot typically did as well. They had developed a shorthand while working together over the years, and Charlotte's blessing on our work was as good as a final approval.

But even if they loved the design, Ruth and Elliot were also practical: another factor in their consideration was how a design had fared with our focus groups of children, as well as how marketable the ensemble promised to be. The Handlers also considered the fabric's quality and whether we could maximize its usage so there was very little scrap left. They were extremely thrifty, hated waste, and put recycling rules into place at Mattel long before sustainability was considered fashionable or necessary.

That's how my very first design for Barbie, that Jacqueline Kennedy–inspired mix of red and white separates, traveled from its early idea through critiques to final approval. Like other Barbie fashion designs of the period, this breezy, summery look was christened with a name—Crisp 'N Cool—and made its appearance in stores in 1964. I was absolutely thrilled, and from that initial moment of success, I was hooked.

Above: *My first outfit for Mattel was based on Jacqueline Kennedy's clean, classic look.* ✴ **Next page:** *From sketch to success! We called my first outfit Crisp 'N Cool.*

Short White gloves

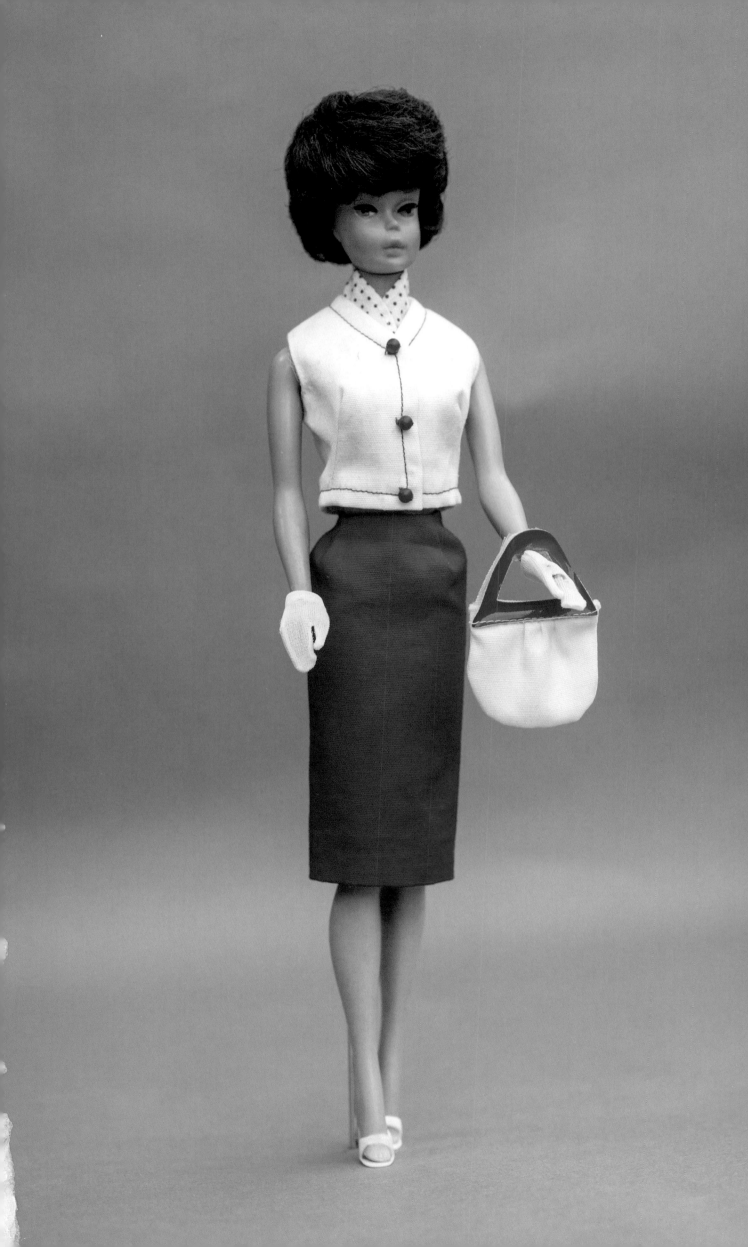

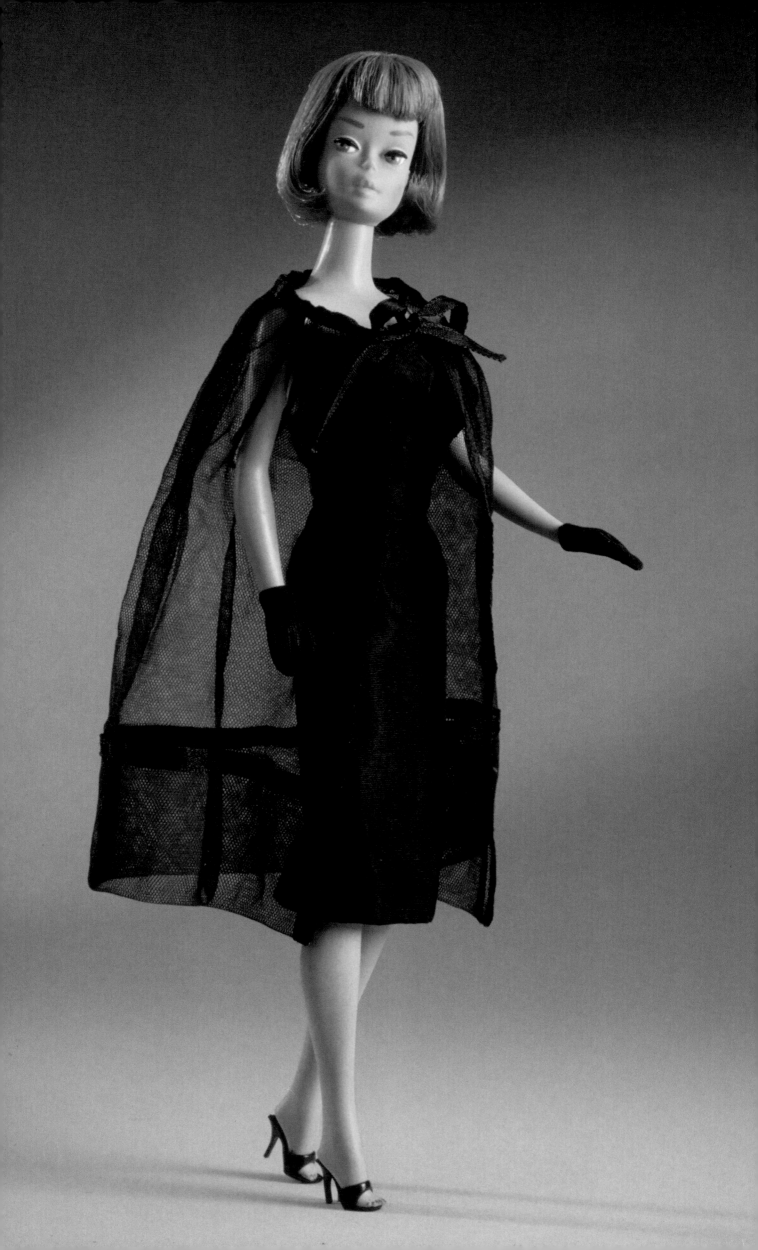

A Little Black Magic

Each of us was inspired by the style and fashion we saw all around us, and that extended to Ruth Handler as well. One day in 1964 she brought into Charlotte's office a dress from her wardrobe, an elegant black cocktail sheath with a sheer, matching cape. Ruth had never done this before—and she wouldn't do it again—but she loved this dress, and she thought it would be perfect for Barbie. She asked Charlotte to assign one of us to create a doll-size version of this chic party look.

I was still the freshman member of the team, but that's not why Charlotte decided I was the one who should undertake this task—this was a direct request from Ruth, so guaranteed success was the priority. By this time I really had come to admire Charlotte, whose knowledge of Barbie was encyclopedic and whose fashion sense was impeccable. I was ecstatic when she entrusted me to re-create Ruth's dress, and I wanted to reinforce her confidence in my abilities. I studied every element of that design to create its Barbie counterpart, a black silk sheath and a matching evening coat in black tulle, finished with a ribbon trim in black satin and a tie at the neckline. Short black gloves, black open-toe shoes, and a gold purse completed the ensemble. We named the fashion Black Magic.

Charlotte was never effusive in her praise, but I knew she was happy with my design. And Ruth absolutely loved it; I don't think I realized just how much until I saw her autobiography, *Dream Doll*, which she published in 1994 to coincide with Barbie's thirty-fifth anniversary. There on the cover, next to Ruth's portrait, was Barbie—not in her original, 1959 striped swimsuit, but in the Black Magic ensemble. I felt incredibly honored, though ironically, this particular dress wasn't a big hit with children. They were attracted to the bright colors and whimsical prints so common in Barbie's wardrobe; therefore a chic black dress was a bit off their radar. Moms, however, loved it, and Black Magic also proved a theory Ruth had developed early on with Barbie, that because she was styled as a young woman, the doll could be a bonding experience between mothers and daughters.

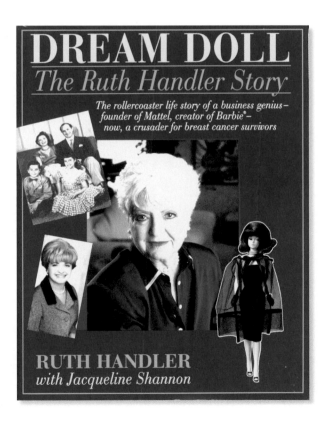

Opposite: This sophisticated ensemble was based on Ruth Handler's favorite cocktail dress. Ruth loved the outfit so much she featured it on the cover of her autobiography (above).

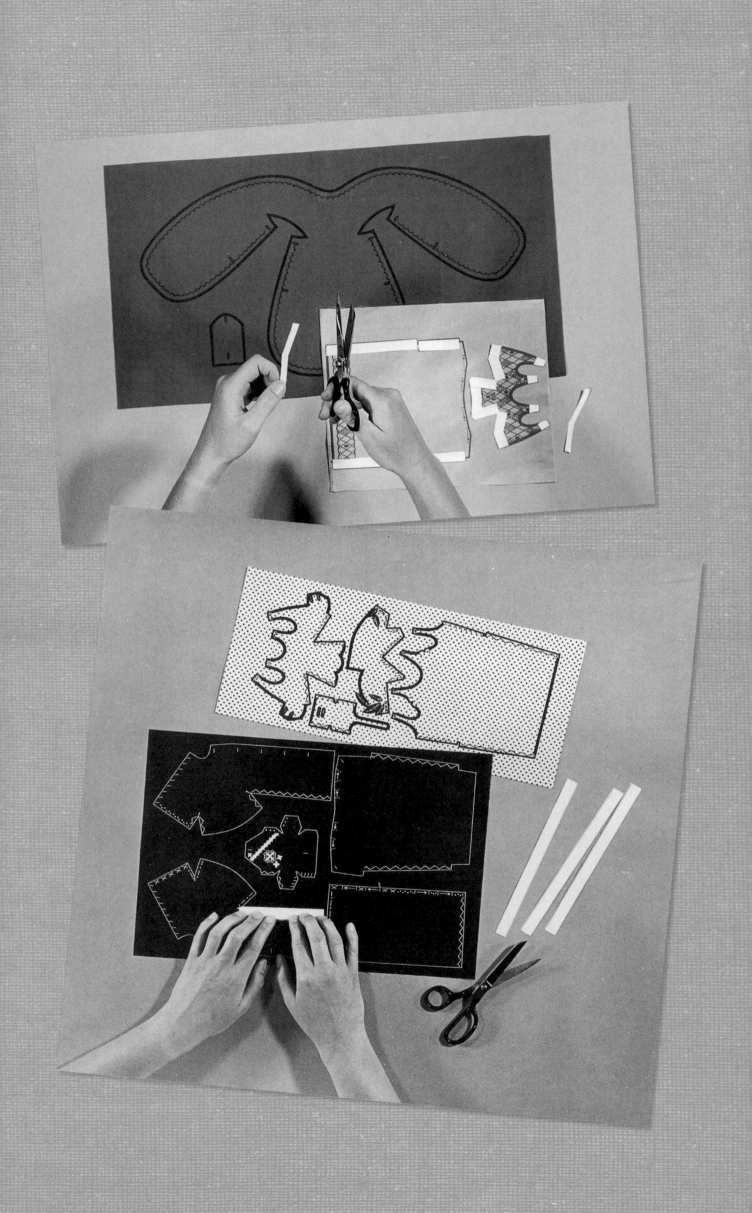

Girls Get Hands-On with Design

Elliot Handler was always on the lookout for a new idea and a way to expand Barbie's universe, and early in my tenure, he recruited me for these special projects. In 1965, he hit upon the idea that little girls might want to create their own Barbie fashions—without the use of sewing needles, of course. He dubbed the concept Sew-Free and asked me to create designs that could be easily assembled with glue strips. Elliot redesigned the packaging—beautiful illustrations that reinforced Barbie's fashion-model status—while I created a pattern that was hand-painted onto a piece of cotton fabric; using children's safety scissors, a child could cut out the pieces and press them together. The next step turned out to be the most fun for kids: decorating the outfit, using adhesive-backed leaves, metallic designs, or flowers in bright colors. The set was completed with ready-made accessories, though sometimes I included a matching head scarf or kerchief as part of the fabric pattern.

Over a two year-period we created twelve Sew-Free patterns, primarily elegant dresses for day or evening, and what we discovered was that children loved decorating the finished outfit more than any other aspect of the project. You still find Sew-Free sets out there in the collectors' market, though for the most part only the finished pieces are available. And as the person who had to figure out how they would work, I'm proud to say those garments are still holding up after more than fifty years.

Opposite: *Sew-Free outfits came with booklets, featuring my hands, so little girls could get step-by-step instructions on how to assemble the outfits.* ∗ **Above:** *Three of the finished dresses.*

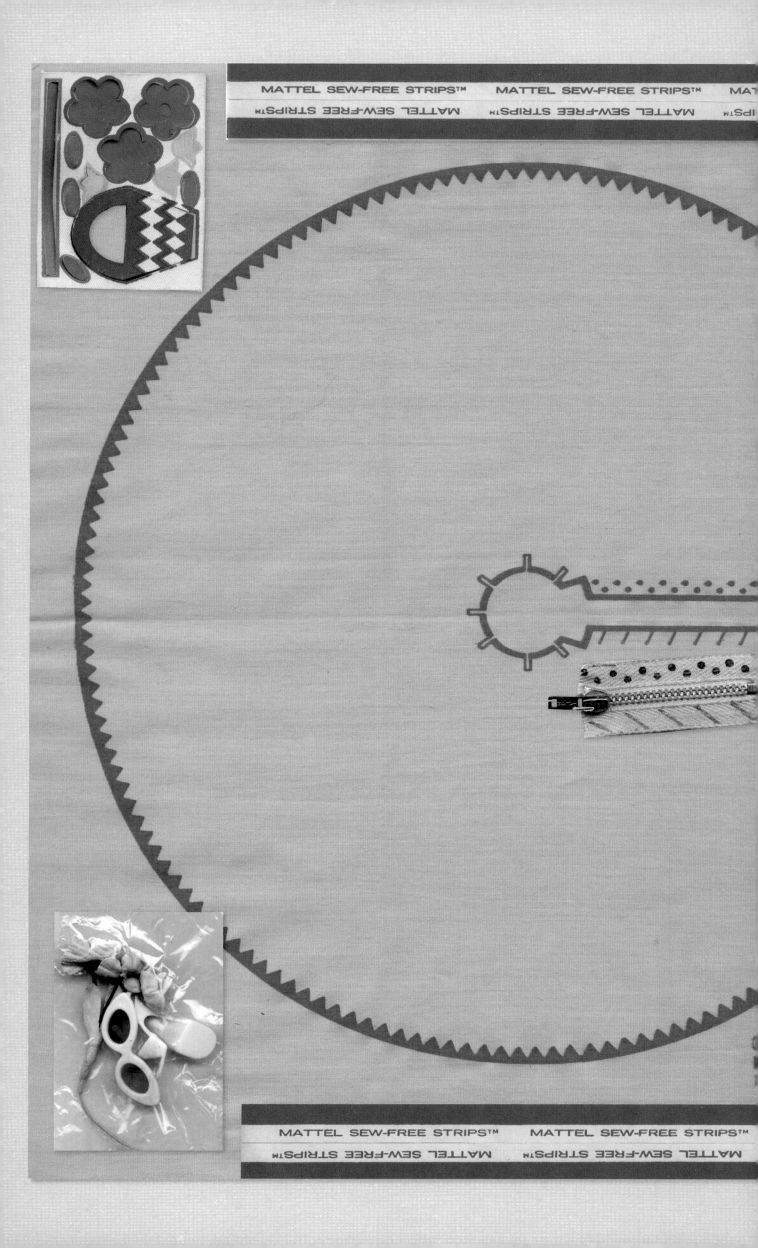

MATTEL SEW-FREE STRIPS™ MATTEL SEW-FREE STRIPS™ MAT

MATTEL SEW-FREE STRIPS™ MATTEL SEW-FREE STRIPS™ IPS™

MATTEL SEW-FREE STRIPS™ MATTEL SEW-FREE STRIPS™

MATTEL SEW-FREE STRIPS™ MATTEL SEW-FREE STRIPS™

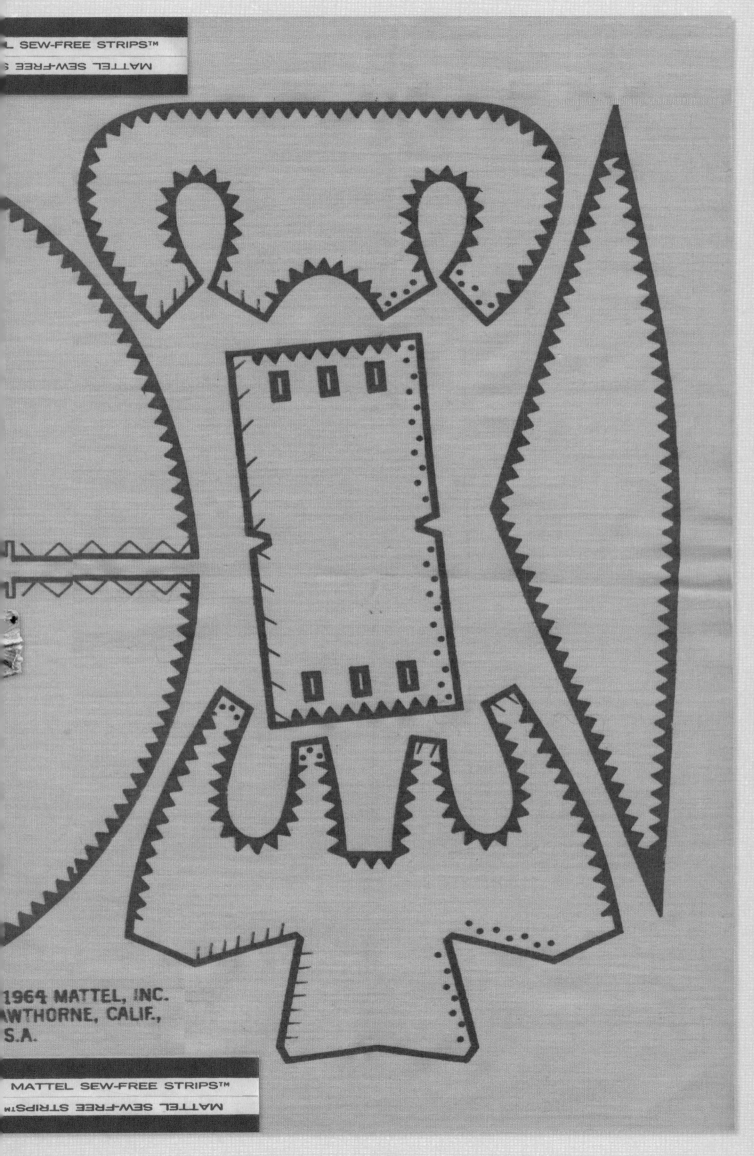

An uncut version of Sightseeing, seen on page 37 (center), along with glue strips and accessories.

**LIKE MAGIC
COLORS CHANGE
OVER AND OVER**

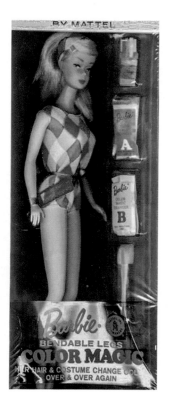

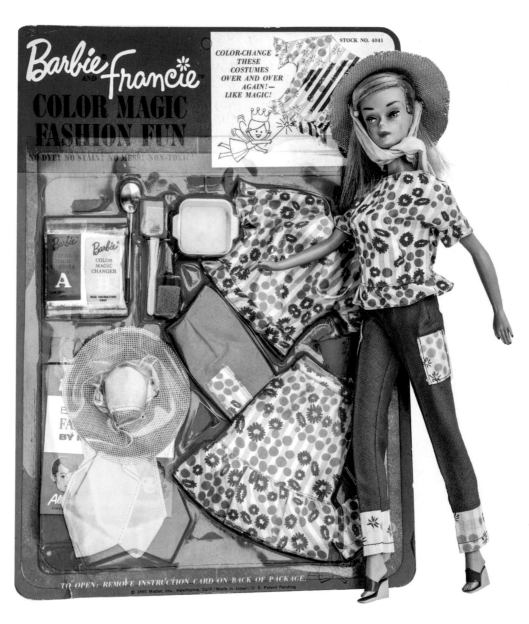

The same was true of another special project Elliot dreamed up and recruited me to realize. In the mid-1960s, with mod fashion at its height, Elliot wanted to highlight the trend by putting Barbie in something bold and brilliant, while also adding a bit of wow factor. The result: the series of Color Magic dolls. Color Magic Barbie came dressed in a bright, graphic mod-style outfit; included with the doll was a special, safe solution created by Mattel chemists and a sponge applicator. A girl would dab the solution on the prints and they would change—the yellow became a deep red while the blue shifted to a somewhat brighter red to create a tonal effect. But Elliot didn't stop there: using the same solution, a child also could change Barbie's hair color!

The hair was such a fun aspect of Color Magic Barbie, but the fashions I designed for this group will always be among my favorites. For the concept to succeed, the prints had to be clean and bold so the color change would feel substantial. We also were making a statement about what we saw happening in fashion and society—the mod look that was dominating runways was an offshoot of the British Invasion that had introduced Americans to everything from the Beatles to Mary Quant, the creator of the miniskirt and hot pants. Quant also was inspired by pop art, and her treatment of colors and striking prints definitely inspired me as well.

Opposite and Above: With one solution, girls altered the color of Color Magic Barbie's hair and her clothes. To make the changes stand out, I went with clean, bold prints for the outfits.

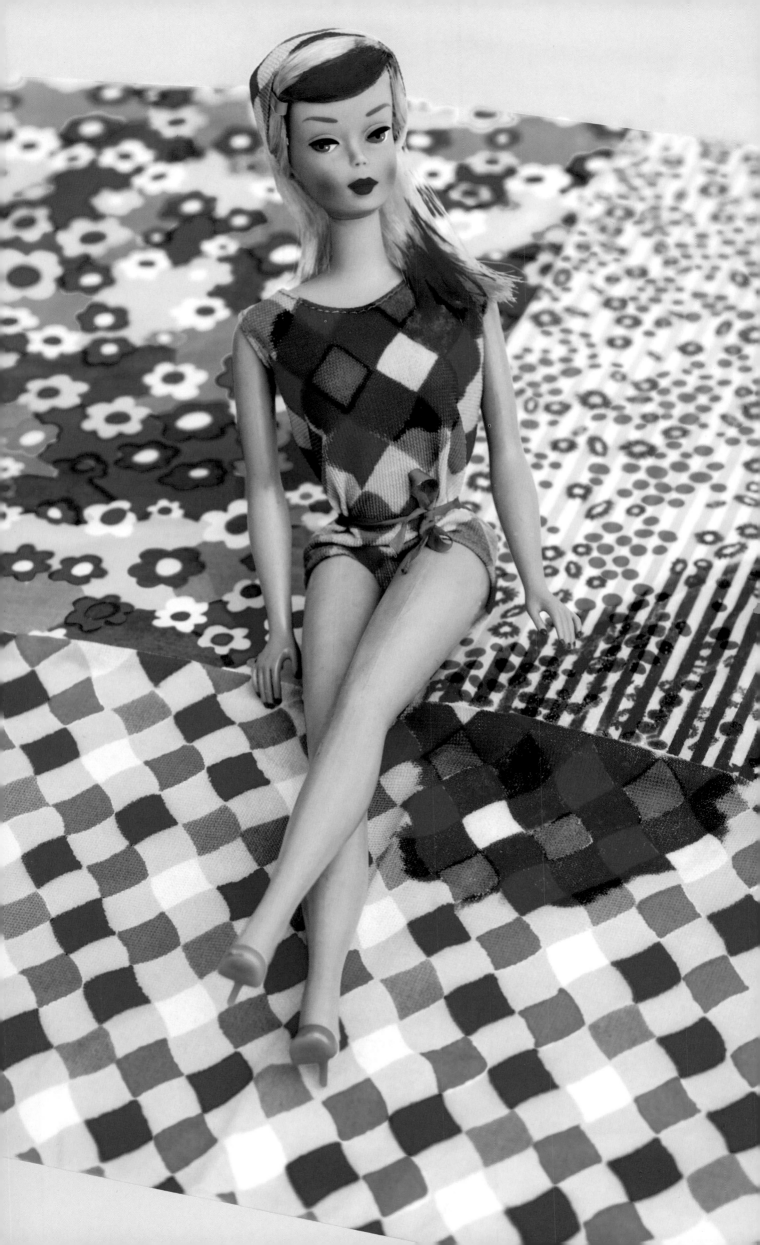

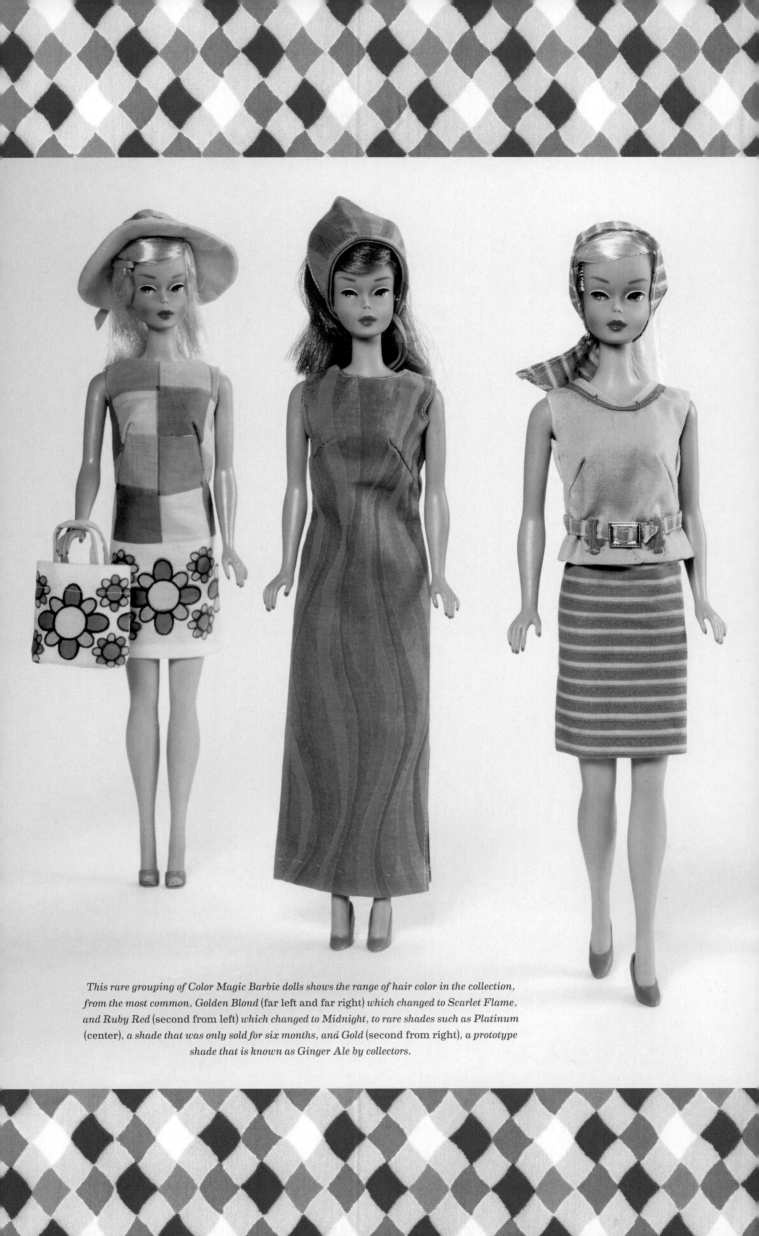

This rare grouping of Color Magic Barbie dolls shows the range of hair color in the collection, from the most common, Golden Blond (far left and far right) which changed to Scarlet Flame, and Ruby Red (second from left) which changed to Midnight, to rare shades such as Platinum (center), a shade that was only sold for six months, and Gold (second from right), a prototype shade that is known as Ginger Ale by collectors.

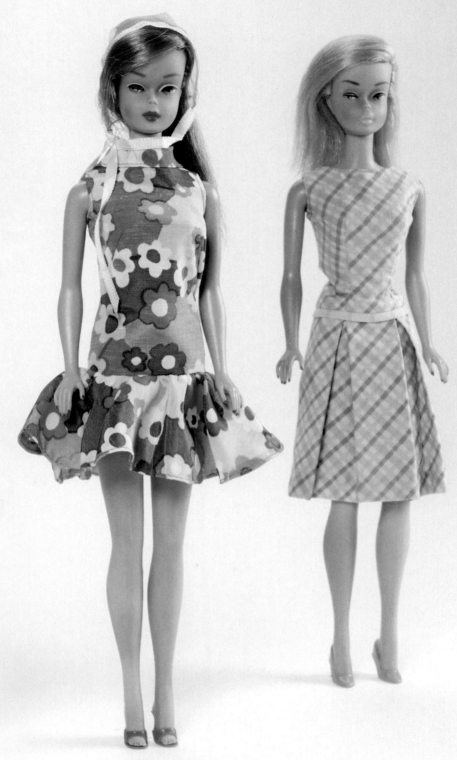

Eight out every twelve Color Magic Barbie dolls sold had blond hair.

My Closet, Barbie's Clothes

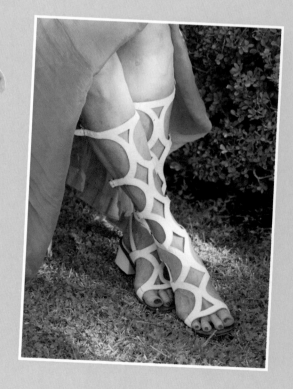

WITH THE LOOKS I CREATED selling well, I felt increasingly confident to imbue my designs with a variety of influences—including clothes I owned. I had bought a pair of white knee-high boots in a graphic cutout pattern, for example—they really were the height of sixties mod style, and soon I was thinking about how they might look on Barbie.

Also, what might she wear with them? I designed a two-piece minidress in a colorful print with a pair of boots that took their cue from mine, though they were a bit more doll-friendly, and we dubbed the look Wild 'N Wonderful.

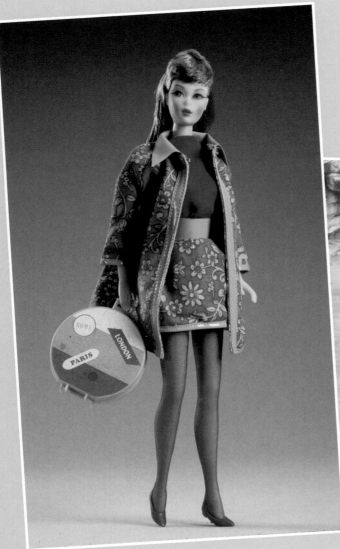

A favorite travel dress of mine in the sixties soon became an inspiration for an ensemble for jet-setting Barbie, Travel Together.

When I was a kid I looked forward to the annual Minnesota State Fair, and that inspired a collection we called Country Fair Fashions. That three-look group played into the mother-daughter fashion trend that became popular during the 1960s. Barbie wasn't a mom, obviously, but she did have a younger sister: Skipper, introduced in 1964. Skipper expanded Barbie's family and allowed us to expand our fashion horizons—Barbie continued to evolve as a chic sophisticate, while Skipper's wardrobe felt decidedly more girlish.

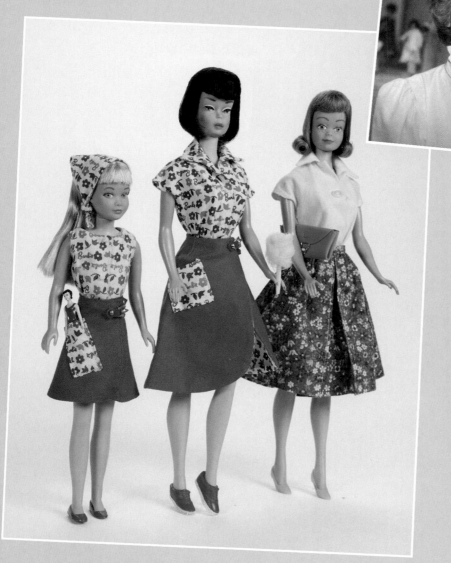

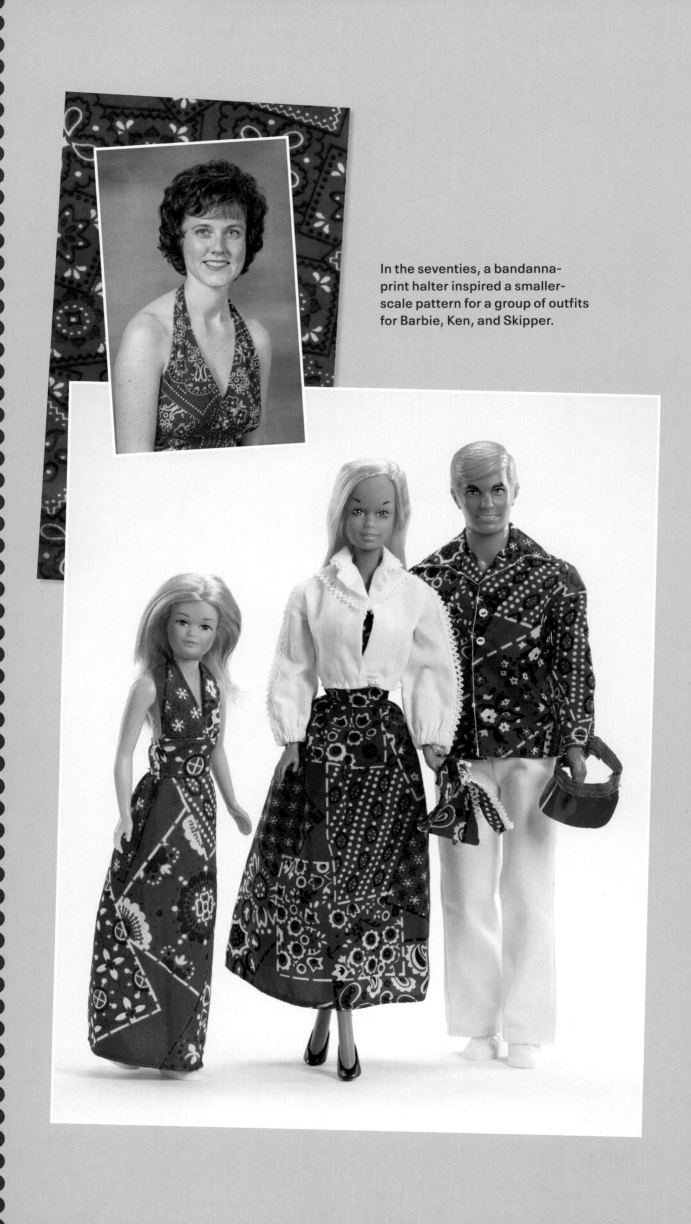

In the seventies, a bandanna-print halter inspired a smaller-scale pattern for a group of outfits for Barbie, Ken, and Skipper.

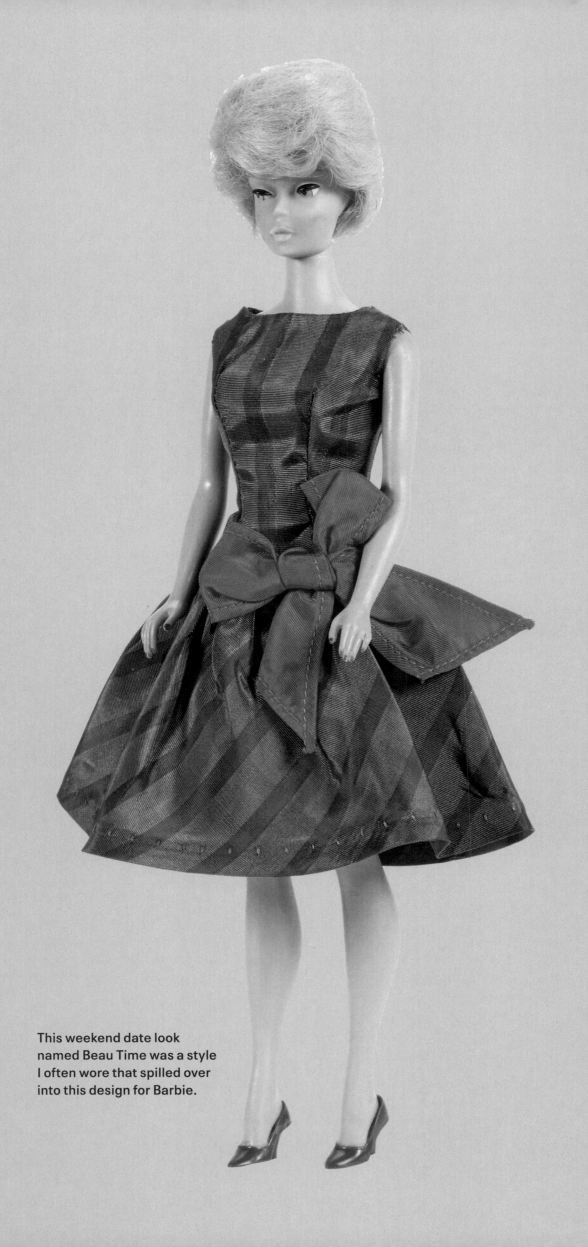

This weekend date look
named Beau Time was a style
I often wore that spilled over
into this design for Barbie.

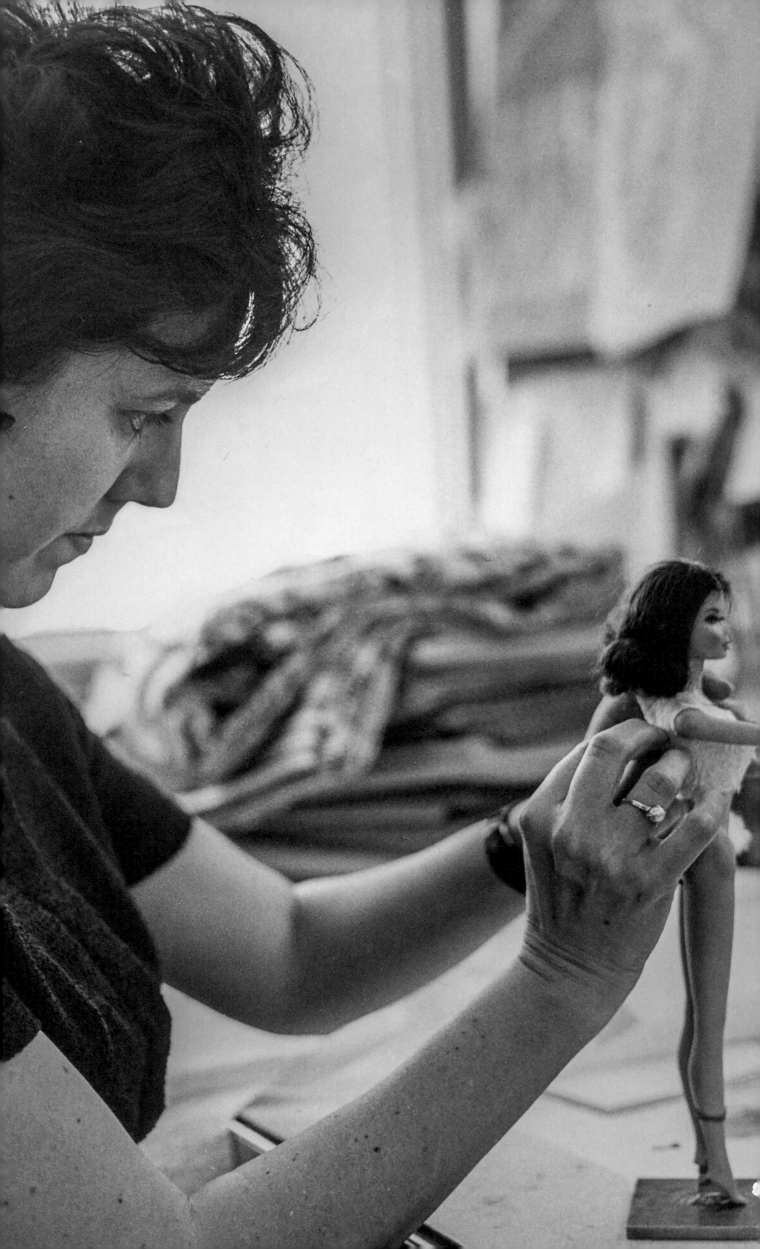

Barbie's Luxe Life

Not unlike a ready-to-wear collection for women, designing coordinated looks also became more important to our work as Barbie's fashions increased in popularity. One day I was asked to use an elegant fabric of white with a gold metallic stripe. Everyone else in the design department snickered a little; this fabric had been sitting around for a while because someone had accidentally ordered 2,500 yards instead of 250, and they had grown weary of seeing this textile in the studio. It already had been used to create a swimsuit and matching head scarf, a regal look that had been named Fashion Queen. But I loved the challenge of this.

My preference when I found a fabric that intrigued me was to drape it on the doll, just as a haute couture designer might on a mannequin or fit model, so I could explore the ways it worked best on Barbie. That gold-striped fabric ultimately yielded two strong looks: an afternoon dress known as Country Club Dance, and a formal evening gown, trimmed with an orange sash, that we named Holiday Dance. Both paired nicely with Fashion Queen, and better yet, we never had to look at that gold-striped fabric ever again.

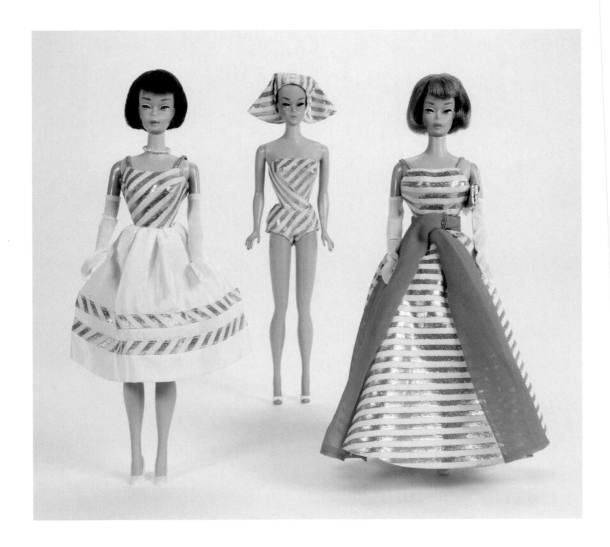

Opposite: *Draping a dress on Barbie, circa 1968.* ✷ **Above:** *The Country Club Dance, Fashion Queen, and Holiday Dance designs featured a gold-striped fabric that had been over ordered.*

Perhaps it was because the entertainment community was so close to where we lived and worked, Hollywood and its influences began to find their way into our work. For Talking Barbie, which had debuted in 1968, I designed a gift set we called Pink Premiere because it seemed ideal for what an actress might wear to the opening of her film.

In 1968 Dean Martin invited Barbie to be a guest on his show. Naturally, everyone at Mattel was terrifically excited—who could ask for better publicity? We sent a large assortment of dolls wearing different outfits over to his studio so he could choose his favorite. The night of the live broadcast, imagine my delight when I saw Dino crooning to Barbie, who wore one of my creations: a white lace jumpsuit with a high neckline and a layer of fuchsia taffeta underneath. The style, known as Jump Into Lace (*below, left*), sold out quickly after that.

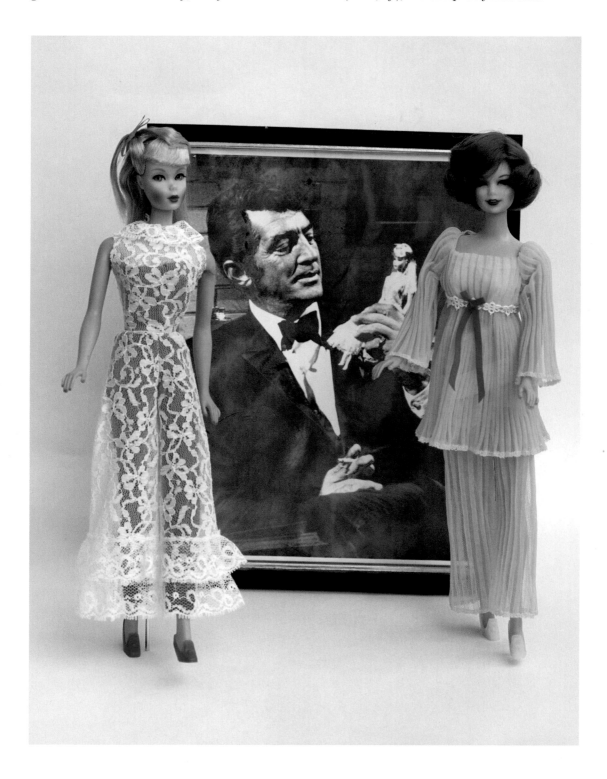

Above: *Barbie (left) wore Jump Into Lace for her appearance on the Dean Martin Show. Lemon Kick (right), was inspired by Barbara Streisand's 1969 Academy Awards look.* ✷ **Opposite:** *Hollywood influenced many Barbie designs, like Pink Premiere, an ideal outfit for a young starlet's movie opening.*

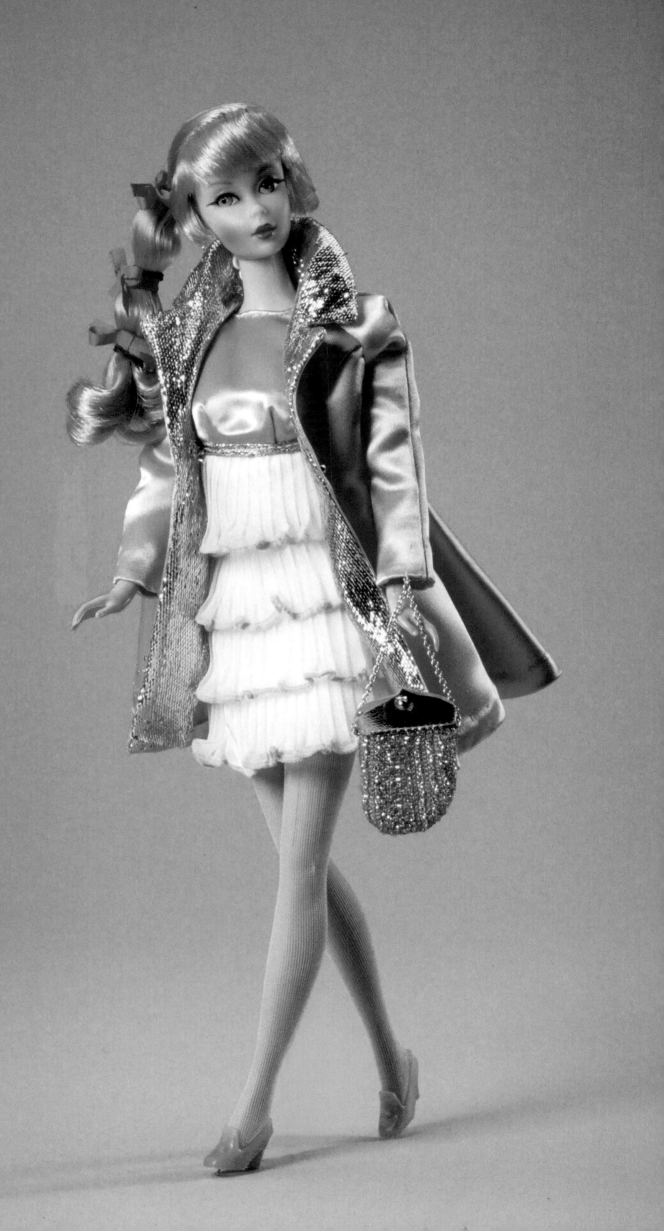

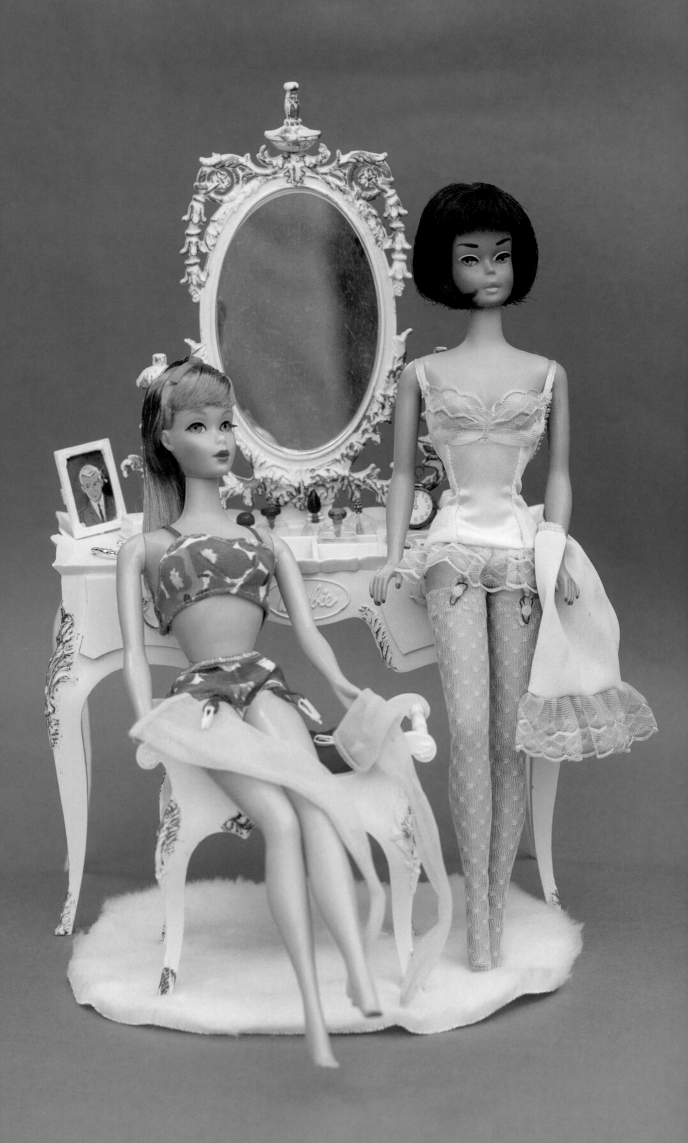

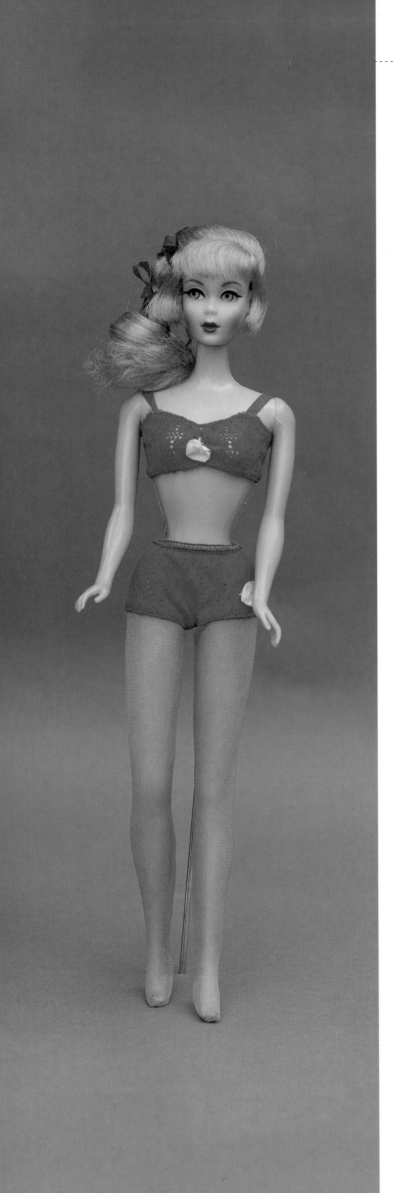

Then in 1969 Barbra Streisand wore a pair of sheer sequined pajamas designed by Arnold Scaasi when she accepted her Academy Award for *Funny Girl.* The look of that ensemble simply delighted me, and I wanted to create a version for Barbie. Streisand's ensemble continues to reign as one of the more controversial looks ever seen at the Oscars, though my design for Barbie *(page 50, right)*—in a soft, pretty yellow paired with matching panties—was tame by comparison.

Those pajamas also signaled a growing shift from dresses into pantsuits. We always wanted Barbie to feel true to what was happening in the world; while we still loved all those sweet, full-skirted dresses and elegant gowns, we also had to embrace the idea that pants were becoming more commonplace among women. With that in mind, I tried to find ways to make them feel fashion-forward and stylish.

Unsurprisingly, Ruth Handler decided to lead the charge for women at Mattel, making pantsuits a regular part of her work wardrobe. If Barbie could wear them, then why not the women who worked to make her a success? By taking the lead on breaking this style barrier, Ruth forever changed the company's unwritten rule—established by male department heads—that women must dress appropriately in skirts (later, in the 1990s, Mattel also joined the casual-Friday movement, allowing us to wear jeans on the last workday of the week).

Opposite: Women's undergarments were also undergoing a sea change by the late sixties, and Barbie was no exception: pantyhose replaced garters and stockings for her, too.

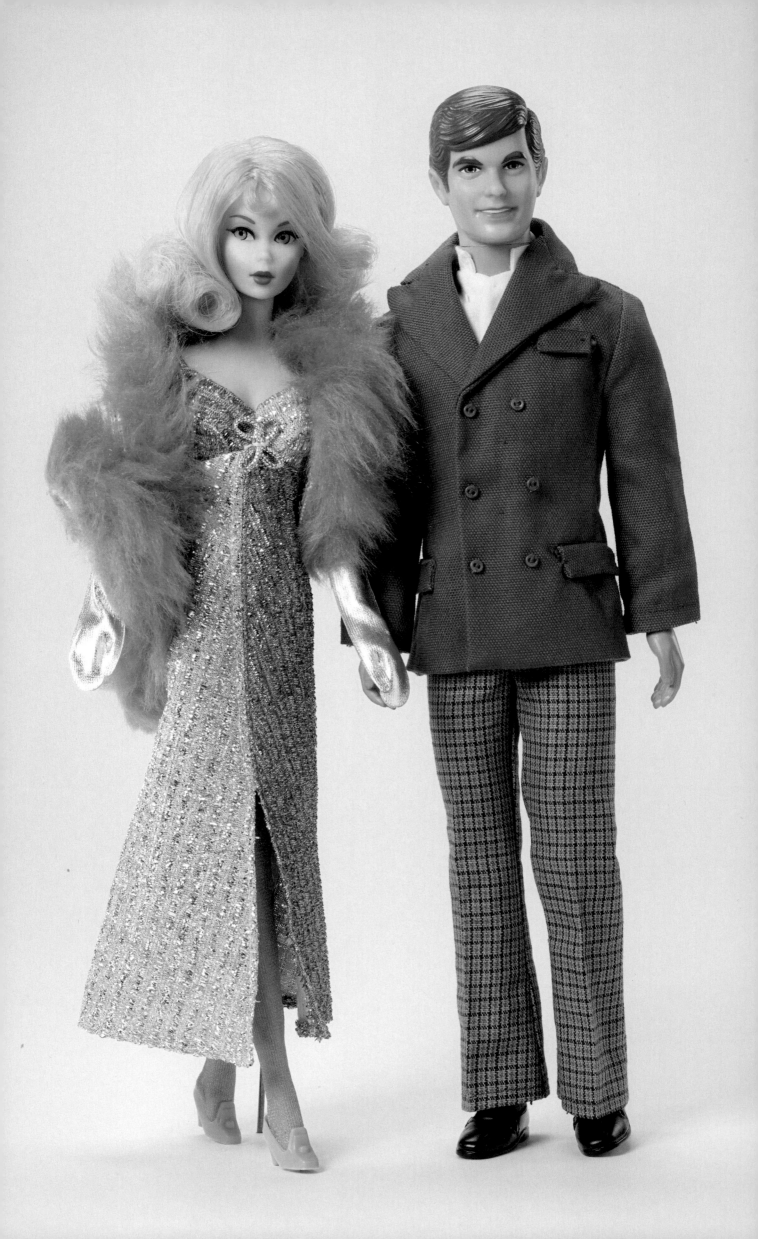

Branching Out

Designing fashions for Ken, whose body had been reimagined to become more muscular and rugged, was added to my assignments in 1967. While I was eager for this latest challenge, I confessed to Elliot during one of our afternoon chats that I knew little about men's clothing. He immediately suggested that I "shop" the stylish men's boutiques that had sprung up in Hollywood and Santa Monica. Ruth had always directed us to think about real clothes when designing for Barbie, considering fashion trends while also being mindful that they must feel relatable to a child. Shopping local boutiques confirmed my designs were on trend—and often ahead of the curve, given that we worked eighteen months in advance of when the dolls' clothes appeared in stores. Ultimately Elliot's idea was perfect, because I felt instantly inspired. One of my earliest designs for Ken, Town Turtle, is a great example of this: his pants featured a slight bell-bottom and were paired with a double-breasted jacket and, as the fashion's name implies, a turtleneck. Ken looked completely of the moment.

This strategy of shopping boutiques or seeing what stylish people were wearing on the street would become key anytime I needed inspiration, and I've always been grateful to Elliot for suggesting it. Years later, at the Barbie Festival in 1994, I mentioned it during a panel discussion, and I could tell Elliot was pleased by such a public recognition. For decades it had been assumed that Ruth was the creative genius behind each element of Barbie, but it was Elliot, in fact, who oversaw design for all toys in the Mattel family.

While Barbie had ruled Mattel's world for almost a decade, Ruth and Elliot already had begun to consider how they might create products that would enjoy a similar influence with young boys. Elliot took a toy automobile, for example, and asked that moveable wheels be added; the miniature cars became known as Hot Wheels. It was an instant success and spawned a universe of additions, from new car models rolled out with regularity to racetracks and accessories to enhance the racing experience.

As the company became more successful, Ruth and Elliot began buying other businesses, and as a result Mattel became a conglomerate, a collection of divisions and companies. A team of advisers was brought in to develop new business; Ruth called them her "young tigers," and it was an apt description, for they loved to roar. The banter and shouting, often accompanied by expletives, was a 180-degree difference from the ultracivilized world of Charlotte Johnson, her four female designers, and the sample makers who assisted us.

We were happy for the success of the young tigers, because any hot toy at Mattel, Inc., ultimately benefited all of us. But we never got used to their rowdy behavior, which most days was like a bunch of unapologetic frat boys. One afternoon I couldn't take it anymore: I stood up on a chair and yelled over the dividing wall that some of their banter simply wasn't acceptable: "Clean up your language!" They thought they ruled the world, but we knew better: we lived and breathed Barbie, the world's bestselling doll—and besides, we were there first.

Opposite: *Town Turtle, one of my earliest designs for Ken in 1968, featured trendy bell-bottoms. Barbie sang to him in Silver Serenade.* ✴ **Above:** *The ad for Town Turtle.*

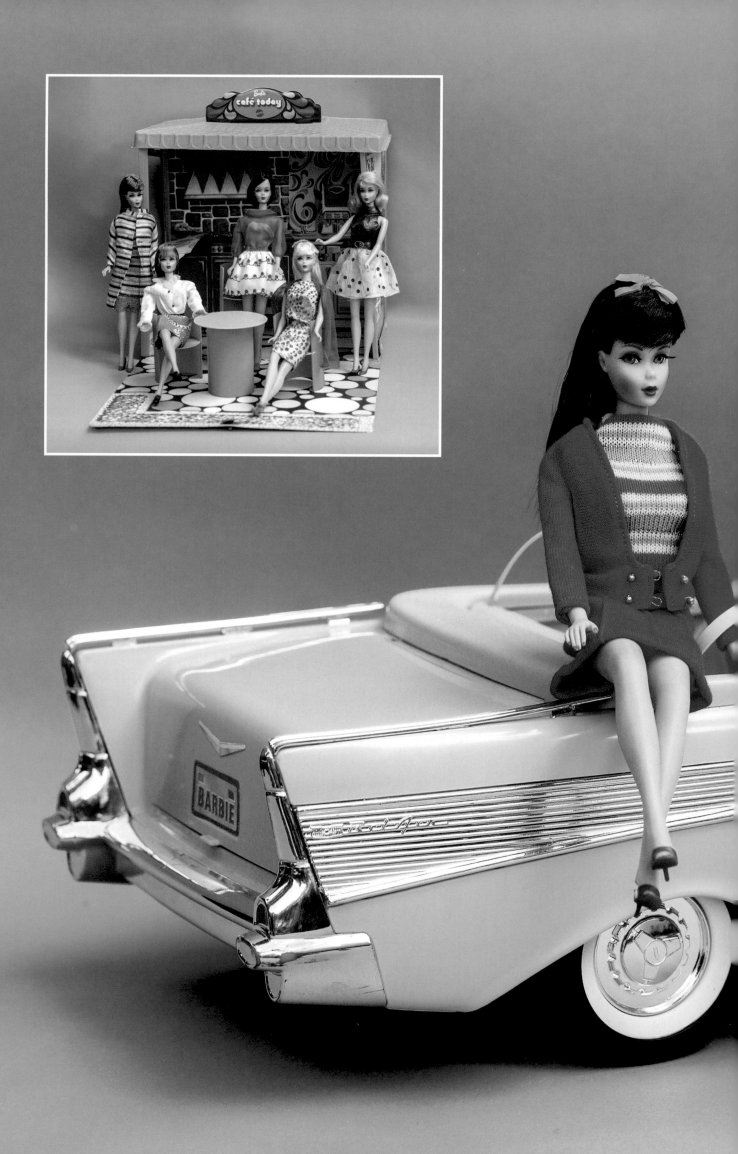

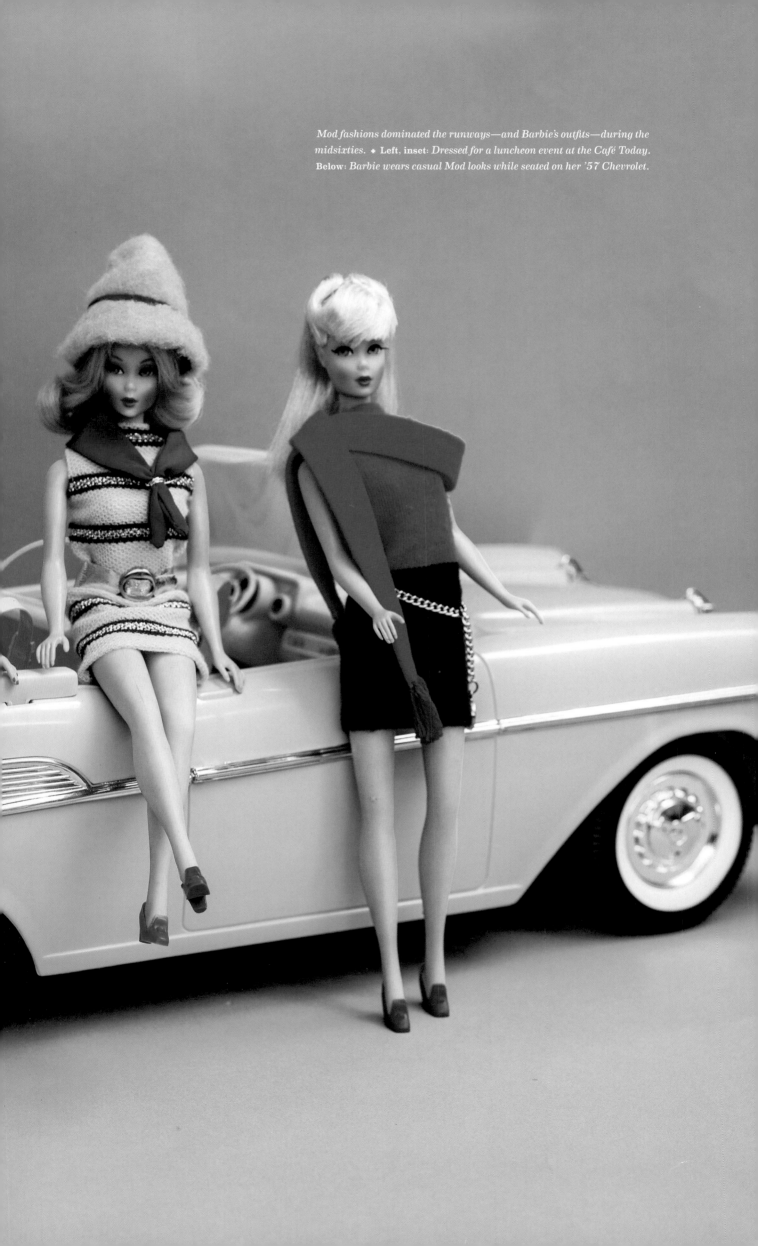

Mod fashions dominated the runways—and Barbie's outfits—during the midsixties. ✱ **Left, inset:** *Dressed for a luncheon event at the Café Today.* **Below:** *Barbie wears casual Mod looks while seated on her '57 Chevrolet.*

The 1970s

The Decade
of Ups and
Downs

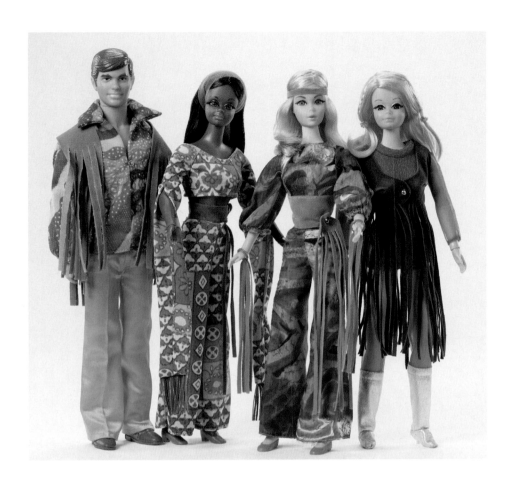

L

IKE MANY WOMEN IN AMERICA, BARBIE ENTERED
1970 with newfound thoughts of independence and empowerment. The 1960s had been very good to her—sales increased 11 percent per year, a figure any toy manufacturer would envy. It was a thrilling time designing for the world's most popular doll. Indeed, as we embarked on a new decade, everyone who worked on Barbie was teeming with ideas for how to expand her universe. Little did we know that the years ahead would also present a variety of challenges that would forever change the way we tackled our work.

Early in the decade, Mattel released two true trailblazers, not only for the Barbie family but also for the entire industry of fashion dolls: Living Barbie and Live Action Barbie. Charlotte was instrumental in the look of Living Barbie, having designed her rooted eyelashes, but it was the recent advances in technology that transformed Living Barbie's body into something remarkable: for the first time, she featured arms that would swing, as well as bendable elbows, knees, and ankles. Little girls went crazy for these new posable dolls, because now Barbie and her friends could sit more realistically at their tea

Above: *In the seventies, Barbie and her friends began to move in realistic ways. Live Action Ken, Christie, Barbie, and PJ—as hippie-chic rock stars—showcased that ability. My fringed vest inspired PJ's outfit.*

parties, or Barbie could swing her arms like she was having a blast as she danced. Posable dolls were a huge step forward for us, and everyone at Mattel was thinking of new ways to showcase Barbie's ability to move.

Among my favorite looks from this period was a group that celebrated the youth culture of the seventies, a hippie-chic collection that took its cue from what we were seeing throughout Southern California and elsewhere.

These designs also were very much a team effort, and two of the department's most recent hires contributed. Marlene Little's ensemble for Live Action Ken included a fringed vest and psychedelic-print

Above: *Barbie's and Ken's clothes reflected what we were wearing in the seventies: long, casual dresses; ponchos and minis; and, on guys, leisure suits and long hair.*

shirt, while for Live Action Christie, who was introduced in 1968 as Barbie's first African American friend, I created a two-piece pant set in a fun print with dramatic long sleeves trimmed in fringe. For Live Action Barbie, Judith Brewer Curtis's two-piece pant set featured the crop top that was so on trend at the time, and during the review process, Charlotte Johnson added the long fringe that cascaded from her wrists. Finally, for the Live Action version of PJ, who had been introduced as Barbie's best friend in 1969, once again I was inspired by an item from my own closet, a fringed vest that I refashioned and paired with a minidress and golden boots.

The Move to Boys' Toys

You could find competition everywhere in our offices: among the Barbie designers who wanted their work to make the final cut, and the friendly rivalry between girls' toys and boys' toys. I enjoyed Mattel's spirited approach to competition and never took it too seriously—but that's also because I was playing on the number-one team.

One Friday Charlotte called me into her office and presented me with a challenge: for three months each year, she wanted me to put aside Barbie and work on boys' toys. Mattel was getting ready to launch Big Jim, a new doll for boys—though, because he was for boys, he was called an action figure. Big Jim was Mattel's entry into the action-figure market, which had become so popular by then, that someone had to design his clothes. With my art-college background, my experience, and a record of designs that sold well, Charlotte viewed me as the top choice among Barbie's fashion team. She told me to think about it over the weekend, though I knew it wasn't really a request. On Monday morning I told her I was raring to go.

I had been straightforward with Charlotte on one important point: Big Jim had been designed as an athletic doll, and sport clothes weren't my specialty. That didn't matter; just as Elliot Handler had helped me with Ken's trendy clothes years before, I hit the stores to "shop" athletic-driven collections. I never bought anything, mind you—instead, I eyed how garments were constructed and jotted down notes after I had left a store, a method of research I later would discover was common in fashion design. I also ordered catalogs for every type of men's sportswear and athletic gear and devoured those details. Our paramount goal for Barbie was to strive for authenticity. The same, I knew, had to be true for Big Jim.

Back at my desk in the design studio, my first assignment for Big Jim sounded easy enough, though I knew it wouldn't be: The boys' toys team envisioned him dressed in a simple white T-shirt, something clean and tight-fitting that showed off his muscles. But Big Jim wasn't yet a pliable doll (that would come later), and while his designers preferred a T-shirt that went over his head, I knew this would be impossible. So for my first project in boys' toys, we were butting heads already.

Ultimately I designed two options: a realistic T-shirt that went over Big Jim's head, and another version that was slipped onto him from the front and fastened in back with Velcro or snaps. Big Jim's designers tried both versions and quickly discovered my years of Barbie experience would be immensely valuable. The T-shirt that fastened in the back was the winner.

While my periodic Big Jim assignment would continue for eleven years, after my first three-month stint in boys' toys, I discovered another benefit when I returned to Barbie: I looked at her with fresh eyes. It was thrilling to be designing for her again—I immediately realized how much I had missed her! And soon enough, she was embarking on adventures of her own.

Above: Living Barbie as she appeared on the cover of the Barbie booklet, c. 1970. ✱ *Opposite: I needed a crash course in men's athletic wear when I started designing for Big Jim, even with my experience in Living Barbie's Shapes Up exercise wear.*

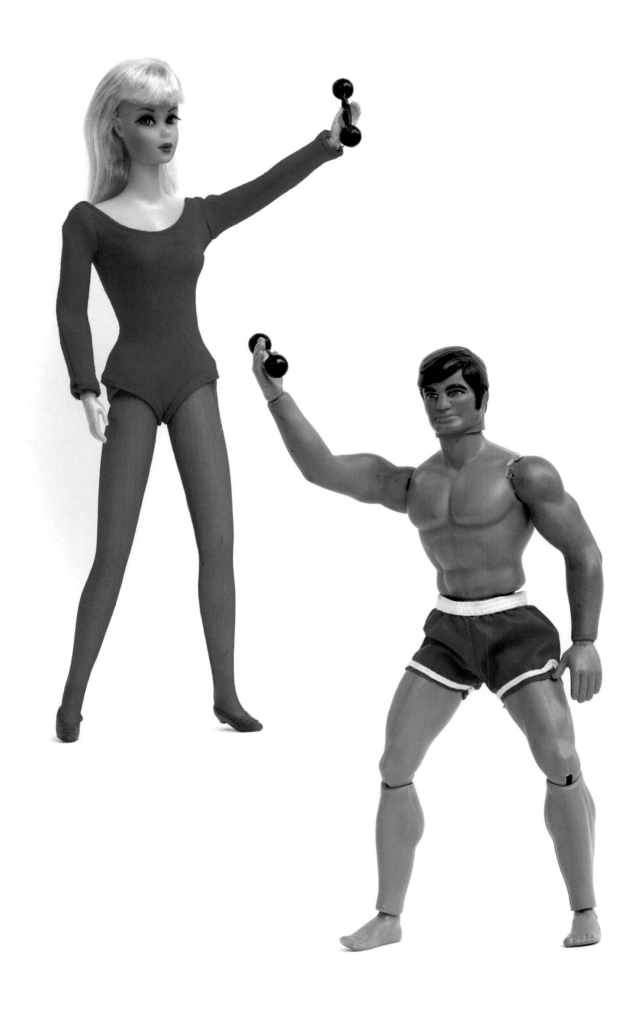

Barbie's Crowning Glory

OVER THE YEARS, WE DISCOVERED THAT LITTLE GIRLS LOVED PLAYING hairstylist with their Barbie dolls, so we were constantly thinking of new ways to make Barbie's hair the highlight of play. In the midsixties, Elliot had come up with Color Magic Barbie, whose clothes and hair changed color. We tested many colors before arriving at the ideal combinations: The blond Color Magic Barbie transformed into a redhead whose hair color we christened Scarlet Flame, while the black-haired Color Magic Barbie changed to a hue of deep ruby red.

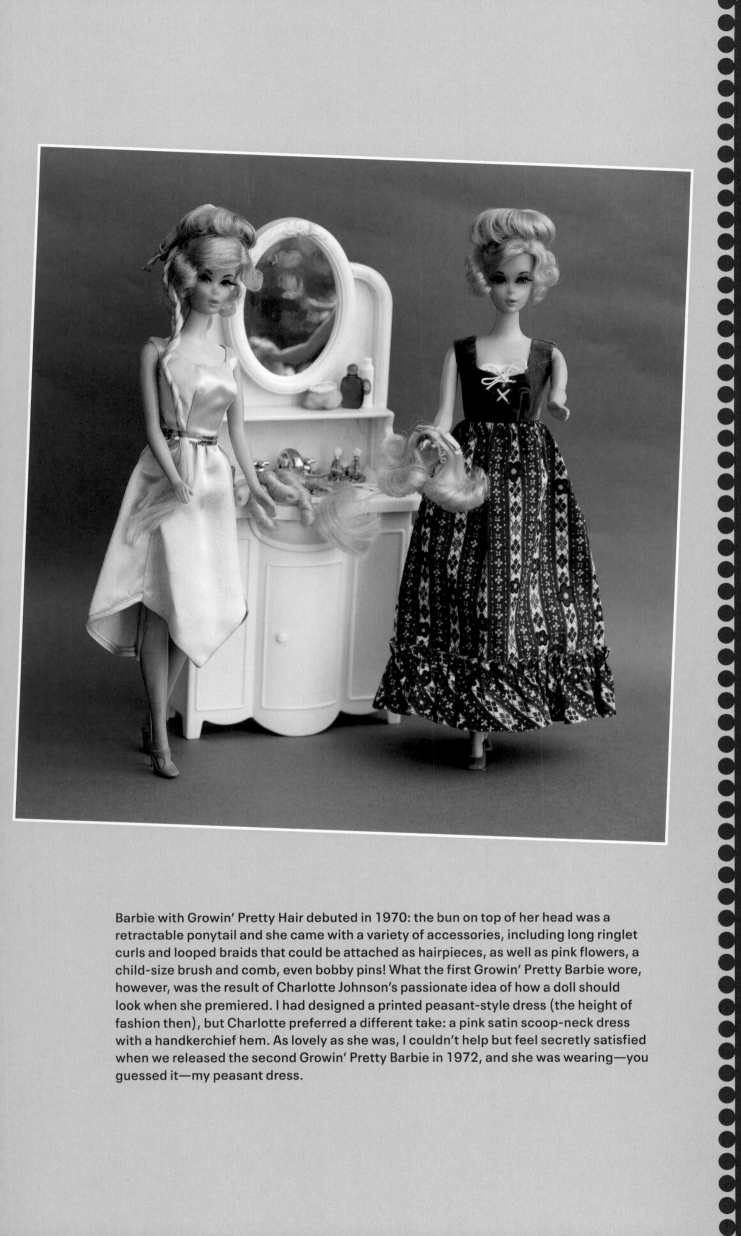

Barbie with Growin' Pretty Hair debuted in 1970: the bun on top of her head was a retractable ponytail and she came with a variety of accessories, including long ringlet curls and looped braids that could be attached as hairpieces, as well as pink flowers, a child-size brush and comb, even bobby pins! What the first Growin' Pretty Barbie wore, however, was the result of Charlotte Johnson's passionate idea of how a doll should look when she premiered. I had designed a printed peasant-style dress (the height of fashion then), but Charlotte preferred a different take: a pink satin scoop-neck dress with a handkerchief hem. As lovely as she was, I couldn't help but feel secretly satisfied when we released the second Growin' Pretty Barbie in 1972, and she was wearing—you guessed it—my peasant dress.

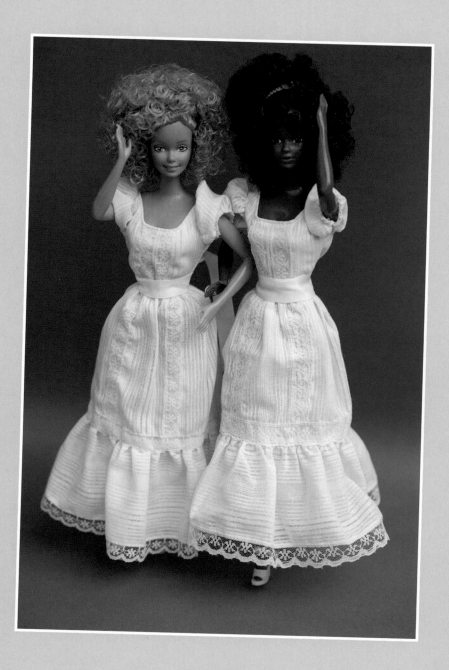

In 1982, Mattel released Magic Curl Barbie, whose hair could transform from curly to straight and back again via the use of a solution included with the doll. It was also the first time the company had created an African American doll as part of the Barbie series. (In the 1960s there was Christie and an African American version of Francie, Barbie's British cousin; then a standalone black Barbie in 1980.) We released the Caucasian and African American dolls side by side and dressed them in an identical yellow dress I had designed, a peasant-style, maxi-length dress with a touch of lace trim. I chose that soft, butter-toned yellow largely because it suited both skin tones beautifully.

The following year Twirly Curls Barbie made her debut. Featuring a long and luxurious head of hair, this latest doll came with a tool that allowed little girls to twirl locks into twisted braids, which then could be styled in different ways.

By now, Barbie had become a truly multicultural doll, so Twirly Curls Barbie came in Caucasian, African American, and Hispanic versions. For her debut, I designed a swimsuit in brilliant fuchsia with a halter neckline and a ruching detail to add shape, and paired it with a wrap skirt finished with a ruffle. Halston, already an iconic designer, was a primary inspiration for this look.

Without realizing it, we also expanded our audience, as little boys, often via their sisters, discovered this latest doll. Over the years I've met thousands of male collectors, and they often mention that Twirly Curls Barbie was their first purchase. They not only love her look but also have fond memories of her from their childhoods.

Paging Surgeon Barbie

Barbie Design Studio also addressed one of the biggest changes during the 1970s: working women. In 1973 I created a "uniform" for flight attendants (considered among the most glamorous professions for young women then). That same year, Surgeon Barbie made her debut in a pale blue scrub gown complete with face mask. While planning the accompanying accessories, I visited a shop that carried miniature accessories in a perfect scale for Barbie and discovered a box of pink "pills" that suited the doctor theme perfectly. Little did I know that "pink pills" was a nickname at the time for amphetamines. Needless to say, they were removed from the product before it was approved for the line. The telephone I planned for the always on-call MD remained part of the set. Ultimately it was an important fashion pack conveying the underlying message that women could do absolutely anything to which they aspired. It wasn't the first time we made such a statement with Barbie, and it wouldn't be the last.

Above: *The Get Up 'N Go series reflected the variety in Barbie's work life. In 1973, I designed these flight attendant uniforms and Ken's pilot togs.* ✱ **Opposite:** *Surgeon Barbie came with a white doctor's coat and surgical scrubs.*

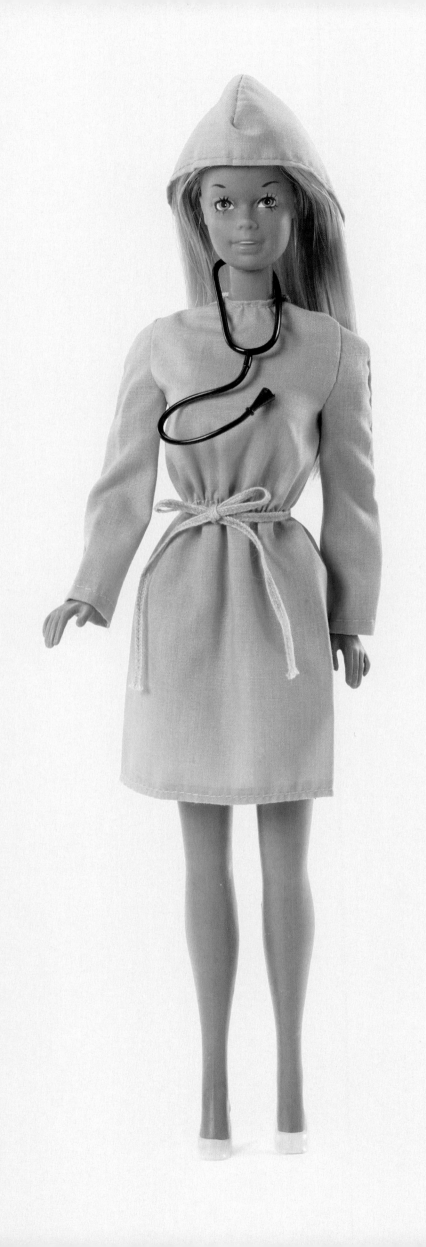

Thanks to Barbie, Mattel was the third-largest clothing manufacturer in the world during the 1960s and 1970s.

Barbie Celebrates Her California Roots

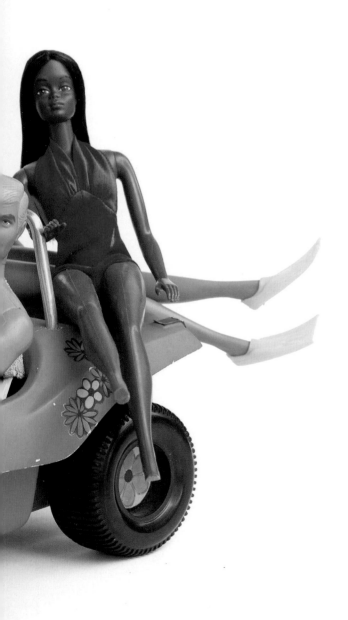

Right around the time Ruth and Elliot Handler were celebrating Barbie's tenth anniversary, they decided it was time to pay tribute to Barbie's home and her California lifestyle. The result: the Sun Set Malibu collection of dolls, introduced in 1971. Barbie's skin was now sun-kissed, though she boasted an even more important feature. Unlike the sideways glance of the original Barbie, Malibu Barbie looked straight at you, her bright blue eyes projecting a beauty that was equal parts smart, aware, and innocent. I loved her the first moment I saw her—and she was an instant hit.

Just like the original Barbie released in 1959, Sun Set Malibu Barbie made her debut wearing a bathing suit. For this new doll, Marlene Little designed a high-neck one-piece swimsuit in aqua. I had designed some test suits, but Marlene won that particular competition, and her aqua suit was chic and stylish. However, Malibu Ken's original orange swim shorts? I did those and was so excited when they were chosen. And when the second version of Malibu Barbie was released, she was wearing the orange one-piece suit I had designed for her.

For the entire design team, Malibu Barbie and her friends indeed opened up a new world for us. We were creating clothes that were ideal for their laid-back California lifestyle, while their tanned skin also meant we could think about brighter color palettes. I often went to the beach for inspiration: I would sit on the sand and think about how Malibu Barbie, Ken, Christie, and Skipper would look in this environment, or I rode horses with friends along the bluff, always thinking of Sun Set Malibu Barbie as I looked out at the Pacific Ocean. I rewatched *Gidget* with Sandra Dee or the wildly popular beach party films starring Frankie Avalon and Annette Funicello; these projected a playful innocence that seemed in keeping with Barbie's story, while their plots always featured plenty of swimwear.

Left: *Malibu Barbie and her friends atop the prototype for the Sun 'N Fun Buggy, raring to go. Standing behind them are two New Good Lookin' Ken dolls and Brad dolls dressed in Malibu fashions.*

Boom Times for Design

We realized another important benefit from the frenzy of our posable dolls: girls were clamoring for new fashions more than ever. Just as Ruth Handler had predicted all those years ago, young girls eagerly embraced the idea of dressing Barbie in a chic wardrobe, with choices for every activity and occasion, and we barely could keep up with the demand for new styles. We sourced fabrics from all over the world, created custom prints and woven plaids that were suitable to Barbie's scale, and added details like gold braid, sequins, or tiny seed pearls when the design demanded it. And, of course, Barbie always had shoes, bags, gloves, and hats to match.

Among my first designs for Living Barbie was a look we dubbed Maxi 'N Mini, which also paid tribute to two important fashion trends of the early 1970s: I crafted a maxi coat using a newly developed metallic fabric and paired it with a minidress in a knit that had been woven with metallic threads. A pair of thigh-high boots balanced out the ensemble, and Living Barbie looked like she might be stepping from the pages of *Vogue*.

Both the maxi coat and minidress were perfect examples of the freedom the design team enjoyed. Indeed, more than any other division at Mattel, we were given carte blanche to make sure everything designed for Barbie was the absolute best, very often using materials likewise created just for her.

Among my favorite examples was a dress I created in 1970, which we had christened Rainbow Wraps. It was a colorful, beautiful dress, but in our discussions for the original concept, the scale of the graphic print was just too large; it overpowered Barbie and didn't look right. The only solution was to create a custom print: I took a piece of printed satin fabric and cut out colorful shapes, which I then affixed onto a blue satin using Elmer's glue (in those days, there was no specialized fabric glue or double-stick tape). Once the print and the scale were just right, we had it reproduced as a fabric to be used exclusively for the Rainbow Wraps dress.

That wasn't the first time I had created an exclusive fabric using this cut-and-paste method. But little did I know at that moment, Rainbow Wraps would be, for several years, one of the last of its kind.

Girls clamored for new styles, and we delivered sophisticated, trendy outfits. ✳ **Above**: *Maxi coats and miniskirts were all the rage.* ✳ **Opposite**: *I created a custom print for an elegant dress we called Rainbow Wraps.*

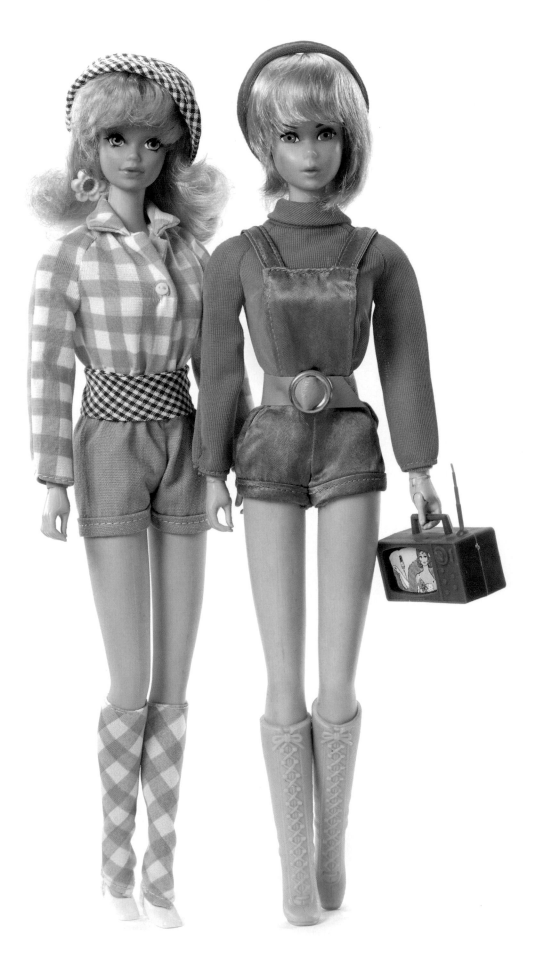

Barbie and her friend Steffie (left) not only reflected the fashion of the early seventies, but also the free rein designers had for matching accessories to clothing and creating prints that were perfect in size for Barbie. That changed after the oil embargo.

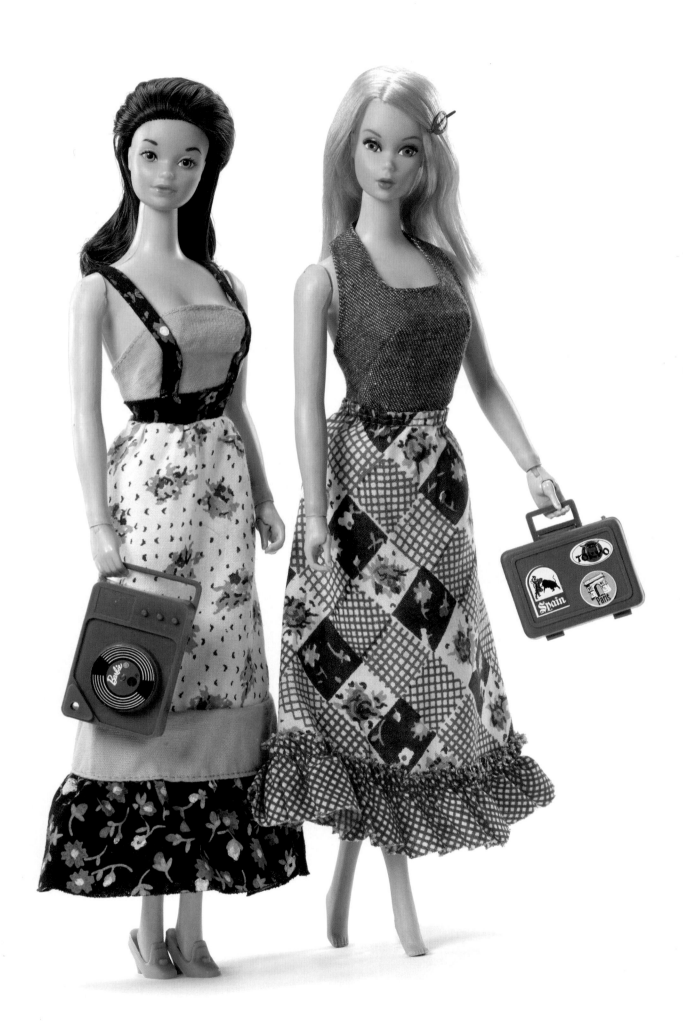

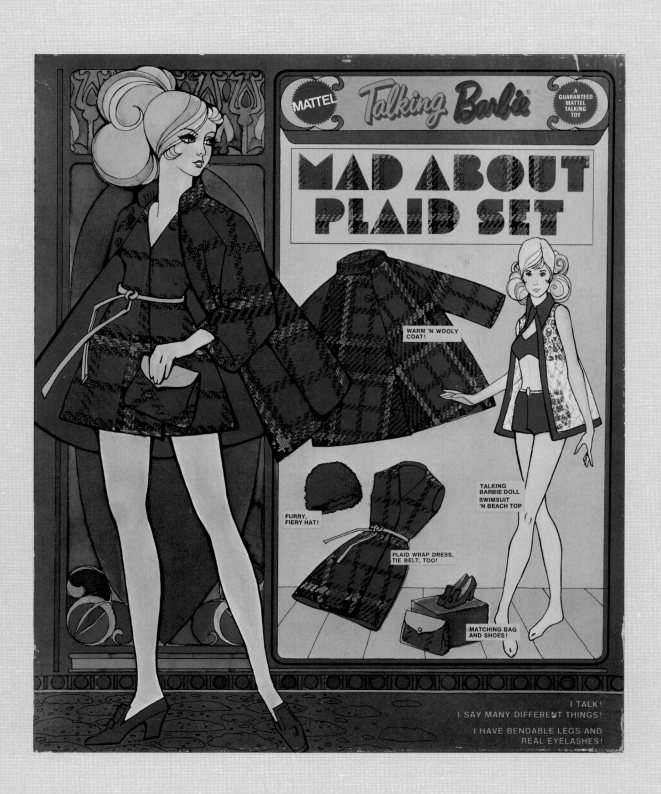

Big Oil's Effect on Barbie

We'd had setbacks before. In 1970, the company suffered losses from a fire in a manufacturing plant. The following year, a months-long dock strike made it impossible for supplies and toys to enter the United States. But nothing affected us as much as the oil embargo in 1973, when the price of oil skyrocketed.

How did such a world-changing event impact Barbie? More than you might imagine. First, most Barbie-related products were manufactured overseas. Transportation costs rose for merchandise shipped from overseas factories to the United States and other distribution points. But the oil crisis also curtailed our free use of polyester, acrylics, and nylon, which used petroleum as a base. These fabrics often could be brighter and bolder than those made from 100 percent cotton, and those bright, whimsical colors often were Barbie's most successful fashions. When the embargo struck, budget cuts were swift and deep.

Gone were the rich brocades, jacquards, and other lush fabrics we had sourced from around the globe. Custom prints vanished, too; instead, we were asked to make do with ready-made fabrics. Similarly, woven-plaid fabrics were eschewed in favor of fabrics using less-expensive screen-printing processes. We also were asked to cut back on accessory designs, namely shoes—instead of new molds for every fashion trend, only the introduction of a new doll would merit a new shoe. It would be almost two decades before we could once again create a trendy shoe for Barbie's wardrobe.

The game plan, ultimately, was a simple one: do a lot more with a lot less. And everyone who loved Barbie rose to the challenge. We reused shoe molds, changing colors to create seemingly new styles in a boot or a closed-toe pump. We became experts at sourcing cotton/synthetic blends so we could achieve the best combination of brilliant colors and vivid prints—and if we were no longer including beading or a touch of braid, a lace ruffle along a dress's hem still added a detail that felt luxurious.

Our shift from a design-driven company to a manufacturing-driven company affected morale—how would you expect otherwise when we had spent more than a decade at the pinnacle of financial and creative success? And yet, every member of our design team was determined that no little girl would ever be able to tell the difference between Barbie's outfits before the oil crisis and those that came after. Together, we succeeded. Although we referred to it as "the glamour deficit," we still were producing fashions that suited Barbie's unique style. And you can't ask for better than that.

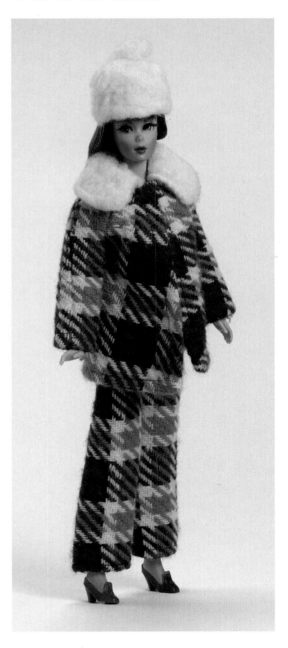

Opposite: *The Mad About Plaid gift set was designed to scale for Barbie.* ∗ Above: *Perfectly Plaid represents the out-of-scale fabrics we had to use after 1973.*

Barbie Loved Dogs and So Did I

I GOT BUSTER, MY BELOVED STANDARD POODLE, IN THE LATE 1960S. I WAS going to name him Jean-Pierre, but he became Buster after he started "busting up" any scene in which he was not the center of attention. When I got a cockapoo a few years later, I began incorporating both pets into my Barbie designs. This Poodle Doodles outfit from 1972 *(below)*, for instance, came with a poodle pup and was part of the Put-Ons 'N Pets fashion series.

Buster died in the early 1980s. But I honored his memory when we decided to give Barbie a stand-alone pet that could match her glamorous lifestyle. In 1984 we debuted Prince *(right)*, a gorgeous white standard poodle—with a face modeled on Buster's—that came with a variety of accessories, from a glittery leash and collar to grooming tools. Because Prince was a French poodle, I also designed a kicky little beret for him just for fun. It always made me smile to think that a part of Buster was now living forever in Barbie's world.

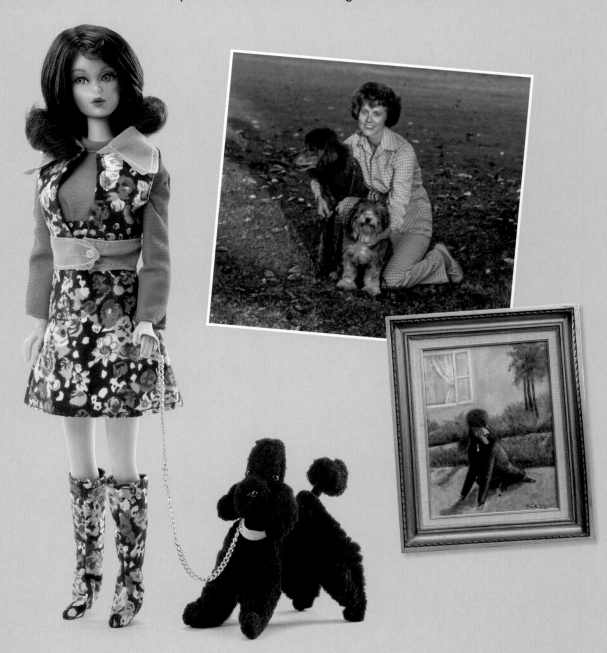

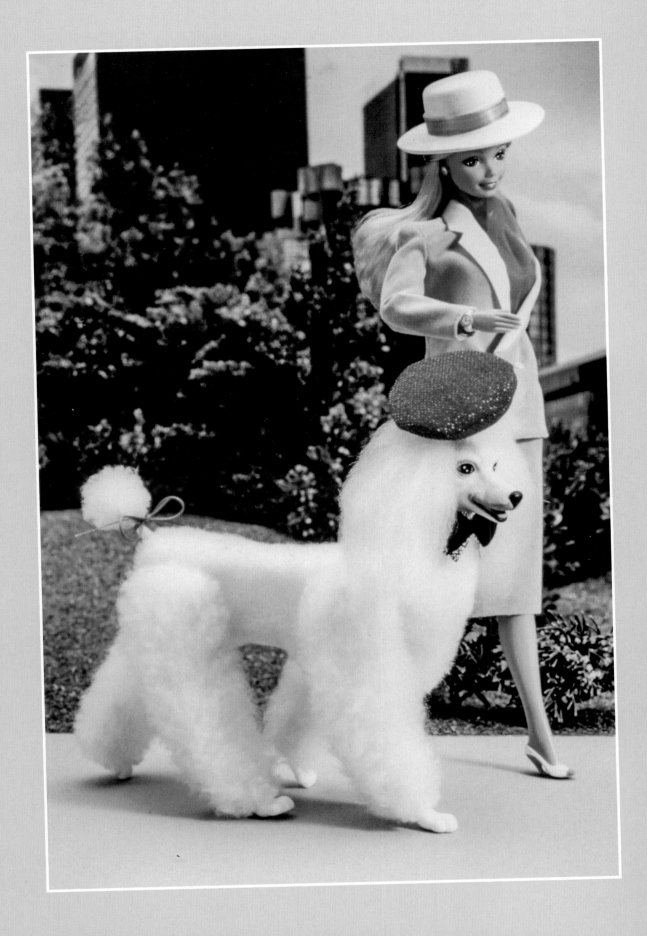

We sold Prince alongside the new Day-to-Night Barbie *(above)*: Kitty Black Perkins, Mattel's first African American designer, conceptualized this look, which consisted of a pink suit that transformed into an evening ensemble by removing the double-breasted jacket and reversing the skirt to reveal a sparkling layer of tulle. Girls always loved Barbie's convertible outfits, and this one is a favorite of mine because it perfectly reflected the trend of the mideighties. The fashion also reflected Barbie's evolution as a career woman: she first broke through the "plastic ceiling" as a business executive in 1985, and we enjoyed showcasing her well-rounded life. Day-to-Night Barbie was part of the message begun by Ruth Handler: girls could explore any career they chose, but work was balanced with fun.

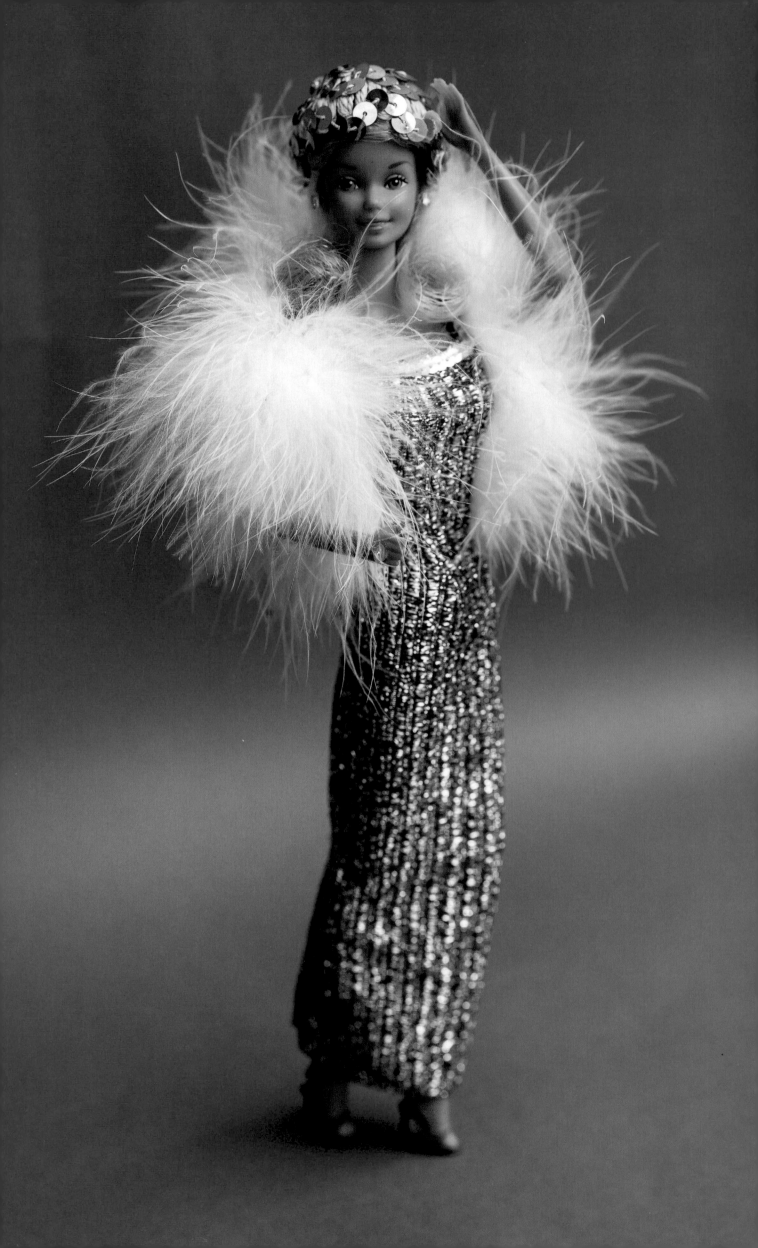

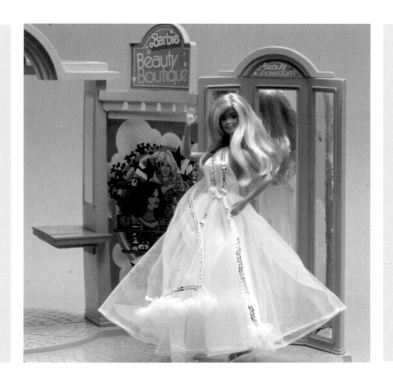

Glamour Makes a Comeback

The oil crisis lingered long after the embargo ended. But by the midseventies, though, we felt newly optimistic, believing that many of the frustrations about shipping and fabrics might disappear with the shift back to glamour. Films like *The Great Gatsby* and *Saturday Night Fever* were celebrated for their unique style, and our glamour deficit at Mattel became a thing of the past. Our design team was tasked with conceptualizing a new Barbie, the polar opposite of the hippie-chic we had embraced a few years before. Our directive was simple: in both the doll and fashion, we should strive for maximum sophistication.

I kicked off this new initiative with a gown in a red and metallic-silver brocade, accessorized with a glittering silver tulle boa that draped gracefully over Barbie's shoulders, with a matching tuxedo jacket designed for Ken.

Soon after, we launched a new doll that marked Barbie's return to romance. Featuring long, flowing hair, a smiling face, bent arms, and a twist waist, this new doll was inspired by current trends in fashion and popular culture. Her name? SuperStar Barbie.

Mattel often released promotional dolls that included exclusive accessories as an added enticement to purchase, and for a promotional version of SuperStar Barbie, I designed a pink knit gown with a silver thread woven through it, topped by sequined straps and accessorized with a feather boa and a glittering sequined evening hat (as a bonus, a child's comb was included). SuperStar Ken also made his debut around the same time as a second iteration of SuperStar Barbie, and for him I designed a navy jumpsuit that included accessories popular among guys of the late 1970s: a sleek belt with a silver star-embellished buckle, oversize sunglasses, even a removable ring. This accessory intentionally was designed to be worn on Ken's middle finger, not his ring finger—even as superstars, Ken and Barbie's relationship status had not changed.

Opposite: *The promotional version of SuperStar Barbie came with an exclusive child's comb.*
Above: *Barbie twirls in Romantic White at the Beauty Boutique.*

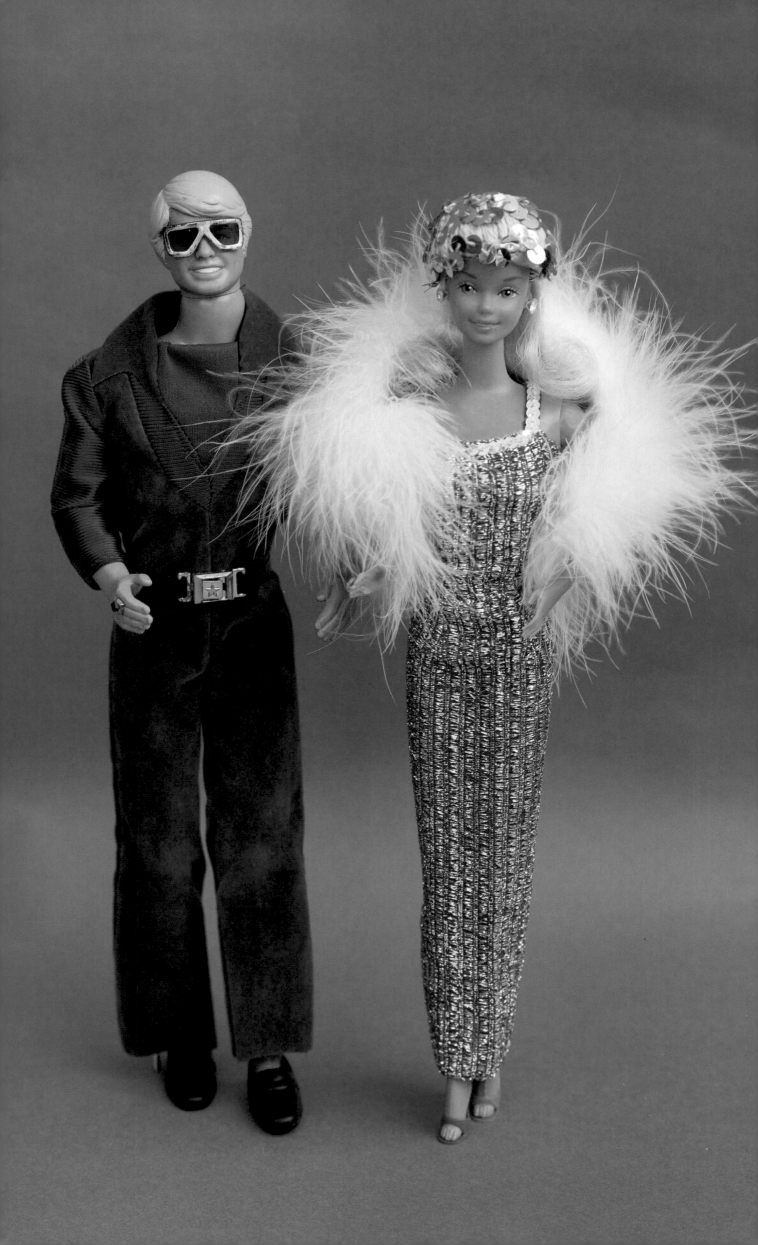

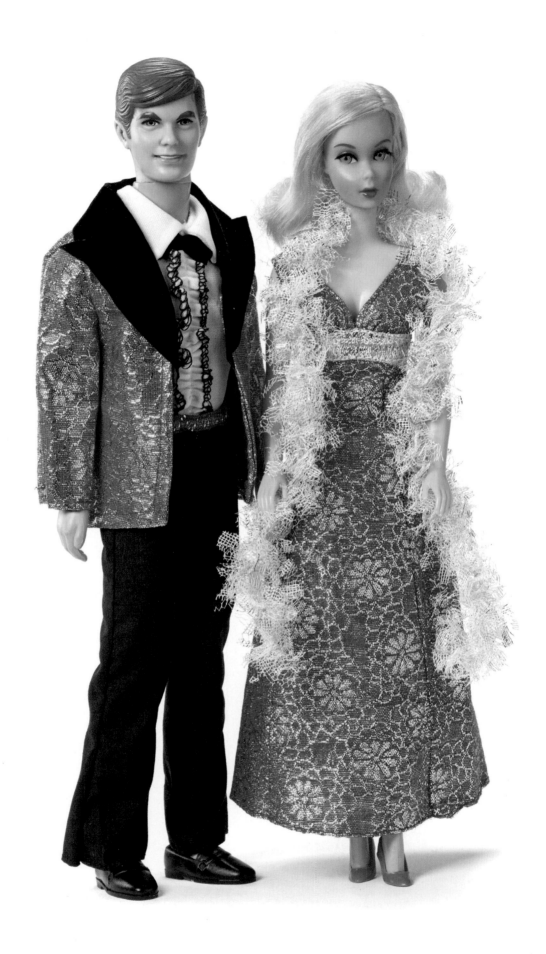

At the height of disco, I created clothes perfect for nights spent dancing. ✳ **Above:** *Barbie and Ken wear scene-stealing brocade.* ✳ **Opposite:** *SuperStar Ken and Barbie wouldn't have looked out of place at Studio 54.*

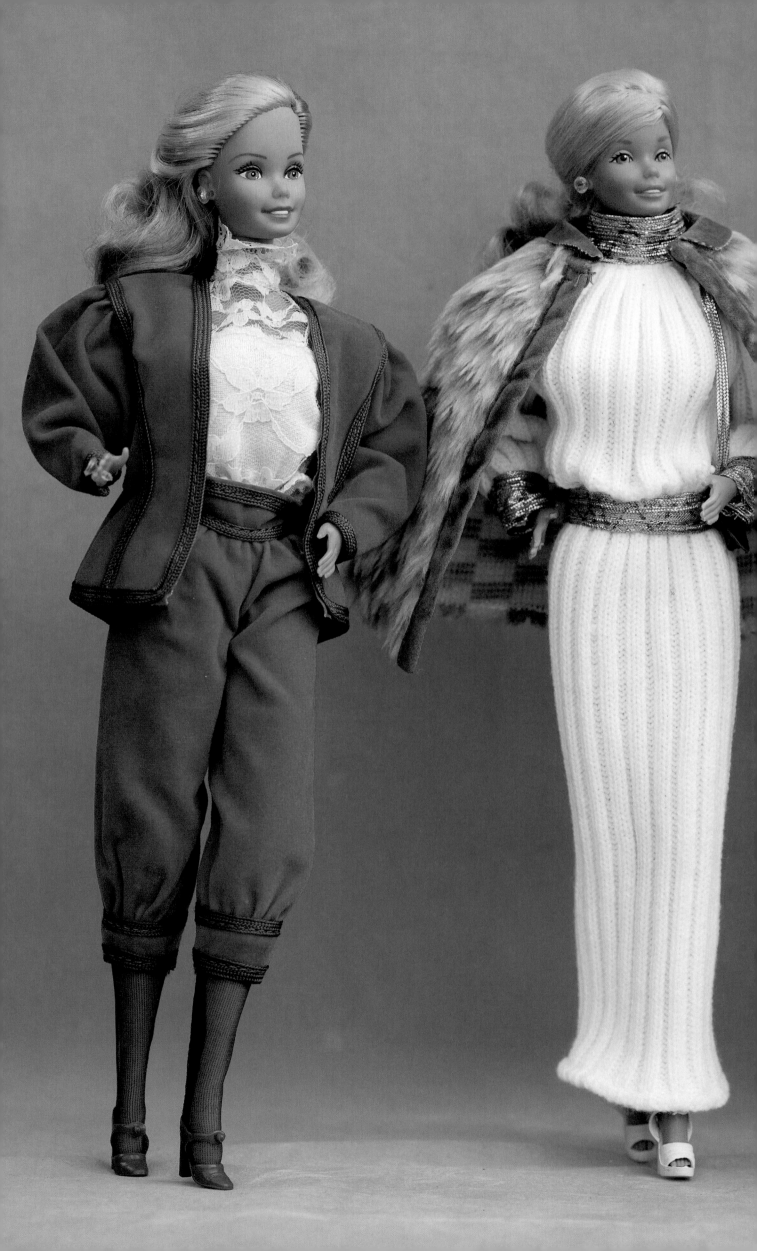

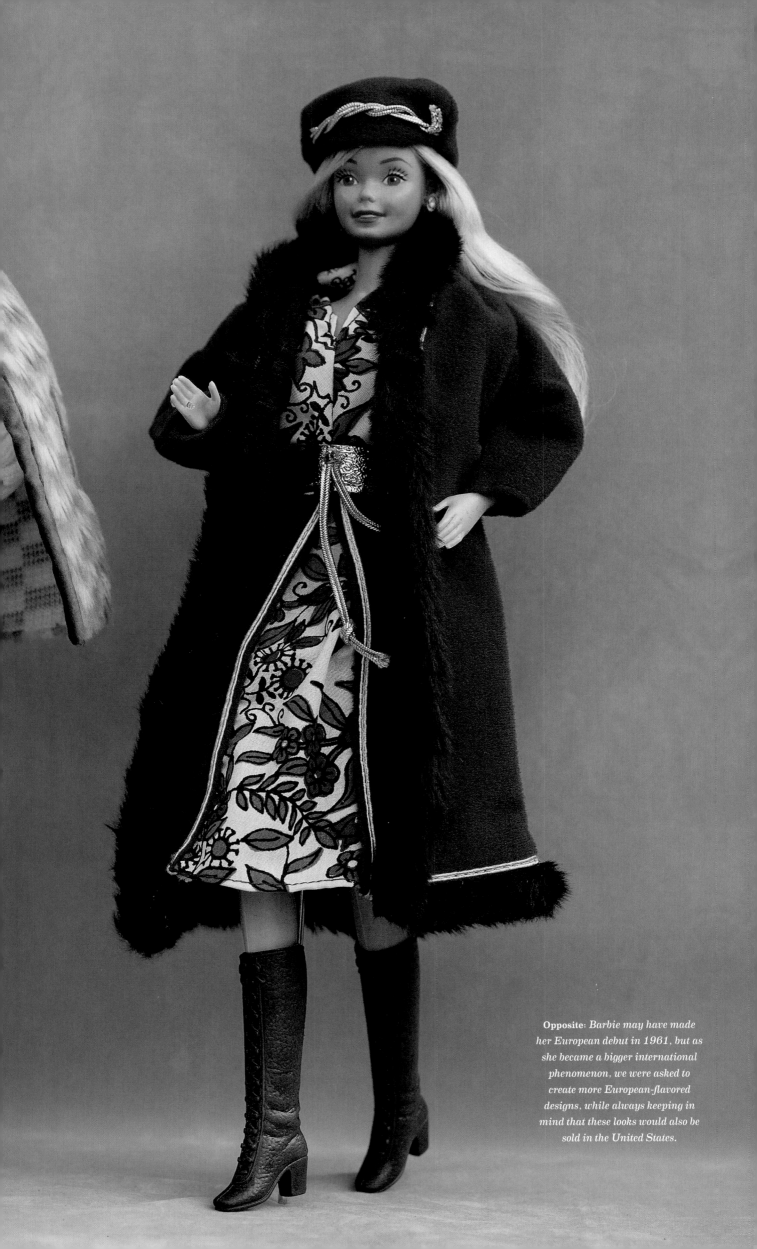

Opposite: *Barbie may have made her European debut in 1961, but as she became a bigger international phenomenon, we were asked to create more European-flavored designs, while always keeping in mind that these looks would also be sold in the United States.*

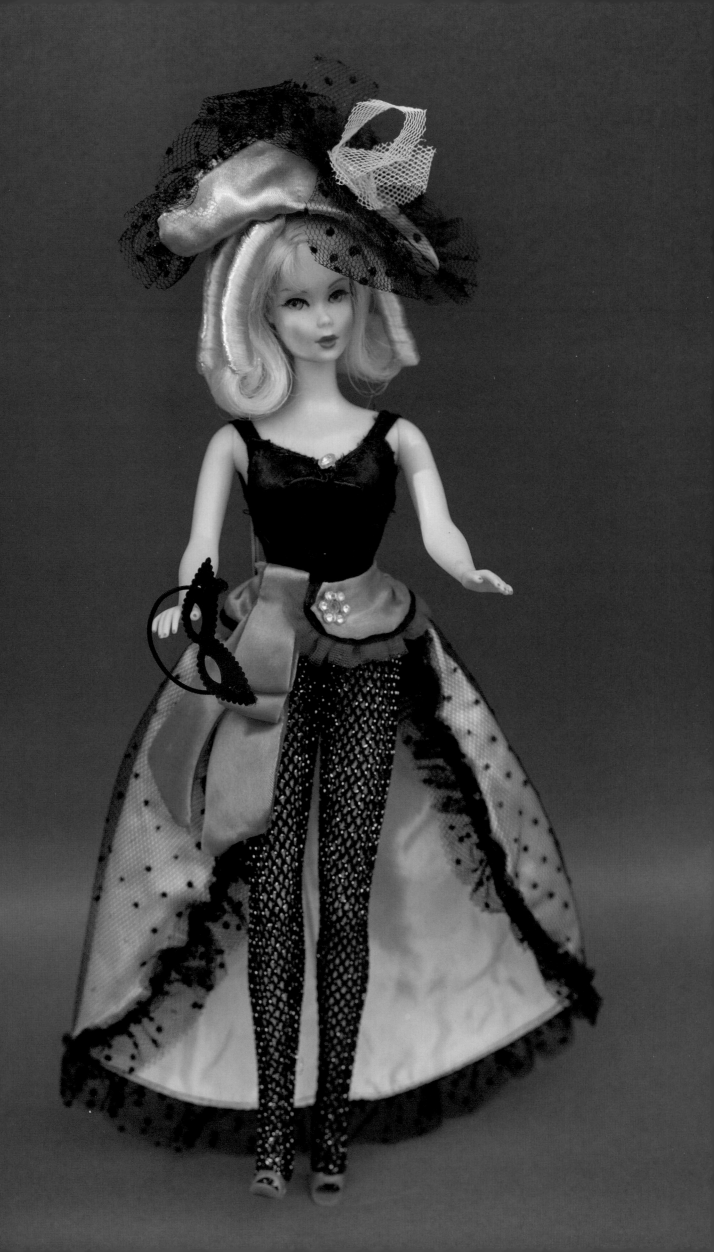

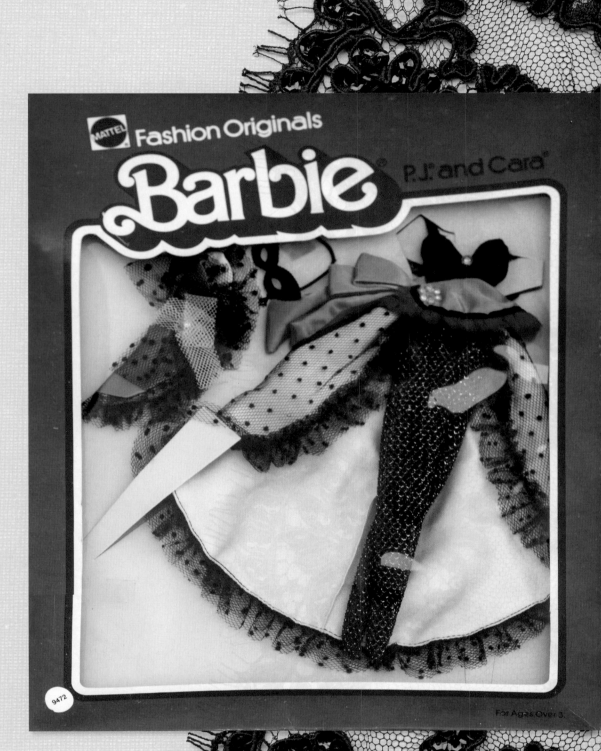

Masquerade Fashion was
inspired by the Venice
Carnival and sold in Europe
first. A year later it appeared
in the United States.

Changes Rock Mattel

Ruth Handler had endured breast-cancer scares throughout her lifetime, subjecting herself to multiple invasive biopsies in the years before mammograms were able to more accurately pinpoint an unusual lump. In the midseventies, her optimism was confronted by an undeniable truth: cancer had caught up with her. Ruth underwent a double mastectomy and stepped back from her day-to-day duties in the office. Unfortunately, the health issues that often caused her to be absent coincided with business practices that quickly came under scrutiny by other members of the Mattel board. Perhaps most admirable, in all those years that proved to be the most difficult for Ruth and Elliot, they never once let on that anything was wrong.

I learned about their financial troubles when the newspaper reported one day that the Handlers had lost control of Mattel. It's not an understatement to say that so many of us were in shock. And yet, the output continued. *Keep your head down, Carol, and keep working*, I told myself.

By the time the upper-management structure had begun to settle itself in 1975, Ruth and Elliot Handler were gone, and a vice president, Arthur S. Spear, had taken control of Mattel. The people who had given me so much creative freedom for more than a decade were no longer there to offer their nods of approval, while the vibe at Mattel took on a decidedly more corporate flavor. Once again, those of us on the design side chose to ride out the storm.

As the seventies drew to a close, the design team tried to stay one step ahead of trends, just as Ruth had always asked of us. We were offering a new, glamorous approach to Barbie that would help guide us into the next decade. Unfortunately we were about to lose an integral member of our team. Charlotte Johnson was experiencing difficulties we couldn't understand at first—but soon enough, they couldn't be ignored.

Opposite: *Fashion Photo Barbie came with a toy camera. When girls "focused" the camera, Barbie changed poses.*

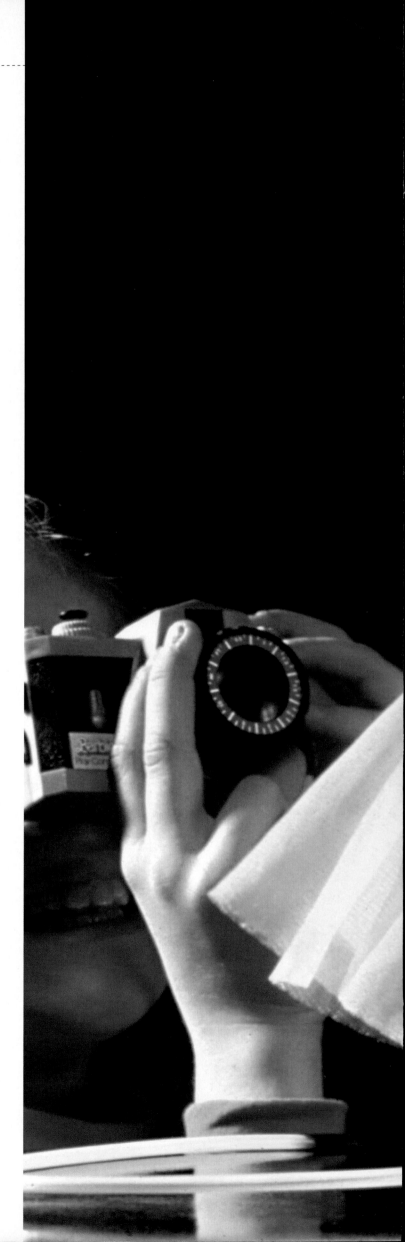

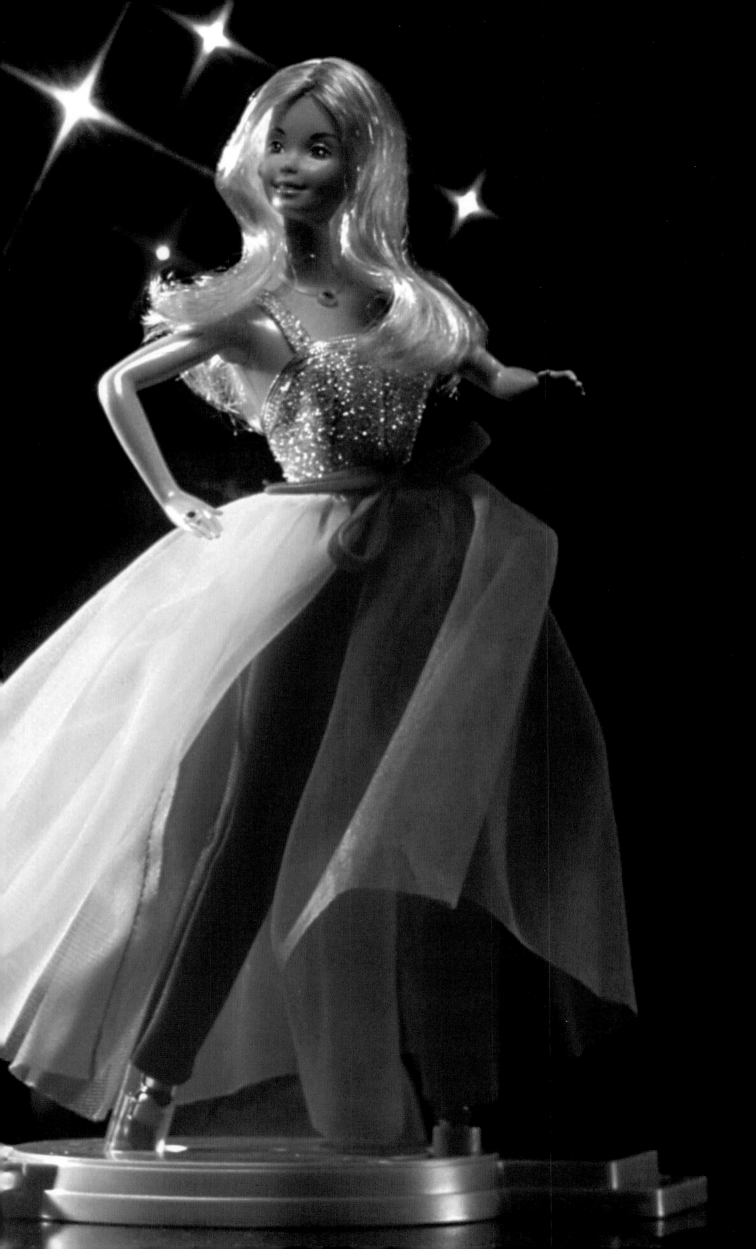

The
1980s

New
Adventures
for Barbie
and Me

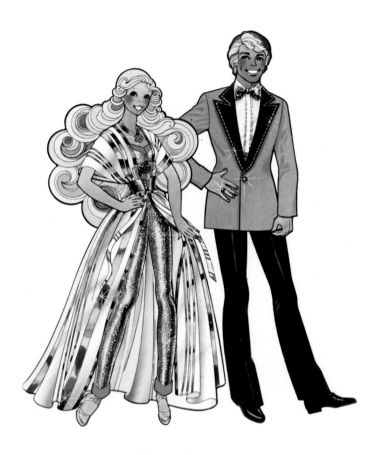

FOR SEVERAL MONTHS, EACH OF US IN THE FASHION-design department had noticed that something wasn't right with Charlotte Johnson. She didn't seem like her poised, self-assured self; she couldn't remember project details that previously would have been effortless for her, and sometimes she forgot appointments and meetings altogether. Perhaps most alarming was the occasional erratic outburst, which was nothing like the Charlotte I had come to know.

Though it had been identified as early as 1906, Alzheimer's disease didn't become part of the public conversation until the late seventies. Everyone in the department, so respectful of Charlotte's position as the head of the design department and her history with Mattel, did all we could to shield her from the scrutiny of the executives who now oversaw the breadth and scope of the Barbie line.

By this point I had spent almost two decades working for Charlotte; we had battled occasionally over design decisions, but ultimately I respected her enormously for both her talent and the unwavering passion she brought to Barbie every single day. Most important, she had become my friend. Watching her decline was devastating.

Charlotte knew that she no longer was bringing her best self to work, and so in 1980 she decided to retire; she was sixty-three years old and had been with the company for twenty-two years. It was an incredible moment of mixed emotions: I was happy she was able to leave on her own terms, but the reason was sad and frustrating. It would be at least another decade before we would begin to understand what Alzheimer's does to those we love.

Above: An illustration for Gold 'N Glamour fashions that appeared in a Mattel-produced brochure in 1980. Barbie's hair looks a lot like Farrah Fawcett's!

Barbie

World of Fashion

"We Girls Can Do Anything.
Right, Barbie!"

MATTEL

0007-5300

But all of us, Charlotte included, put on brave faces and gave her a retirement party attended by her friends at Mattel.

We also planned a special going-away gift: a solid-gold Barbie. I still remember her smile when she saw the trophy she so richly deserved for helping to fashion a lifestyle for the doll beloved by millions of little girls.

Charlotte's departure ranked high among the changes that marked the beginning of the 1980s. The corporate structure at Mattel became even more formalized. Instead of creating ensembles from start to finish, we no longer perfected our own patterns; that function was taken over by a new department, leaving us more time to come up with concepts and designs.

In this new environment, the review procedure also changed: a designer would present a 3-D model for approvals at the newly created design-review meeting, now attended by members of the soft goods, marketing, and merchandising departments. With marketing planning the line and forecasting sales—a function previously performed by the Handlers—their opinion mattered. Once a design was approved, we would turn over our 3-D model, plus pattern and fabric listing, to the soft goods department, and they would take it from there.

Yet the fashions we created continued to reflect current trends: Gold 'N Glamour, released in 1980, remains a favorite of mine, also because I loved how Mattel's marketing department continued to evolve Barbie's image via the illustrations seen on the brochures.

With Gold 'N Glamour, Barbie's lush blond locks were meant to evoke thoughts of Farrah Fawcett, who had wowed TV audiences in *Charlie's Angels*, while Ken's thick head of hair was based on Robert Redford. With each generation, Mattel would be inspired by the icons of the period, and you would find these details subtly used in the illustrations.

Opposite: In the 1980s, marketing booklets returned to illustrations of Barbie instead of photos. This booklet cover featured the tag line from the Mary Lou Retton Great Shape Barbie ad. ∗ Above: Inspiration prints for future Barbie designs from my collection of fabrics. Although the zigzag and white floral prints were common motifs in the late 1980s, only the orange floral made it onto a doll: the Hawaiian Superstar Barbie, an extremely rare exclusive to Europe and Canada in the early 1980s.

A Barbie for Her Youngest Fans

While preteen girls loved the fashions we designed for Barbie, our market research was revealing new data we couldn't ignore: children were discovering Barbie as early as two years old. The doll and some elements of her wardrobe, however, didn't feel as effortless in the hands of a child that young; bendable legs could make it difficult to put on a pair of pants, for example, while tiny buttons frustrated toddler fingers. The answer was a doll that not only would be easy to dress but also would help develop a child's motor skills.

We debuted My First Barbie in 1980, and she was an immediate success with both little girls and their parents. My First Barbie was conceptualized with one straight and one permanently bent leg, allowing her wardrobe to slip on and off with ease. Her fashions were designed with equal attention and care, featuring larger and longer openings and easy-to-use closures like Velcro and large snaps. For this inaugural doll in the series, I designed a

wrap-style swimsuit in a bright yellow with blue trim and ties: yellow slacks or a skirt would slip over the swimsuit, offering bonus value.

The use of these high-contrast primary colors was intentional, as were the ties on the clothes, which helped preschoolers learn this useful skill. Finally, inspired by that Gold 'N Glamour illustration I loved, My First Barbie's thick hair had a beautiful wave, and the doll included a miniature brush and comb, another element that combined teaching with play.

I designed clothing and dolls for the My First Barbie collection until the end of my tenure at Mattel.

Among my favorites in the series was My First Ballerina Barbie, released in 1987. I created a soft pink, tutu-like dress for her, and for the first time, a My First Barbie outsold the lead glamour doll in the "big girl" line. Her popularity only grew over the years.

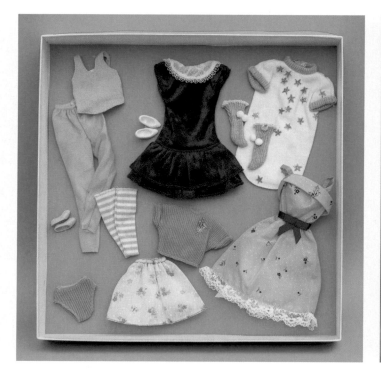 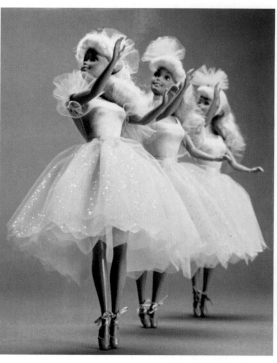

Above: *My First Barbie's outfits* (left) *featured large openings and snaps to make dressing easier. My First Ballerina Barbie* (right) *was a megaseller.* ✷ **Opposite:** *The swimsuit-plus-cover-up outfit I designed for My First Barbie's debut.*

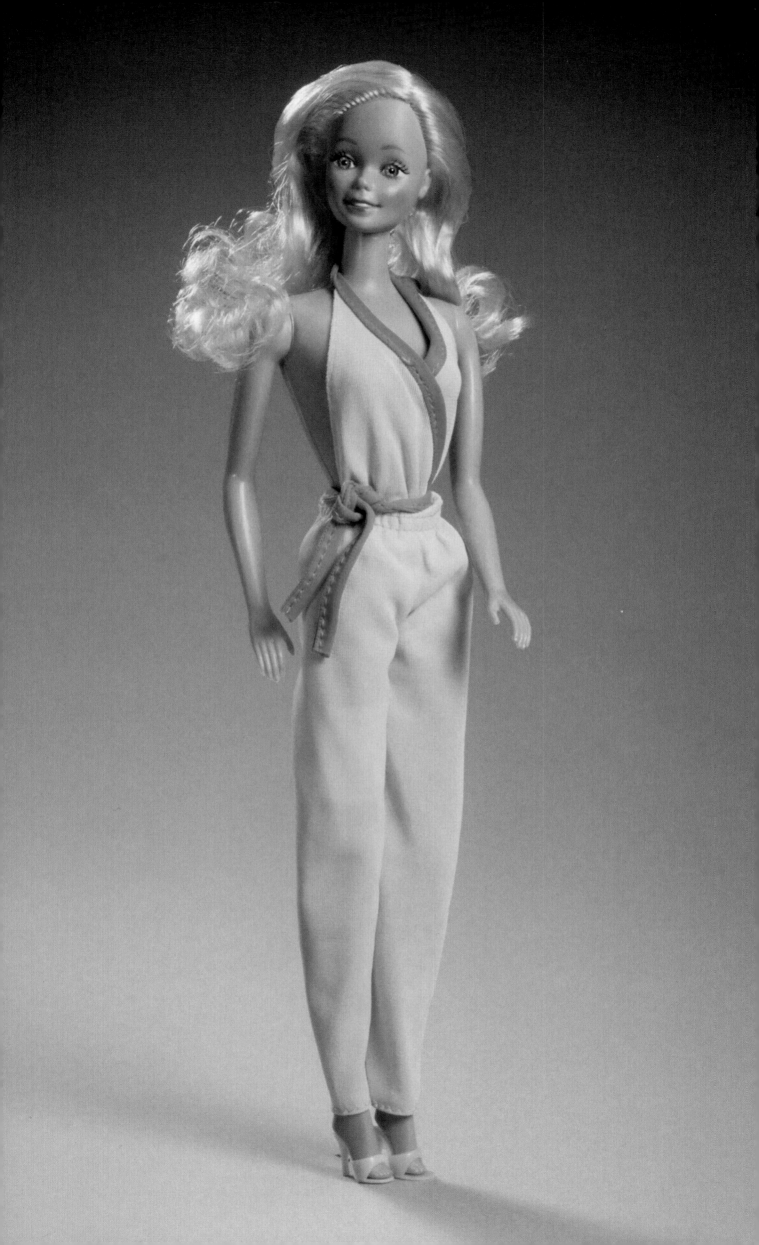

Barbie's International Appeal

BY NOW BARBIE WAS A GLOBAL PHENOMENON—SHE IS CURRENTLY sold in more than 150 countries—and we wanted to celebrate that idea by producing dolls of different nationalities. From a design standpoint, this latest collection was a chance to broaden my horizons. With each new installment, I dived happily into the research to create a doll that was beautiful and a bit whimsical, yet also appropriate and respectful of the country she represented.

The British royal family inspired the first doll in the line because a modern-day English princess seemed a good fit for Barbie. I designed a white sequin-trimmed satin bodice and matching full-length skirt with gathered tiers in sheer tricot; this Barbie came with the Twist 'N Turn waist, so those tiers created a lovely sense of movement during play.

As the International Collection gained momentum, we decided to call it Dolls of the World. For the Russian Barbie, I was inspired by *Dr. Zhivago* and designed a pink ankle-length dress with gold trim and touches of faux fur at the shoulders, and finished the look with black boots and a fabulous faux-fur hat, a perfect contrast with her blond hair.

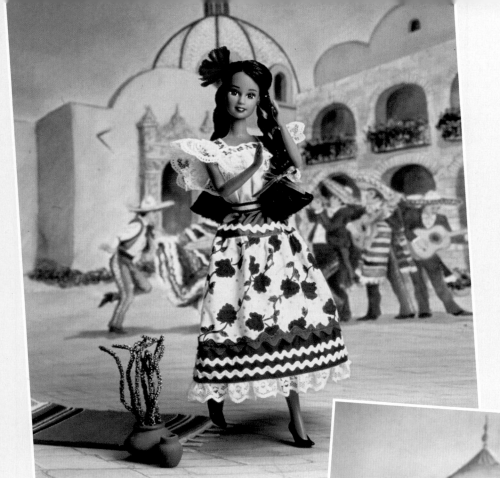

When I was contemplating the doll for Mexico, a friend who was born there showed me a few of the traditional dance costumes she had collected. I used those to create a peasant-style, lace-trimmed dress, with a floral skirt and peplum that combined to evoke the Mexican flag.

I had designed an elegant, traditional sari trimmed in pink and gold for India Barbie, but by the time my concept reached the factory in Malaysia, it had been altered by our Hong Kong workroom in an effort to cut costs. Their finished product more closely resembled a traditional Chinese cheongsam. Luckily the mistake was caught in time by the factory's workers, who refused to produce the "sari," which they considered both inaccurate and disrespectful of India's culture. In the end I got the correct, refined dress I originally had envisioned.

Mattel continues to celebrate international themes—Barbie has represented forty different nationalities, with some countries and cultures interpreted multiple times—so I'm proud to have played such a key role in both the launch and so many subsequent designs. These dolls were sought after from the beginning; indeed, many passionate Barbie collectors point to Dolls of the World—or, as they were later known, Princesses of the World—as the series that ignited their interest. It would be another decade before Mattel split the Barbie business to create a collector division alongside a children's play division; by then, collectors were way ahead of us.

Barbie Is Bitten by an Eighties Bug

The tremendous success of *Urban Cowboy* in 1980 spawned a newfound frenzy for country-western influences in fashion. Western-style shirts became all the rage. I wasn't immune to this trend, especially as someone who already loved to ride horses. After a vacation spent riding through the mountains of Idaho, I couldn't wait to design an embroidered shirt for Barbie—that became 1982's Wild West, part of the Western series: a head-to-toe look that included my take on the Western shirt, denim-style pants with a *B* embroidered on the back pocket, a silver belt, and a cowboy hat. That same year, Mattel hosted its annual company celebration with the theme of—what else?—Country Daze. For the costume competition, I made a copy of Barbie's Western outfit for myself and dressed her in the design I had created. At the party, I carried the doll or placed her in a holster that I slung around my hips. We captured first prize.

Jane Fonda's *Workout* video in 1982 spawned another craze—this time for exercise gear. Leotards and leg warmers in every color found their way into women's wardrobe, including Barbie's.

Great Shape Barbie premiered in 1983 wearing a bold turquoise leotard with a pink tie at the waist for a touch of contrast; I accessorized the style with a matching headband, striped leg warmers, ballet-style flats, and a fun little gym bag. This highly posable doll was meant to dance or do high kicks and emphasized an active lifestyle—but what I loved most about her was the sense of female empowerment that was built into both the collection and the ad campaign. The latter featured Olympic gymnast Mary Lou Retton, at the time one of the world's most-recognized women, and her starring role in Great Shape Barbie's TV commercial ended with the line "We girls can do anything—right, Barbie?"

Above: Great Shape Barbie was inspired by the aerobics craze. ✳ **Opposite:** *First I designed a Wild West outfit for Barbie, then one for myself. I won first prize in the costume competition at Mattel's annual outing.*

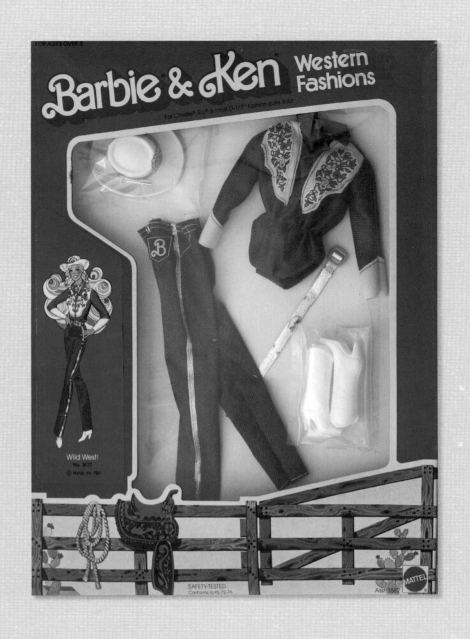

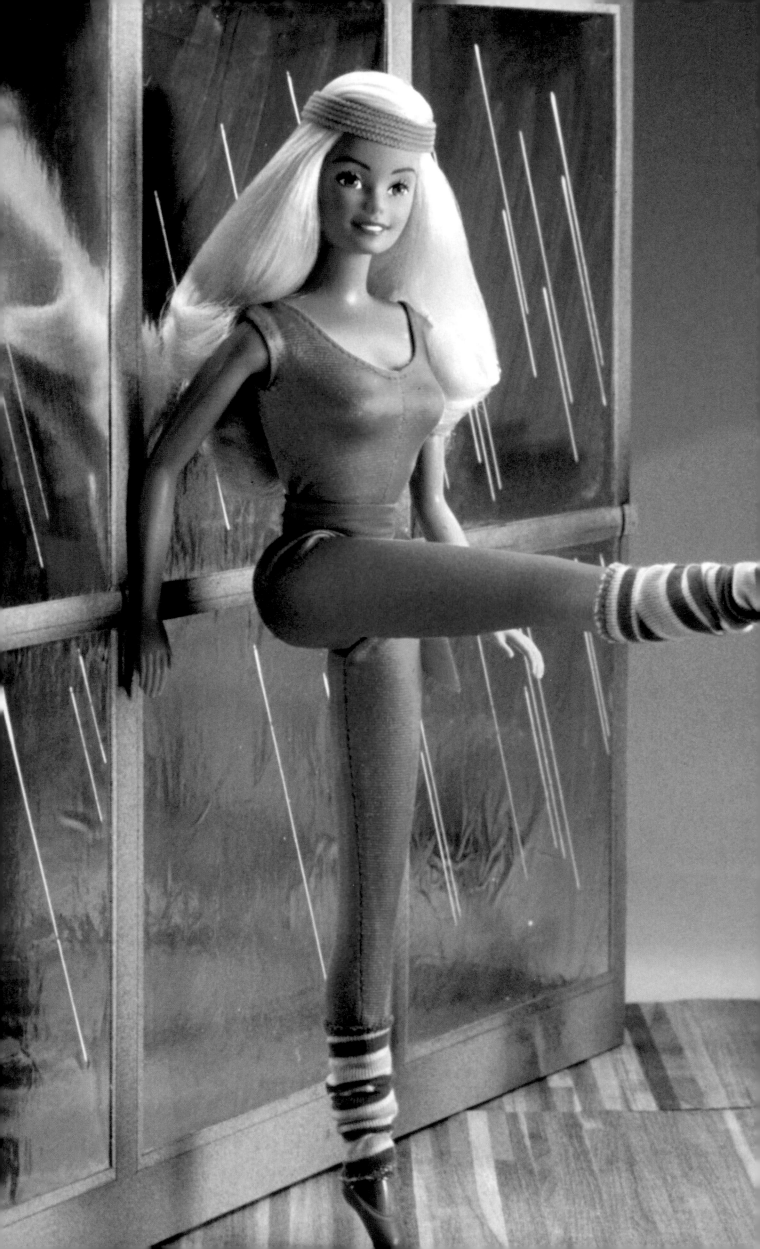

Among all the Barbie dolls Pixar could have chosen, it's Great Shape Barbie who is seen in the *Toy Story* films.

Designers Are Dazzled by Barbie

FASHION'S MOST FAMOUS NAMES HAVE ALWAYS KEPT AN EYE ON BARBIE. The first designer to personally confess his love of Barbie to me was Yves Saint Laurent, whom Charlotte and I met in the late sixties when he was hosting a fashion show and luncheon at Perino's, a landmark Italian restaurant on Hollywood's Wilshire Boulevard. Following the fashion show, we introduced ourselves to the famed couturier, and as soon as he heard the word *Barbie*, his face lit up. Then he told us he always looked at our line to see what we were doing. I was simply dumbstruck, but I also know that I didn't stop grinning for the rest of the day. Over the years, I have wondered: *Did I inspire the great Yves Saint Laurent?* His pantsuits did resemble the ones I created for Barbie *(below)*!

In the 1980s, no name personified glamour quite like Oscar de la Renta, so imagine how thrilled we were upon learning that the couturier who dressed movie stars, socialites, and first ladies wanted to lend his name to Barbie. Of course, these were the days before designers signed on with Mattel to create a special-edition Barbie; instead, we produced outfits inspired by the designer's collections and aesthetic, with de la Renta selecting his favorite.

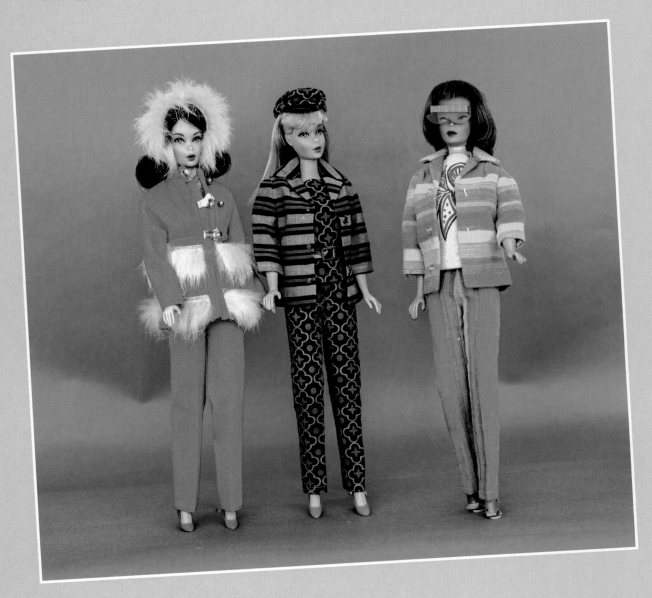

My submission *(above)* evoked the grand galas where Oscar de la Renta gowns had become a staple: a one-shoulder ball gown in a shimmering azure blue jacquard, with a touch of flowers in organza at the waist, and a matching cape and evening bag in blue satin. This entrance-making look was among more than a dozen entries that were sent to New York to be reviewed by Mr. de la Renta at his Seventh Avenue headquarters.

Later I learned the details: each doll was set up on a table, a row of miniature glamour girls. Mr. de la Renta, always the picture of dignity, entered the room wearing a crisp suit. He slowly toured the display, stopping in front of each doll to examine the details of the stitching, gathering, and seams. He said very little during the process and looked at several ensembles more than once. Finally he stopped in front of my ball gown and cape; with only the slightest nod of his head, the decision was made. My look was one of four fashions that would be sold in 1984 as Oscar de la Renta for Barbie.

Back in our own studio, we congratulated each other on this wonderful moment and Barbie's official entry into the world of high fashion.

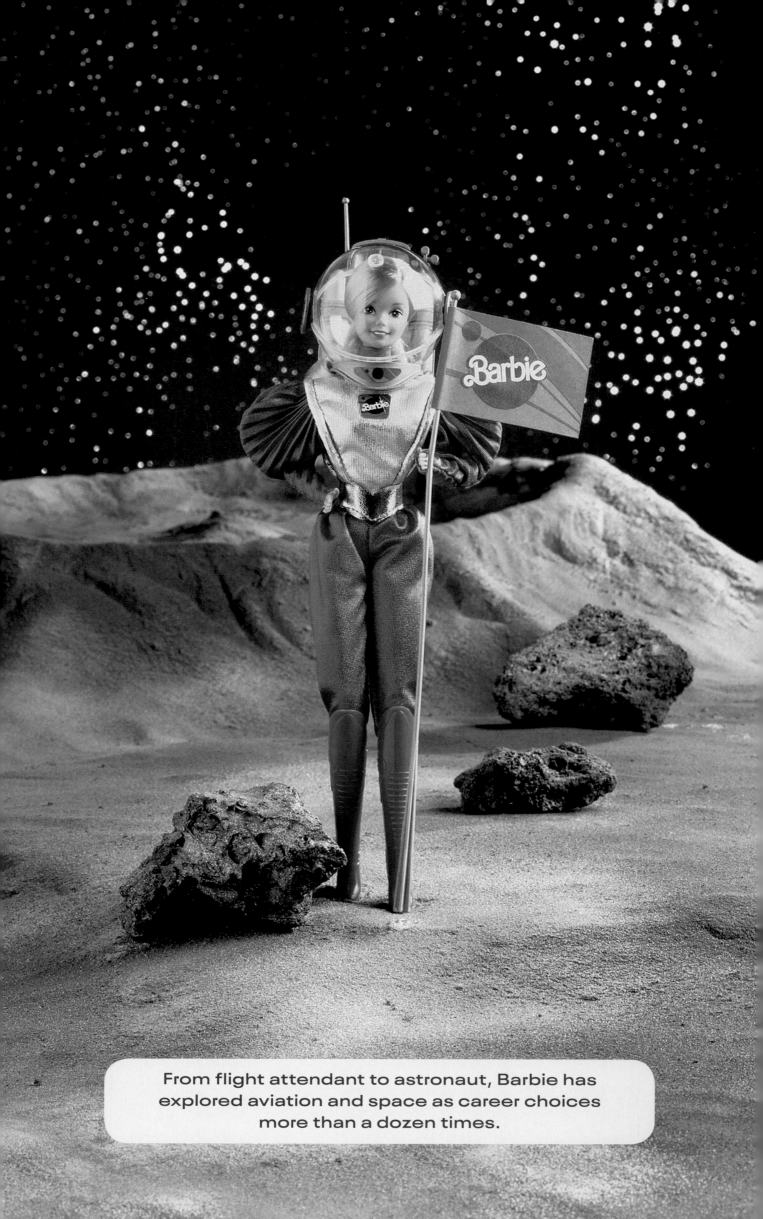

From flight attendant to astronaut, Barbie has explored aviation and space as career choices more than a dozen times.

Travel Beckons

Mattel had never replaced Charlotte following her retirement, and her absence was beginning to be felt. In addition to overseeing our department, she also would check in on the many overseas factories we now worked with to ensure that standards were still meeting our expectations. With computers taking over many aspects of our production process and fabric orders, we were discovering that breakdowns were occurring, as these early computers sometimes didn't pick up on nuances that a human instantly would recognize. The result: unnecessary orders and millions of dollars in needless inventory. Mattel executives decided that, as the senior designer on the team, I was the most qualified person to step in and figure out ways to use this excess fabric.

I was beyond excited. I always had dreamed of traveling and working in Asia—I had toured China before I joined Mattel and loved everything about it. Meanwhile, for several years I had been constantly on the lookout for ways to grow my professional status within Mattel—toward this end, I had started working on my MBA—and I knew my

latest responsibility would only help that goal. I didn't have to be asked twice.

This new adventure started out with several trips to Hong Kong, alongside one of Mattel's textile experts, to oversee the transition of a new line, a function previously performed by Charlotte. Not long afterward I was asked to base myself in Tokyo for six weeks to work with MA-BA—a joint venture between Mattel and Bandai Toys—to resolve issues we were experiencing with Japan's Barbie doll.

If I was looking for new experiences, I couldn't have envisioned something better. In Tokyo, for example, I quickly discovered that male colleagues were not accustomed to working with a woman on their level. When they walked, they expected me to follow a few steps behind. One day I stopped in my tracks and waited; they turned around and looked at me, and caught on very quickly. From that moment on, we walked together.

Of course, this travel-based assignment wasn't my full-time job. I was still one of Barbie's key designers and had to balance both workloads. Back in the design studio, we discussed revisiting Barbie

Opposite: *French designer Thierry Mugler inspired my vision of Astronaut Barbie's flashy uniform.* ✳ **Above:** *When a computer glitch resulted in warehouses of surplus fabric, I designed 130 outfits to use it up, including these dresses, nicknamed Sweater Puffs.*

as an astronaut, as NASA's space shuttle program was in full swing at the time. We had created a fun astronaut costume for Barbie in the 1960s, but with physicist Sally Ride becoming the first American woman in space in 1983, it seemed natural that Barbie should explore a similar dream.

I designed a fantasy-driven astronaut suit and a more realistic one that were both tested by our children's focus groups. But as we examined the reaction to my designs, research revealed that children maintained some fear about space. I decided to remove reality from the situation: Astronaut Barbie would appear to emerge more from the pages of a comic book than the hallowed halls of NASA. Yet she still would convey the message that Barbie could venture into space because she could do anything.

To create this new collection, I turned to French designer Thierry Mugler. He created dazzling and fantastical clothes, with nipped-in waists and exaggerated shoulders, and every woman who wore them looked strong and powerful. He also explored themes of space and robots, making Mugler the perfect inspiration. I loved the freedom of this project: the basic astronaut style worn on the doll consisted of a bodysuit in pink and metallic silver that could be interchanged with slacks or a miniskirt and then paired with high boots.

For the fashion collection purchased separately, I let my imagination go wild. Welcome to Venus featured a mini with a flowing cape, while Space Racer was dazzling in silver, with a cropped jacket that showcased wonderfully padded shoulders, paired with a matching metallic-silver miniskirt and thigh-high boots.

And then one event changed everything, just weeks before the collection's scheduled debut at the annual International Toy Fair. On January 28, 1986, the space shuttle *Challenger* broke apart seventy-three seconds into the flight, and all seven crew members were killed, including teacher Christa McAuliffe. We pulled the television commercials and all related advertising, but kept the line, as a considerable portion of its production already had been completed. Still, we struggled with the decision: Would Astronaut Barbie remind kids of that tragic moment?

Ultimately the astronaut collection found its audience. In fact, in 1995 an African American Astronaut fantasy Barbie doll and a Barbie wearing the astronaut suit we created in 1965 were displayed at the Smithsonian Institution's National Air and Space Museum in Washington, DC. Over the years, Mattel has donated thirteen aviation- and space-themed Barbie and Ken dolls to the Smithsonian, and today you will still find a grouping of astronaut Barbie dolls on permanent exhibition at the Smithsonian's James S. McDonnell Space Hangar in Chantilly, Virginia.

I had continued to juggle my workload between California and Asia, and then in 1988, Mattel made me an offer: they needed someone to head up a new design department they were planning for our Hong Kong office; was I interested in becoming an expat? I couldn't pack my bags quickly enough. I rented out my Los Angeles home, put most of my furniture in storage, and headed to Hong Kong.

Again, I was tasked with finding a solution to a computer malfunction that resulted in surpluses in several factories. A member of the team was able to fix the glitch in the computer system, halting the unnecessary reorders, but what to do with all that extra fabric? My mind was spinning with ideas—the outfits had to be stylish and on trend to attract the eye, but inexpensive to entice parents to open up their wallets. I nicknamed one example Sweater Puffs, which combined a knit dress with a frilly, textural skirt. It reflected late-eighties fashion, yet because of the simplicity of the knit, wasn't costly to produce.

Every design was approached in a similar fashion, and thus I chipped away at those surpluses. The clothes sold quite well, in fact—so well that a Mattel exec decided to spend a bit more money on the program to upgrade the packaging. Ultimately, at the end of my tenure, I had created designs that used up the inactive inventory in three warehouses as well as two forty-foot containers on the Hong Kong docks, all while overseeing quality control and ensuring processes were streamlined and worked well together.

And in the midst of accomplishing these goals, I had immersed myself in a culture I had come to love. I lived in a complex across the road from the American Club and just up the hill from Hong Kong's famed Stanley Market, which became a favorite destination. The fish had been caught just an hour before, and I learned to love buying it so fresh, as well as eating it right there on the street; it was so much better than the fish I had tasted in the United States.

I couldn't have asked for a better adventure. But at the end of the two-year assignment, I was ready to go home.

Opposite: *Reality continued to take a backseat for these outfits from the Astro Fashion line.*

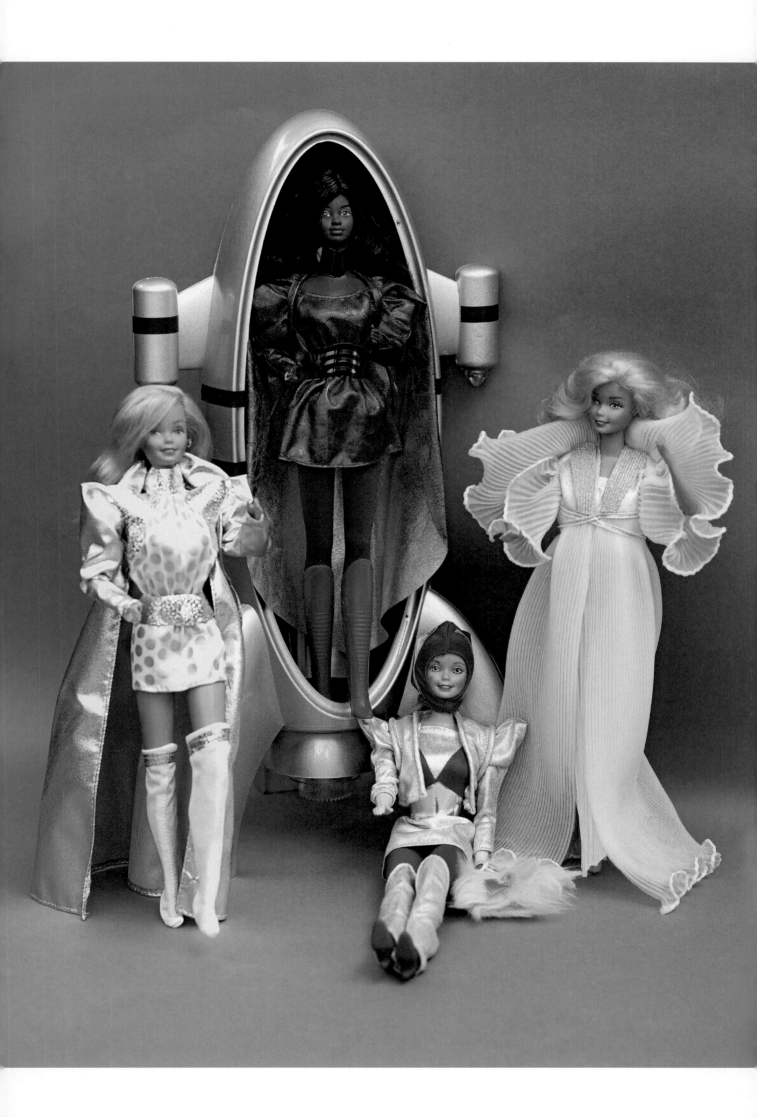

Above and Opposite: *The excess fabric also resulted in the Fashion Finds line.*

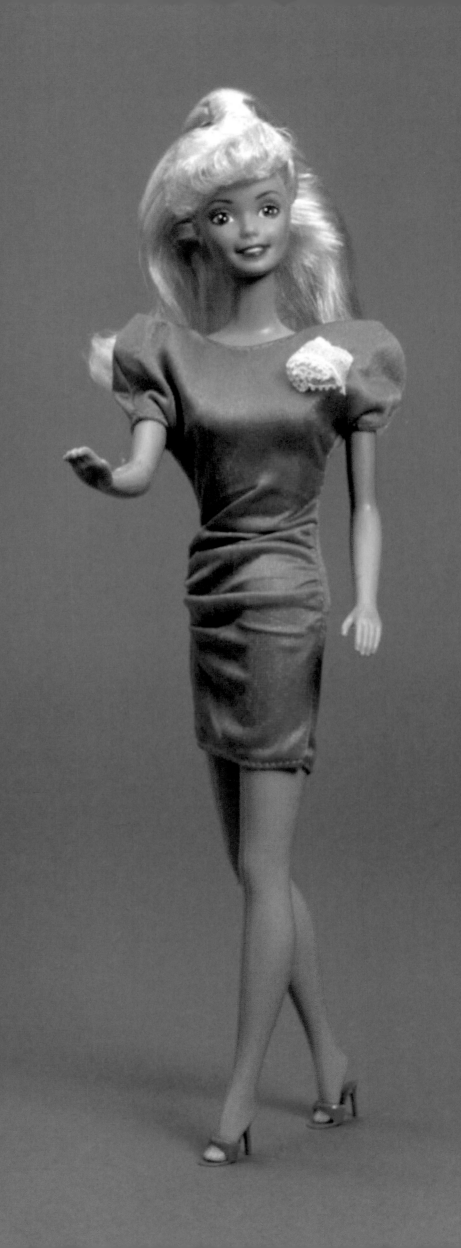

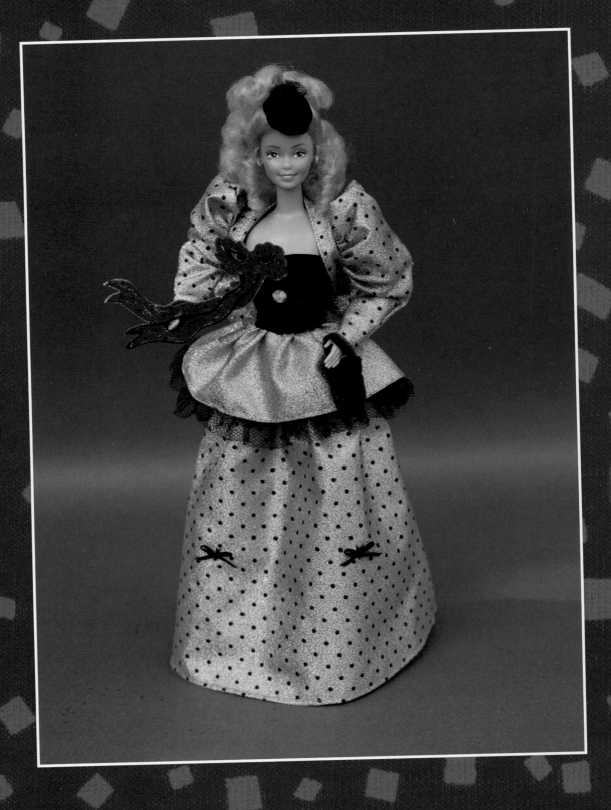

American Beauty was conceived first as a way to honor the design team, and I was going to be the first one showcased. When Mattel's marketing team grew skeptical, American Beauty transformed into a collection of dolls themed to various cities. New Orleans was the first in the series, and my design was changed to a convertible look in mauve and black with polka dots, with a ball gown skirt that could be removed to create a minidress that Barbie might wear to a Mardi Gras parade. Her accessories included a mask I painstakingly worked on so its eyeholes were the correct size for Barbie's face and it could stay in her hand. Ultimately Mardi Gras Barbie became the only doll in the series. Mattel decided to shift focus to our US Armed Forces, and American Beauty evolved to become a tribute to women in uniform.

In Tokyo, I created a clothing line for the Barbie exclusively marketed in Japan. My hotel room became a design studio for the prototypes (right), which I later presented to the Ma-Ba team (above). My stay in Japan included time for fun! (below).

In 1988, I moved to Hong Kong for work and got a firsthand look at the factories that made Barbie's clothes. I also had time to explore Asia (left). I worked with a team of four (below) in the new design department and was responsible for overseeing designs into production. These photos (bottom and opposite top) show the process of spreading fabric and die-cutting in a small factory. A larger factory in China or Malaysia (opposite center) sews the dresses with fabrics produced in Taiwan (opposite bottom), and the motto was "Do it right the first time."

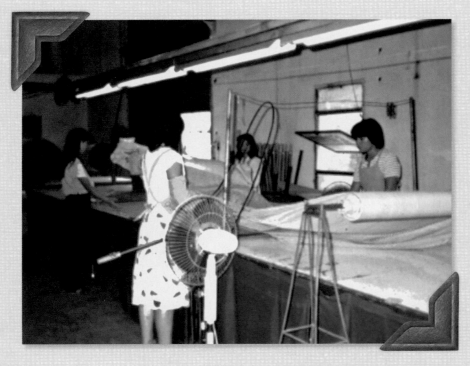

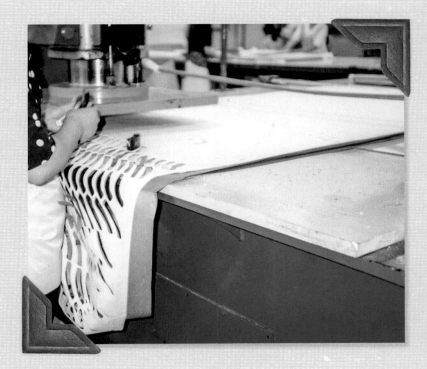

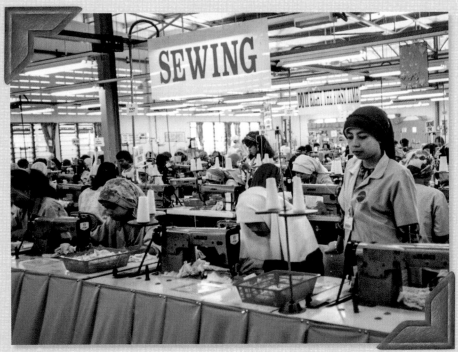

Barbie Rules the World

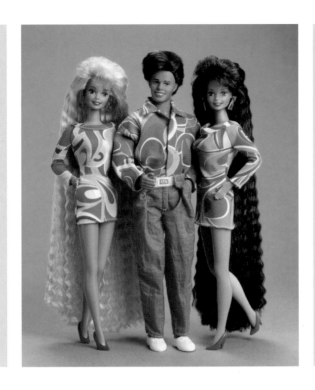

R ETURNING FROM HONG KONG, I EXPERIENCED
two cultural shifts: the transition back into life in America and
at Mattel. And while it wasn't a challenge to ease back into the America
I remembered, I couldn't say the same about Mattel.

A corporate, "numbers first, design second" philosophy had taken hold. The fashion-design department was teeming with new employees, each of whom had been given a mandate to produce quickly and efficiently; this meant the competition that always had driven our quest in creating the best for Barbie had increased exponentially, with more of us jockeying for those coveted, limited slots of outfits to be sold. After two years of problem-solving in Asia, I had been hoping I would be greeted with "Welcome back!" Instead, the reaction was "Who are you?"

Did I let that faze me? Definitely not. I was approaching three decades at Mattel and with Barbie, and my philosophy had always succeeded: *Keep your head down, Carol, and produce solid, salable work.*

My first assignment upon returning was a great example of this—the Dinner Date collection. As its name implies, the idea was that Barbie was going out on the town and needed a fabulous dress; for this new grouping we also took a his-and-hers approach, designing coordinating looks for Ken. No matter whether they were going to the movies, out dancing, or to a black-tie gala, the collection offered the perfect look for this iconic couple.

I also loved Dinner Date because it reminded me of the days when I would design a full collection— not only in the quantity and range of looks produced, but in the relationships you could discern between these designs, from the color palette to details like the frill or the cut of a skirt. It was a high-fashion approach that appealed to the older children who played with Barbie (and, as we increasingly saw, the burgeoning number of collectors). As we entered the 1990s, everyone at Mattel was finally beginning to fully comprehend the incredible scope of consumers who loved all things Barbie, and how vital it was to craft dolls and fashions that would both suit specific age groups and appeal to the overall audience.

Above: *The Pucci-inspired prints I designed for Totally Hair Barbie showed up on Ken's coordinating outfit, too.*

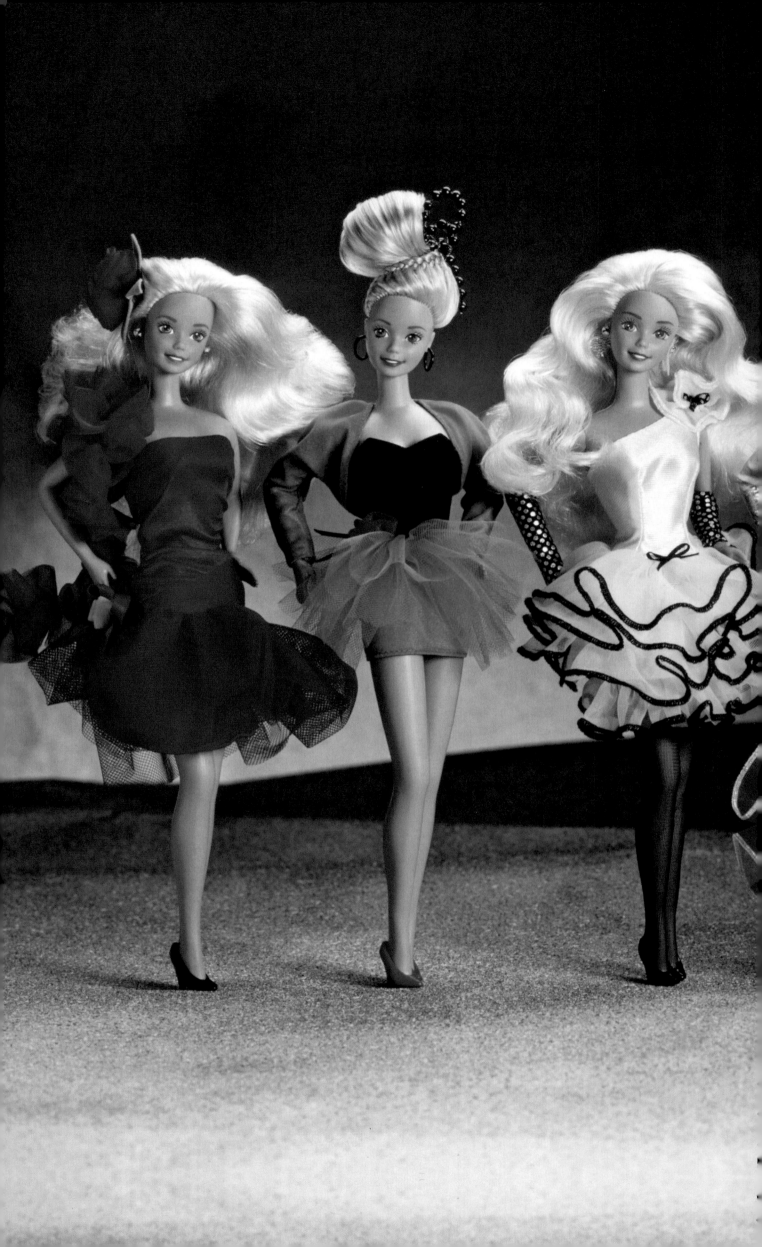

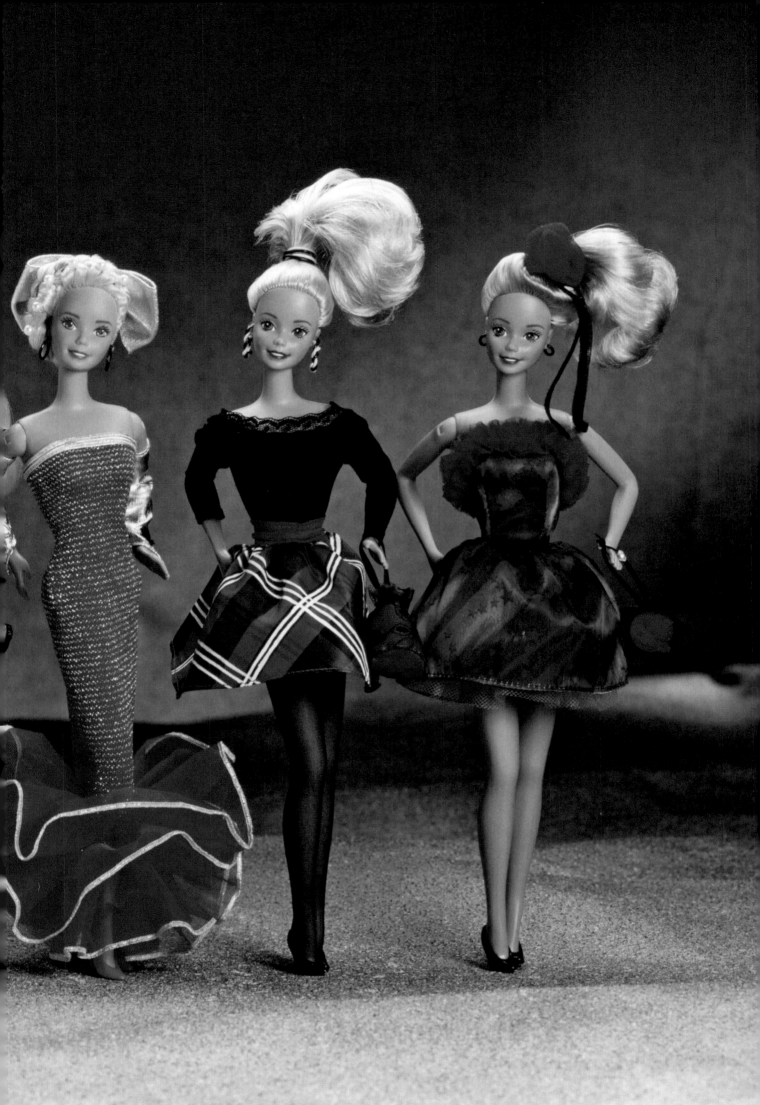

Above: I designed the entire Dinner Date collection, high-fashion clothes for Barbie and Ken's special-occasion date nights at the club or fancy restaurants.

The Best-Selling Barbie of All Time

WE'D KNOWN FOR DECADES THAT CHILDREN SPENT HOURS INVENTING new hairdos for Barbie. So in 1992, we planned to debut a Barbie with a new hair element to wow everyone. We had been working with a Japanese manufacturer that had developed a method of both crimping and straightening hair, but an accident destroyed their work. With the International Toy Fair approaching, we needed a quick solution. Then one day it hit me: Why not just create an over-the-top, fantastic mane that would be the doll's starring feature? I would design colorful accessories that suited her gorgeous locks, but we would "dress" Barbie in her hair. Her name? Totally Hair Barbie.

The marketing executives loved it. While the design department experimented with different hair lengths, I researched what Barbie should wear (while keeping in mind that Ken would be dressed in a coordinating look). I wanted Barbie's clothes to exude the same sense of fun that her kicky, crimped locks would, so I decided to model them on the work of Emilio Pucci, the Italian designer renowned for vibrant, graphic patterns.

Of course, Pucci prints are typically too large in scale to suit a Barbie doll, so I revisited the practice of creating a custom print by fitting together graphic shapes—in a tonal pink palette for blond Totally Hair Barbie, and a tonal blue palette for the other dolls—and gluing them onto a minidress I had designed. Because the print was so bold, I kept the lines of the dress simple. For Ken's shirt, meanwhile, I was able to find a print that could be scaled down, and I paired that with solid coordinating pants. Barbie's look was finished with matching hair accessories, including hair gel, a suggestion by Jill Barad, Mattel's CEO at the time.

After returning from Asia, I felt I had lost my place in the hierarchy of the design studio in California. Coming up with a solution to avert a near fiasco had reinforced my position as the designer with the most seniority and had shown that my talents remained formidable. The proof: Totally Hair Barbie became the bestselling doll in Mattel's history; indeed, the company's annual report the following year touted the doll as "A $100 Million Success!" I was bursting with pride.

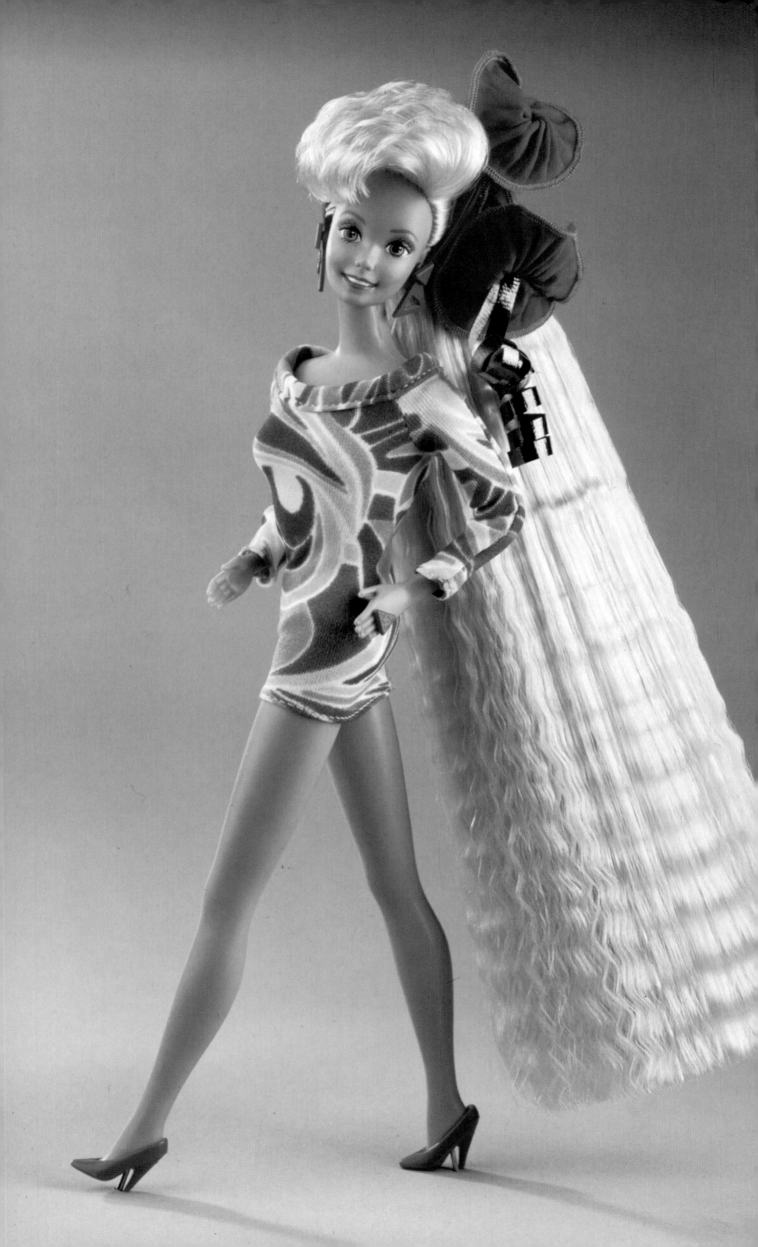

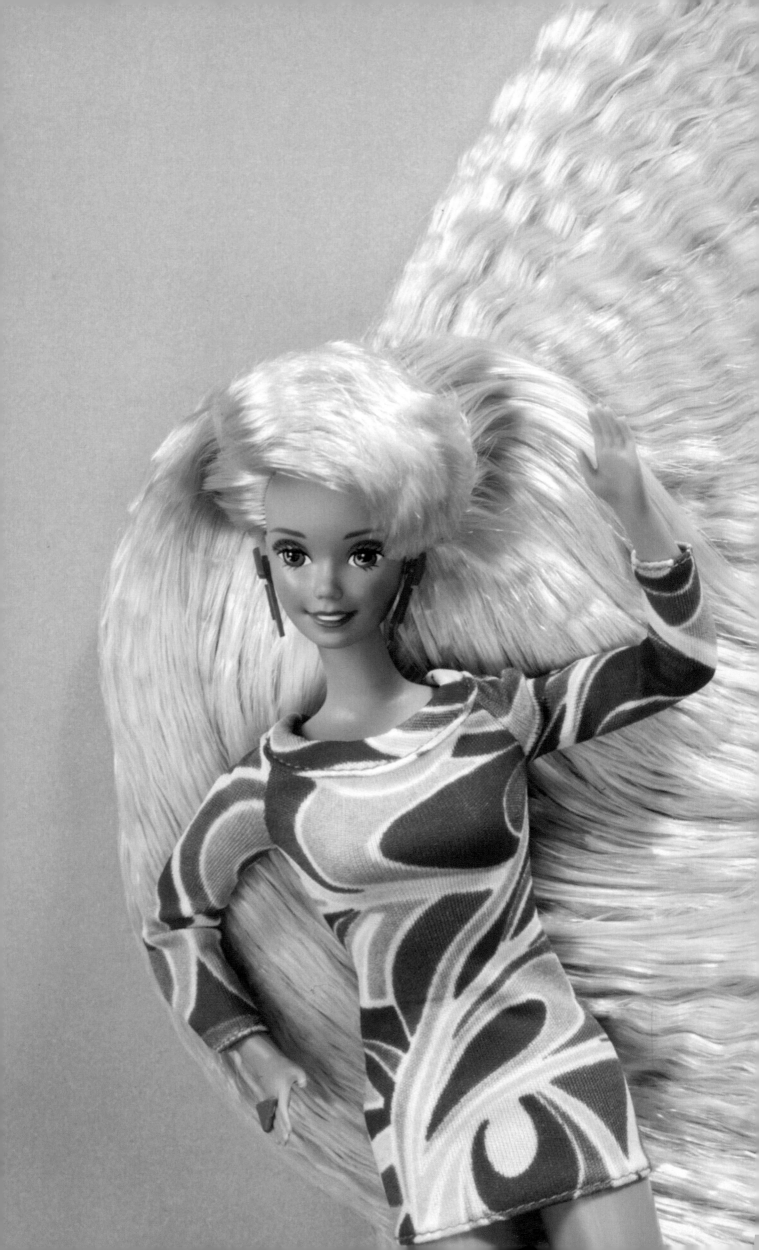

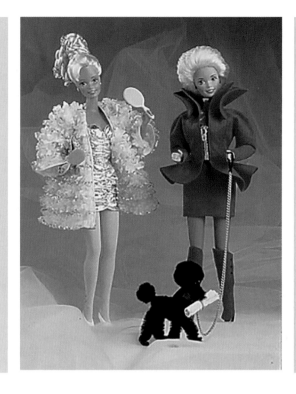

Collectors Feel the Love

For years informal collector clubs had been spring-ing up all over the world, and a National Barbie Convention was already an annual event in the United States. Our next step was clear: it was time to formally recognize and embrace this burgeoning demographic in the Barbie family. I had attended the 1990 national convention, taking copious photos of the types of dolls and accessories sold and dis-played at the event, and upon my return produced a presentation for Mattel executives. We needed specific product that would appeal to and celebrate our collectors, I explained. Because these exclusive, limited-edition dolls would be meant for display, not play, we could craft them using the highest-quality materials. Like Ruth Handler's first Barbie doll, limited-edition collector dolls had the potential to increase in value, making them irresistible. Recog-nizing the opportunity, Mattel formalized the idea in 1992, creating a separate collector division within the Barbie universe.

For the inaugural doll in this highly anticipated launch, Barbie's designers were also about to achieve a goal: our name on the box. Only Charlotte Johnson had enjoyed recognition, so imagine the excitement in the design studio more than a decade after her retirement when we learned that we, too, were about to be celebrated in the Barbie pantheon. For many of us, designing for Barbie wasn't merely a way to earn a paycheck; she inspired us, as did the generations of children who loved her. At national conventions and other events, men and women told me how much Barbie meant to them as kids and how much it meant to introduce Barbie to their own children. That has always moved me.

Some Mattel executives were skeptical, though. Would consumers really care who had designed a particular doll? But I had been out there talking to Barbie's fans; I knew better. And it wasn't merely that they knew about Charlotte—they wanted to know more about the rest of us as well.

Since I had the most seniority, I was the nat-ural choice to design the inaugural collector prod-uct, a three-doll group we named Classique. I knew the premiere doll needed to be ultraglamorous.

Opposite: *Benefit Ball Barbie and my personal display of the Classique collection, pictured here with me.* ✳ **Above:** *The Classique collection featured a red-carpet-ready coat and dress and a suit tailor-made for high-end shopping.*

I remembered a fashion design I loved from the 1960s, which we had dubbed Benefit Performance, and I decided to update the idea for the 1990s. I didn't hold back. Perhaps because I come from a family of redheads, I've always been partial to a red-haired Barbie, so I started with a lush mane of auburn curls. To offset that rich red hair, I designed a sumptuous gown in a beautiful sapphire-blue trimmed with a shimmering gold fabric. The gown's asymmetrical styling, with an elegant side drape on the skirt and a satin "boa" that wrapped around one shoulder, evoked a grand gala. Her accessories were equally luxe and included long fingerless gloves, also in a glistening gold. Benefit Ball Barbie was a knockout.

The second and third dolls in the Classique collection would likewise showcase high-wattage moments in Barbie's dazzling life: attending a Hollywood premiere in a frilly minidress and matching jacket, or shopping on Fifth Avenue in a crisp suit. Both looks were in keeping with what was on the fashion runways at the time, and together, the three looks created a narrative of Barbie as the ultimate icon of sophisticated style.

Mattel execs, however, were getting skittish. Three dolls was a major commitment for the launch of a new group, while talks over the need to credit the designer continued. One day, I was called into a meeting and asked a question: Had I ever thought about changing my name? If Mattel was going to formally introduce a designer into the mix, shouldn't that designer's name sound as glamorous as the doll herself? Even though I was incredulous, I didn't bat an eye. I also wondered what Charlotte Johnson would have done in that scenario—she was a stylish, visionary woman with an equally ordinary-sounding name—and figured she'd do what I ultimately did. "My name is Carol Spencer," I said. "For Barbie, it always will be Carol Spencer." And with that, I left the meeting.

Soon after, the decision was made: Instead of three dolls with three separate fashions, Classique would be released as one doll—Benefit Ball Barbie—with the Hollywood premiere and Fifth Avenue looks produced as fashions only. And my name would appear in small letters after "Designed by" on the back of the box. This wasn't what I originally envisioned, but it was still a step forward for Barbie's designers. When Benefit Ball Barbie debuted in 1992, I remember looking at that first box, the doll's rich auburn hair and blue gown still waiting to be revealed inside, and then turning the box over. There it was, in small gray letters: *Designed by Carol Spencer.*

Opposite: Benefit Ball Barbie was the first doll in the brand-new collector's line. She was also the first doll to feature the designer's name—mine!—on the box.

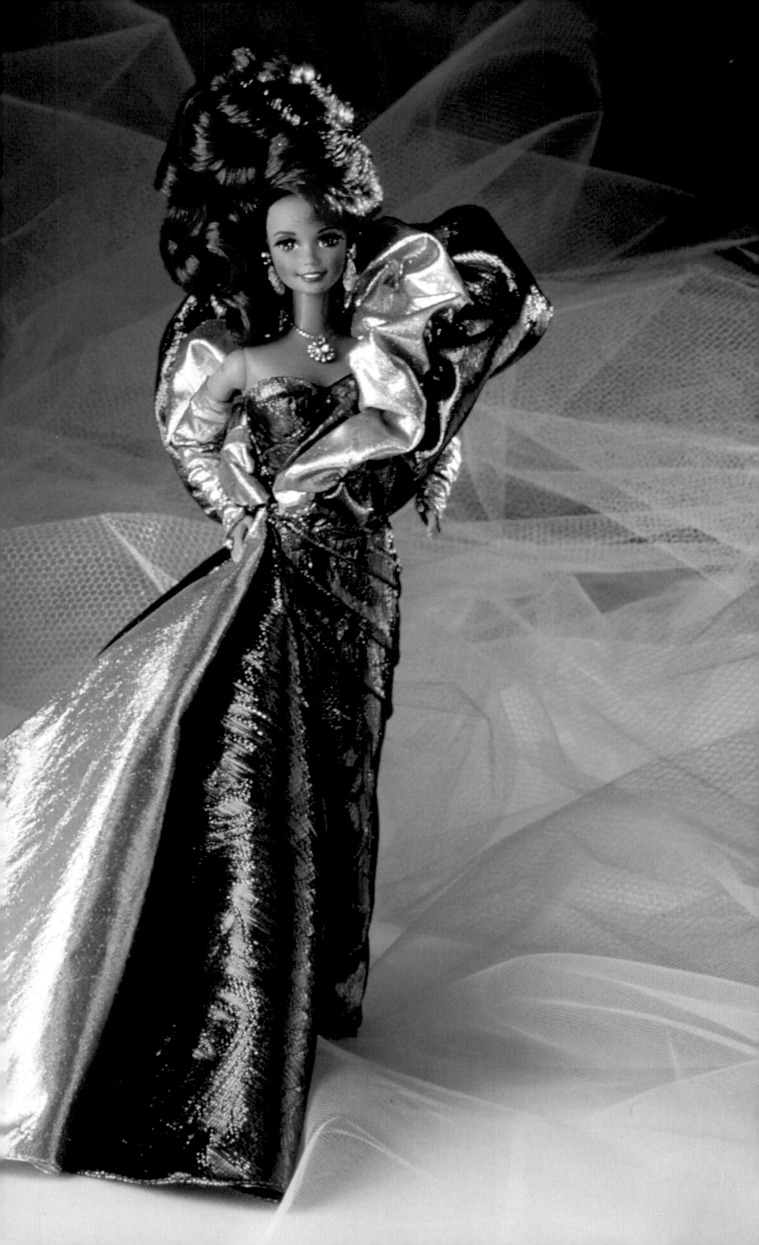

My First Ballerina Barbie Gets a Makeover

MY FIRST BALLERINA BARBIE continued to be a hit among young children, but in focus groups, both children and their parents noted that it was difficult to tell all the different Barbie dolls apart when they were undressed. As I mulled over how to make this still-popular ballerina more easily identifiable, I remembered a thirty-inch Marie Osmond doll that Mattel made in partnership with Olive Osmond, the matriarch of the Osmond family, in the 1970s. I had created the samples for that doll's wardrobe, though I never had to worry about the underwear: A devout Mormon, Olive had insisted that the doll's underwear be sculpted on the body, so she would never be without it.

I realized that by creating a similar feature for My First Ballerina Barbie, she would be easy to spot amid a toy box filled with other dolls. Besides, the idea was perfectly in sync with the doll's original intent of being easy to dress. In the design studio, I found a bit of white lace and fashioned it into underwear on the doll, then walked it over to the model shop. I often found that mocking up a doll in this fashion was the best and most immediate way to communicate an idea to the Mattel engineers. In addition to her now-sculpted panties, we also painted her legs a stark white to simulate ballet tights and added molded-on pink ballet slippers. There was no mistaking My First Ballerina Barbie now.

Opposite: My First Ballerina Barbie's sculpted panties and white legs made her instantly recognizable and easier to dress.

Barbie Becomes a Pop-Culture Icon

As Benefit Ball Barbie gained recognition among its intended audience throughout the United States, I went on a signing tour—though, again, Mattel executives weren't enthusiastic about the idea. That may seem difficult to believe today, with designers showcased so readily in the Barbie universe, but in the early 1990s, no one dreamed people would clamor to have their doll signed. Having spent time around collectors by this time, I felt the audience would be there—but I still hedged my bets. I used my own vacation days for the signing tour and asked Mattel's marketing department for only inexpensive flights and hotels. Once the tour locations and dates were set, I sent handwritten notes to the collectors clubs within two hundred miles of each event, inviting them to attend my signing and requesting that they spread the word among their members. My first stop: New York City and the legendary toy store FAO Schwarz. On the day of the signing, the line at FAO Schwarz was out the door and around the block.

We were mobbed at each event. Barbie collectors were thrilled we were starting to cater specifically to them, and they didn't have to wait long for the next great limited-edition doll. In 1994 Mattel was celebrating thirty-five years of Barbie; by then, almost one billion Barbie dolls had been sold. This phenomenal success deserved a special doll.

More than anything, I wanted this anniversary doll to look regal as well as beautiful. I decided to use a luscious metallic gold brocade and embellished it with hand-sewn beadwork. The slim gown was fully beaded in a modern-art pattern, while the brocade coat—lined in a shimmering pink, Barbie's signature color—featured opulent long sleeves and small sprays of faux pearl and crystal beading, with gold bugle beads finishing its edges. In addition to gold and pearl jewelry, I completed her look with a headdress of gold beading and more faux pearls that topped a cascade of blond hair. Her name? Gold Jubilee Barbie. After years of cost cutting and designing low-priced fashions, it felt wonderful to again experience creative freedom—and to design the most expensive Barbie ever produced for public sale. (If you're wondering about the priciest Barbie ever sold, that honor goes to a doll created in 2010 as a partnership with Australian jewelry designer Stefano Canturi, a one-of-a-kind piece featuring a genuine diamond necklace and crafted to raise money for the Breast Cancer Research Foundation. Her final auction tally? $302,500.)

This limited-edition doll included one more embellishment that marked another high point in my career. Based on the resounding success of Benefit Ball Barbie, Mattel executives realized the value of the designer's signature. This time my name wasn't just on the box; we put it on the doll. On the back of Gold Jubilee Barbie, there it is, also in gold: "Carol Spencer." Even more than Benefit Ball Barbie, this felt like a cultural shift within Mattel, an affirmation of an individual designer's contribution to Barbie's success.

> At the time of Barbie's thirty-fifth anniversary in 1994, two Barbie dolls were being sold every two seconds somewhere in the world.

Opposite: *Gold Jubilee Barbie, created for the thirty-fifth anniversary, was one of the most expensive dolls produced.*
Next page: *Mattel honored me by putting my signature on Gold Jubilee Barbie, a milestone for the design team and me.*

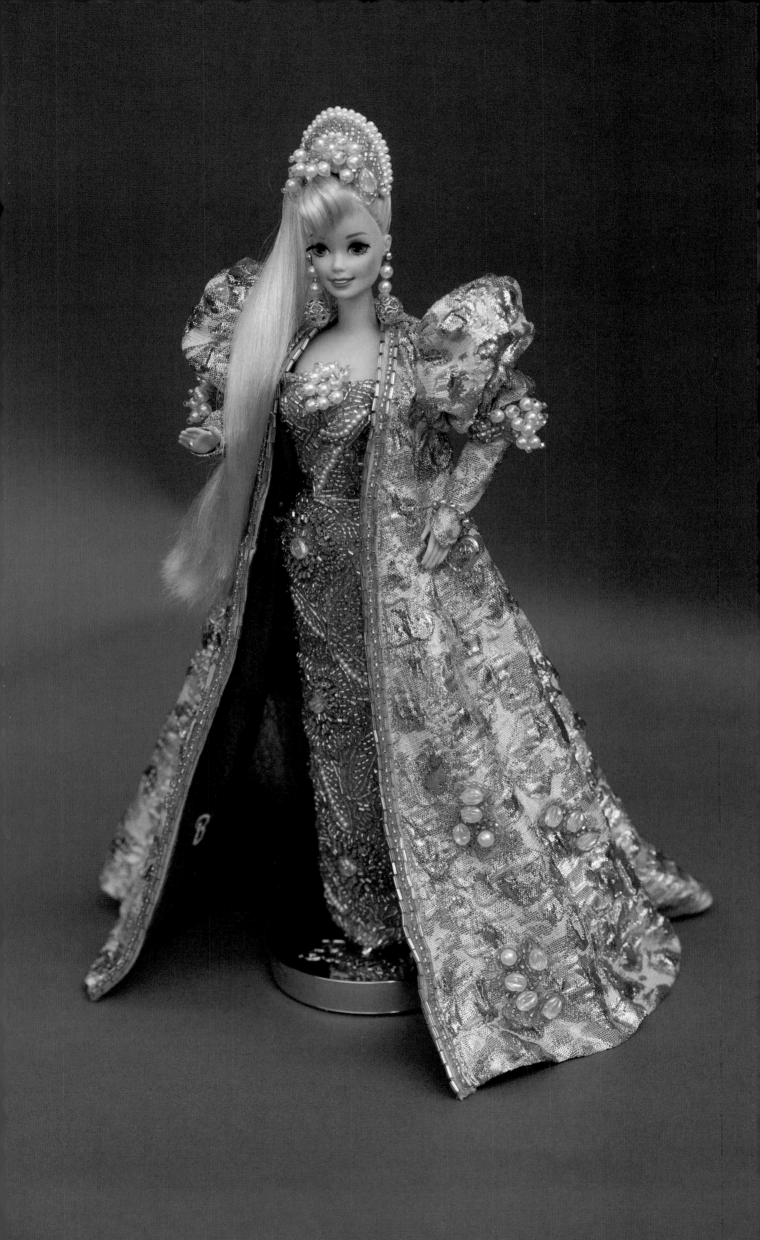

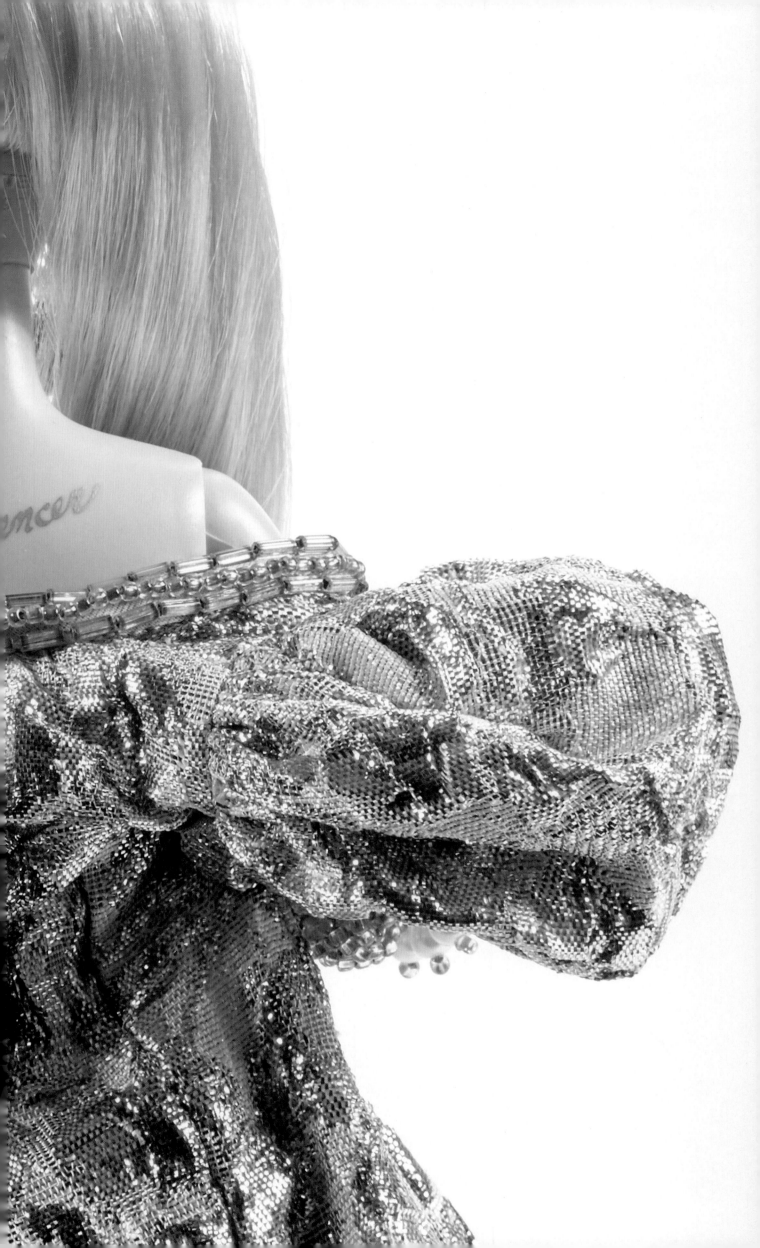

A Special Gift for Ruth

AS PART OF BARBIE'S THIRTY-FIFTH ANNIVERSARY, WE HELD A MATTEL Barbie Festival at Disney World in Orlando. To my delight, Ruth and Elliot Handler were also there. Ruth looked wonderful, and I was so pleased to see the audience reaction: as the mother of Barbie, Ruth was naturally treated like the ultimate celebrity, with standing ovations whenever she appeared. The following November, we presented Ruth with a birthday surprise: her very own Jeweled Splendor Barbie. Unlike the original doll *(below)*, Ruth's one-of-a-kind Barbie was dressed in a pink velvet gown embellished with ruby-red beading and silver threadwork *(opposite)*. We put a miniature Barbie in her hand, crafted with plated gold, and next to her, we placed a miniature reproduction of Ruth's autobiography, *Dream Doll: The Ruth Handler Story*.

We received a lovely thank-you note soon after, in which Ruth mentioned how touched she was and that her specially made Barbie would occupy a place of honor in her living room, "making the whole room glow."

That festival would be the last time I saw Ruth; she passed away in 2002 from breast cancer. I'm so glad my last memory of her is of those moments in Orlando, enjoying the standing ovations. She deserved them.

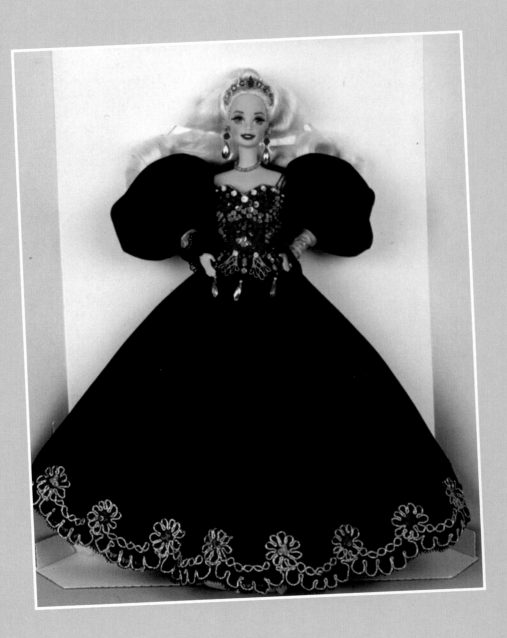

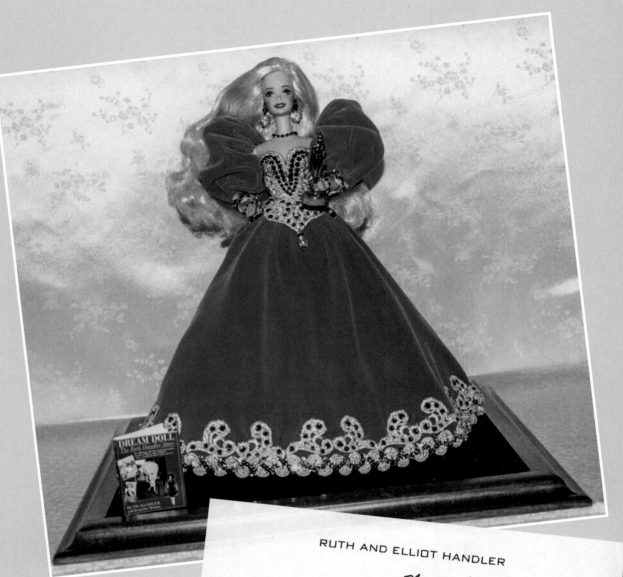

RUTH AND ELLIOT HANDLER

November 8, 1994

To all my friends at Mattel —

The very special Barbie doll, designed by Carol Spencer, which you sent me for my birthday, is about the most gorgeous thing I've ever seen. She now occupies the place of honor in my living room, making the whole room glow.

I've thoroughly enjoyed making appearances for Mattel in 1994, and I've especially enjoyed working with so many of you.

Thank you for the doll. It's hard to express how much I appreciate it.

Love,

Ruth Handler

AVENUE OF THE STARS #2803 LOS ANGELES, CALIFORNIA 90067

My "Baby" Makes Her Debut

Even as the collector division continued its fantastic growth, we never forgot that Barbie was first and foremost a doll meant for children. Focus groups showed that Barbie's increasingly younger audience also played with baby dolls: was it possible to combine the two? While millions of "weddings" have taken place over the years, Barbie and Ken never officially married, so giving them a baby was unthinkable. The solution was a baby sister for Barbie and Skipper. As the senior member of the design studio, it was up to me to conceptualize this new family member.

Designing a brand-new doll is no easy task, and you're far from alone. Focus groups, marketing meetings, sales meetings, design, modeling, and engineering meetings: everyone at Mattel had an opinion on this new doll, and typically another contender was needed before a final decision would be made. I stuck with my instincts to create Baby Sister Kelly, a four-and-a-half-inch doll with blond hair and blue eyes that mirrored classic Barbie's features.

By the time Baby Sister Kelly was approved, I had begun working on another project, so Abbe Littleton, another member of the design studio, came up with her clothing and accessories. She created a complete play set, which included a crib with movable side rail and rotating mobile, and fashions that ranged from an adorable pink onesie with bunny feet to a lace-trimmed dress and tights for special occasions.

Kelly was an instant success among the audience we wanted to reach, though her name also has been the source of many questions. While we called her Kelly for her US introduction, we couldn't clear the name for global use, so we later changed her name to Chelsea.

Ultimately few aspects of my Barbie career were more fulfilling than coming up with the concept of Baby Sister Kelly; Ruth was Barbie's mother, but I was Kelly's mother. It took eighteen months to give birth to her—I loved to joke that it was quite the extended pregnancy, though I enjoyed every minute of it.

Above: *Sketches for Barbie's baby sister, originally named Kelly.* ✳ **Opposite:** *I created Barbie's youngest sibling, but Abbe Littleton, another designer, came up with her adorable clothes and accessories.*

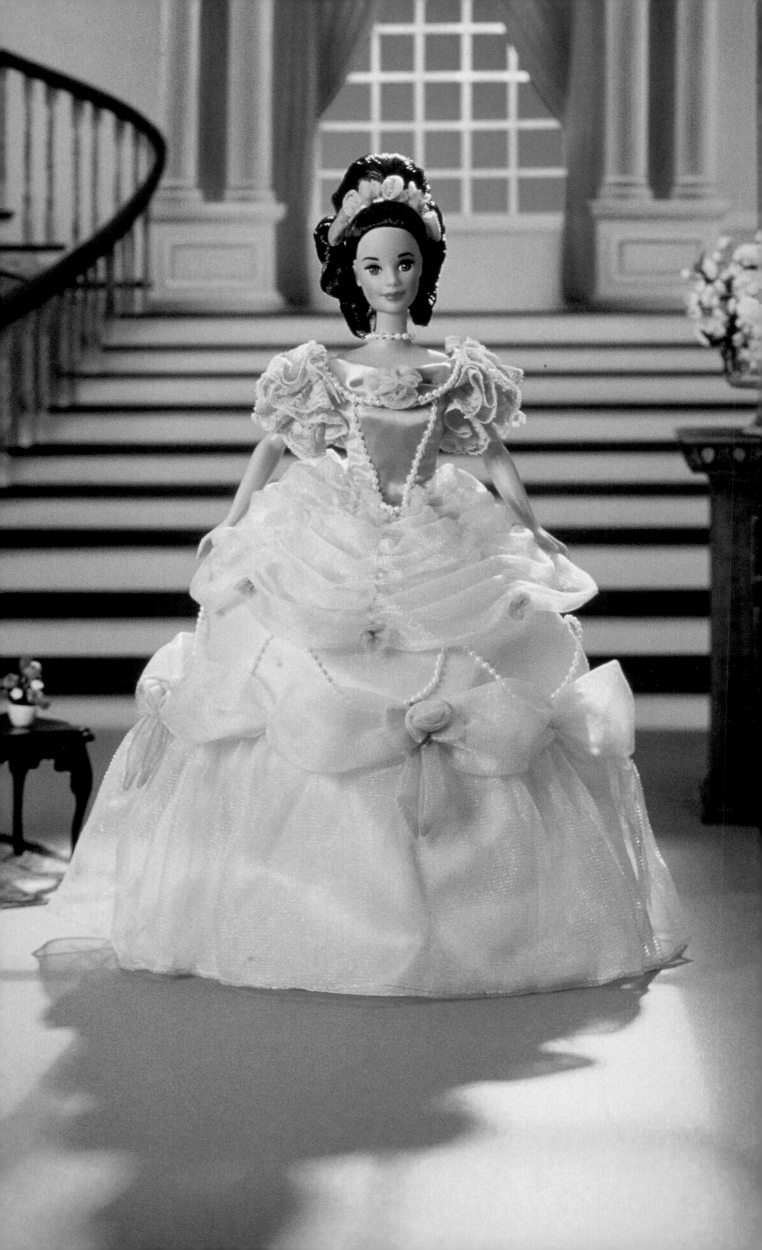

Collector Dolls
Take Center Stage

Even with each new success, there were still frequent challenges within the halls of Mattel. We had introduced a Great Eras series in the collector division, an opportunity for us to explore the opulent fashions of different centuries; one of the most valuable pieces of feedback we received from collectors was that they loved the fashions to feel lavish and luxurious, but they also wanted them to feel authentic.

Among the various time periods we explored, I couldn't imagine a more lavish era than the one of Marie Antoinette at Versailles. So for the fourth edition of Great Eras, I designed a French Revolution doll wearing a thoroughly extravagant pink satin gown trimmed with plenty of frills: pink lace, tulle ruffles, pink bows, and pearl beading.

The approval process for French Revolution Barbie proceeded well—until one gentleman spoke up during a marketing meeting. "Why would we produce a doll in an era that's all about beheadings?" he asked. I explained that the doll wasn't meant to be Marie Antoinette; rather, she represented a specific period in fashion that was luxurious and favored by collectors. But there was no stopping him now: "Beheadings!" he repeated. His insistence soon changed the tone of the room. Before I knew it, "French Revolution" was not moving forward as a concept. They loved the fashion, however, and asked me to use it for a US-inspired design. I made some adjustments to the bodice, changed the time period to the 1860s, and created a Southern Belle Barbie to include in the Great Eras collection.

As for the French Revolution? Marie Antoinette Barbie was introduced in 2003 as part of The Women in Royalty series. I'm glad I wasn't asked to design it, as my heart wouldn't have been in it. Though sometimes I wonder what the "Beheadings!" gentleman might have thought of Marie Antoinette finding her way into Barbie's world after all.

I had to put my foot down for another doll in the Great Eras series. While most design rules had relaxed since that stringent, belt-tightening period of the 1970s, we still had a struggle with new shoe molds.

Opposite: After a French Revolution Barbie was nixed for the Great Eras collection, I restyled the bodice (above) *for Southern Belle Barbie's sumptuous gown.*

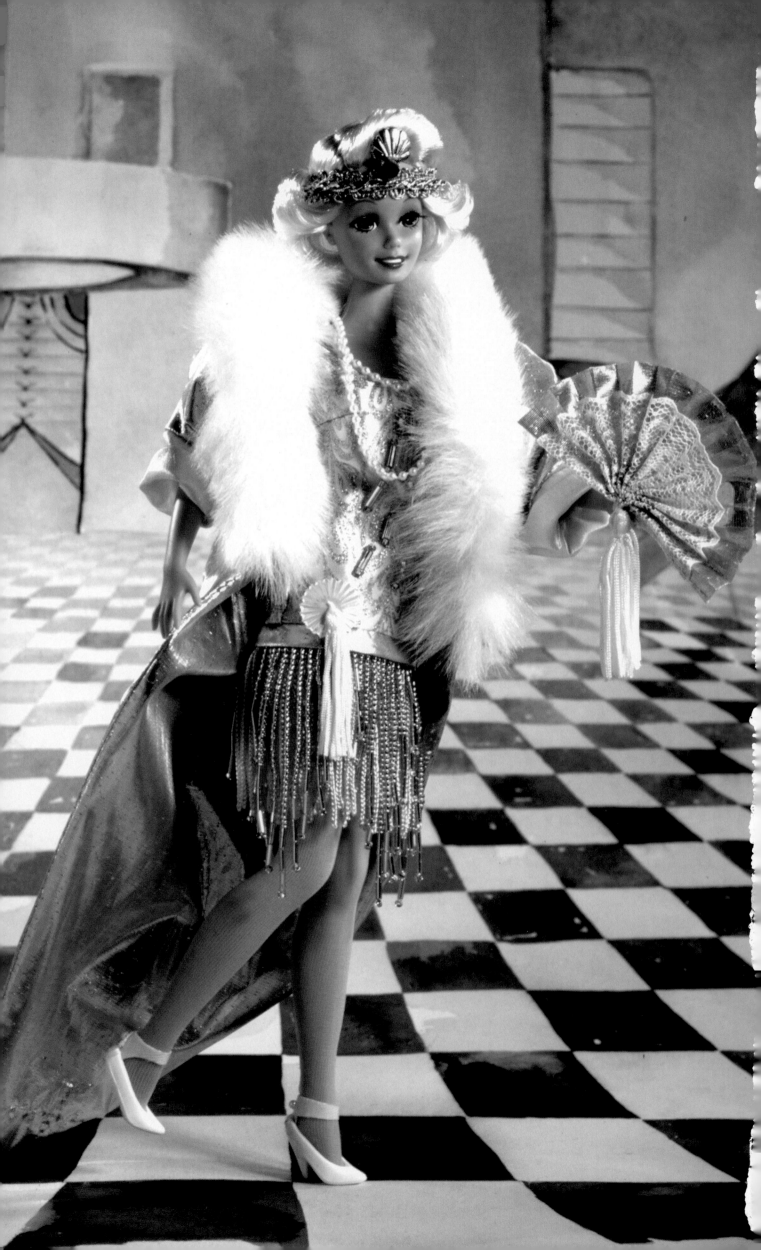

For Flapper Barbie, meant to represent the glamorous Jazz Age of the 1920s, I wanted an ankle-strap shoe, but it didn't exist amid the available molds. Barbie needed to wear one, so I fought for this change by pointing out how much our collectors valued authenticity. With the collectors division continuing to earn strong sales, Mattel executives agreed, and I got what I needed by adding a separate ankle strap with a button sewn onto a pump to produce accurate shoes for our gorgeous Flapper Barbie.

This was also the first doll in which I worked with Mattel's new computer-design programming, brought in to create custom designs on textiles.

I learned how to create a design directly on the computer using a stylus, or import a hand-drawn design via a scanner. After years of cutting and pasting bits of fabrics to create a custom print, this was a huge change, and I loved the ease of it. All of a sudden, worrying about scale was a thing of the past.

In the midnineties, the collectors division experienced one of its biggest successes when Mattel decided to celebrate classic films with a Hollywood Legends series. For the inaugural dolls, Mattel partnered with Turner Entertainment, which owned the rights to 1939's *Gone With the Wind*. It was a natural choice: a beloved film with a sustained fan base

Opposite: *Flapper Barbie Doll showing off her ankle-strap shoes and my first computer print design.*
Above: *Barbie's high-heels, from the 1960s (bottom shelf) to the 1990s (top shelf), including the flapper ankle straps.*
Above, right: *We added gold glitter and beads to enhance my computer print design for the bodice of the dress.*

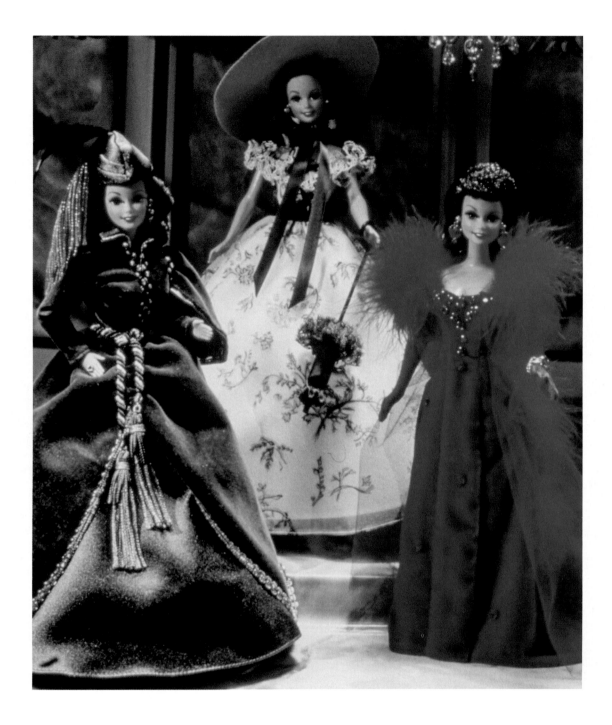

and a strong female character in Scarlett O'Hara, and Walter Plunkett's beautiful costumes.

The first dress I created for the series had become iconic among Scarlett's costumes: the green "drapery dress," famously crafted from the velvet curtains at Scarlett's beloved Tara. I copied each detail as intricately as possible, including the gold fringe on Scarlett's hat and the curtain tiebacks and tassels she had fashioned into a belt.

For another dress in the series, the leaf-print dress Scarlett wears to the barbecue at Twelve Oaks, I trekked over to the Los Angeles County Museum of Art (LACMA), where they happened to have

an exact copy of the dress on display. During my research, I had discovered that Walter Plunkett had enlarged prints he had found from the 1860s, which tended to be small and delicate; Plunkett knew that bigger prints looked better on-screen. Imagine my delight in realizing I actually had to reduce the print back down to its original size and scale to suit Barbie. Plunkett, who loved textile design, would have enjoyed this idea, I think.

A red-velvet gown Scarlett wears later in the film, thought equally iconic by fans of the book and film, as well as a black-and-white afternoon dress Scarlett wears after she marries Rhett Butler,

Above: I researched every detail to re-create the intricate gowns of Gone With the Wind, *the first in the Hollywood Legends collection series.* ✷ **Opposite:** *The prototype for Eliza Doolittle's flower-girl costume, my favorite in the* My Fair Lady *series.*

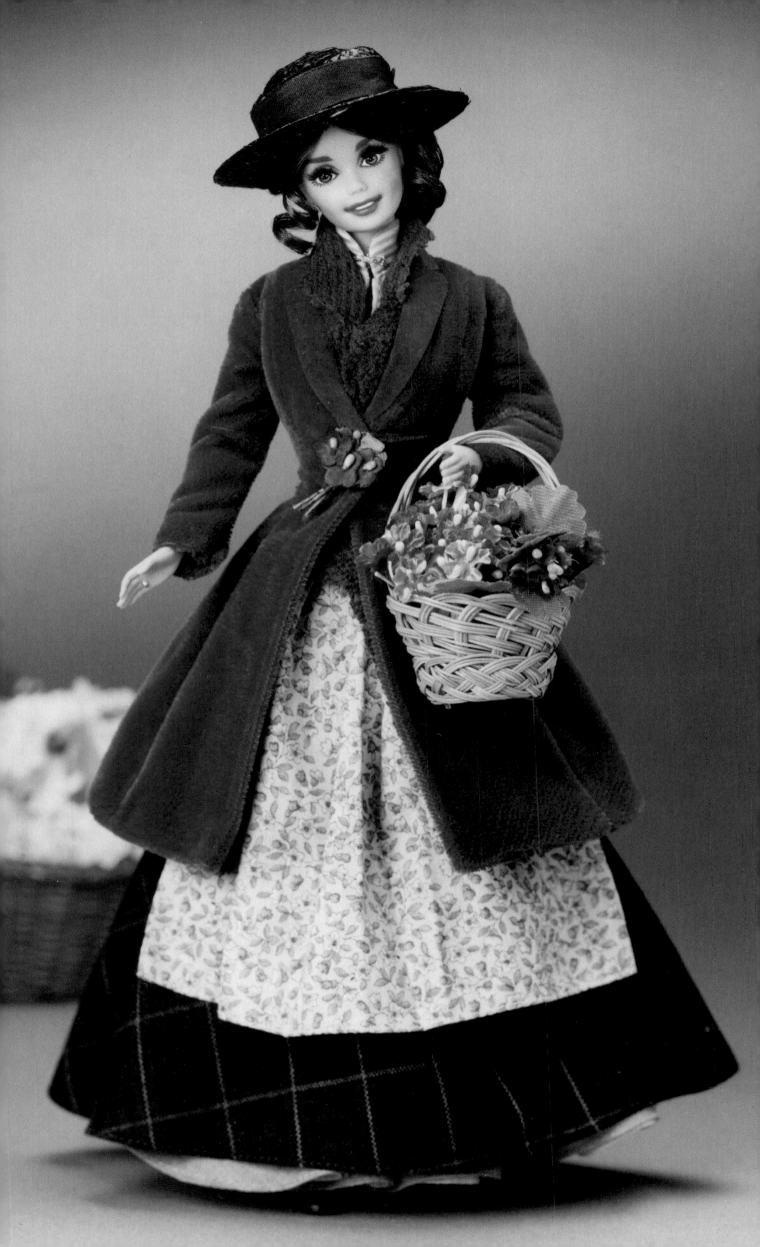

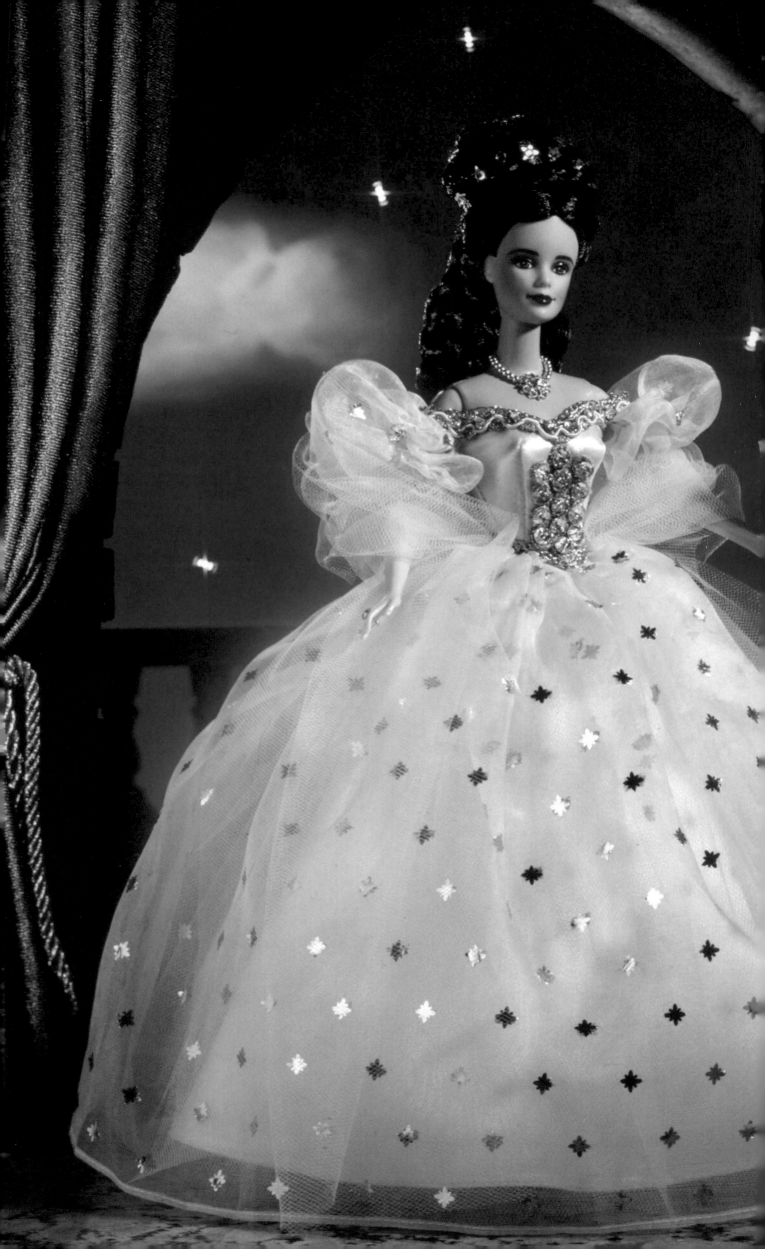

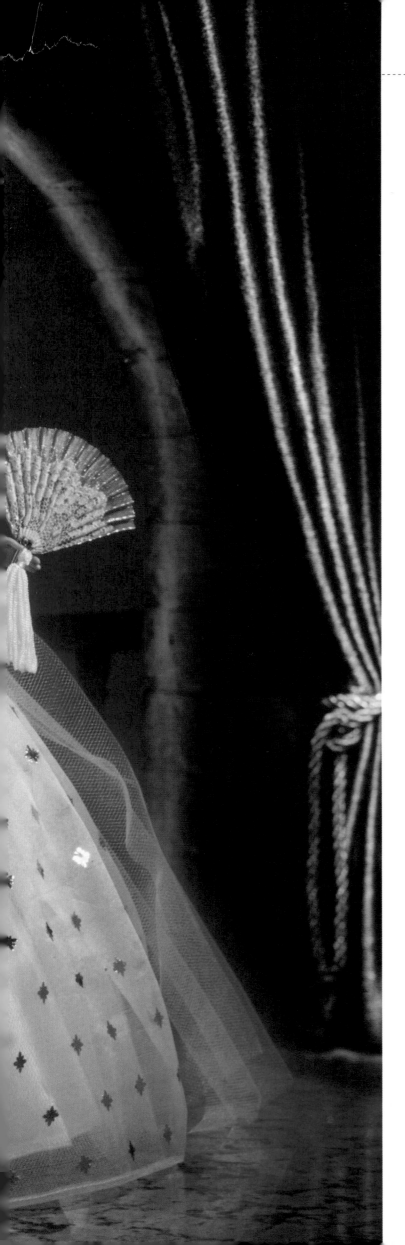

rounded out the four Barbie-as-Scarlett dolls. Of course, there was only one choice for the doll who would assume the role of Rhett Butler, so I also designed an ensemble of evening clothes for Ken. When the dolls were introduced, it was Ken-as-Rhett that drew a five-minute standing ovation.

Another favorite from Hollywood Legends came the following year, when *My Fair Lady* was chosen as the next installment in the series. Cecil Beaton had won an Academy Award for his costumes, and I loved visualizing them in Barbie's size. Topping my favorites in this collection, with all its elegance and drama, was the simple dress and coat Audrey Hepburn wears as a Cockney flower girl, with a scarf wrapped around her neck, a straw hat on her head, and a basket of posies on one arm. It's a look I really love—as imperfect as her early life.

By now collector dolls, with their opulent and elaborate costumes, had become my specialty within the design studio. It was ironic that I originally had been brought on board at Mattel because Charlotte Johnson valued my eye for classic, wearable American sportswear.

In 1996 we were commissioned to create one of the most opulent dolls of all: a limited edition set of Barbie as Empress Sissy, the empress of Austria-Hungary during the latter half of the nineteenth century. An auction was taking place to raise funds for the refurbishment of Schönbrunn Palace in Vienna, and organizers believed Barbie as Empress Sissy would be a popular item. Back to LACMA I went, this time to explore both portraits and the actual gowns worn by this stylish royal figure. Out of this research I designed a diaphanous ball gown in ivory tulle and satin, splashed with fleur-de-lis in metallic gold and tiny seed-pearl buttons down her back—and, naturally, liberal use of Austrian crystals, not only on the gown, but also in her hair and on her matching fan. As Empress Sissy, the commissioned Barbie raised more than $50,000 at that auction, and we loved her finished look so much, I created a version that we sold the following year.

By this time I had become an active member of the Costume Society of America. For the group's twenty-fifth anniversary in 1997, I was asked to create a one-of-a-kind commemorative Barbie for the event's fund-raiser. I relished this opportunity to show off my skills to my fellow members, while

Opposite: *My design of Empress Sissy Barbie raised more than $50,000 at an auction to refurbish Vienna's Schönbrunn Palace.*

celebrating an organization and people I thoroughly enjoyed. As the traditional twenty-fifth anniversary gift is silver, I decided to create the most lavish silver brocade gown I could. It had a heart-shaped strapless neckline, a sumptuous bustled train, long fingerless gloves, and a silver sash with a jewel pinned at her waist. She shimmered with all-over silver beading. Her blond hair was the lightest blond so it might feel a bit platinum. And a silver crown sat atop her head. She was never a Barbie meant for public sale, but she's always been one of my favorites; other than the Costume Society event and later at a Barbie convention, she's never been seen in public.

As 1998 neared, another notion took hold. I was sixty-nine years old, my designs were still popular and sold well, and I loved meeting collectors and fans at annual events. But perhaps it was time to think about slowing down. I had earned my place of respect in the design studio, but I was the oldest one there, and the thought of relaxing a little became increasingly irresistible. I'd been at Mattel for more than three decades, and that seemed like a well-timed moment to call it quits.

But I had one design left in me. Barbie's unofficial collector clubs had finally been organized by Mattel: the company realized this was a captive audience that loved all things Barbie, and they wanted to know more about collectors and their shared tastes and ensure that the clubs would operate in a fashion befitting Barbie's style and stature within the toy industry. Each group was invited to apply for official status, and once granted, each Barbie Collector's Club had access to exclusive dolls, member events, and other opportunities to embrace its Barbie fandom.

Knowing my last design indeed would be for a Collector's Club doll we were calling Café Society, I decided she would be a mix of all the things I loved. That started with auburn hair. From there I designed a luxurious gown of blush-toned charmeuse covered with shimmering lace, and a matching stole lined in chocolate-brown velvet. A beaded ornament held her hair in a sophisticated updo, while a matching beaded choker and drop earrings completed the look. I examined my finished design closely, knowing it would be my last for Barbie and for Mattel. I was satisfied and knew I wouldn't change a thing.

Opposite: *This rarely seen, one-of-a-kind Barbie was created to commemorate the Costume Society of America's twenty-fifth anniversary.*

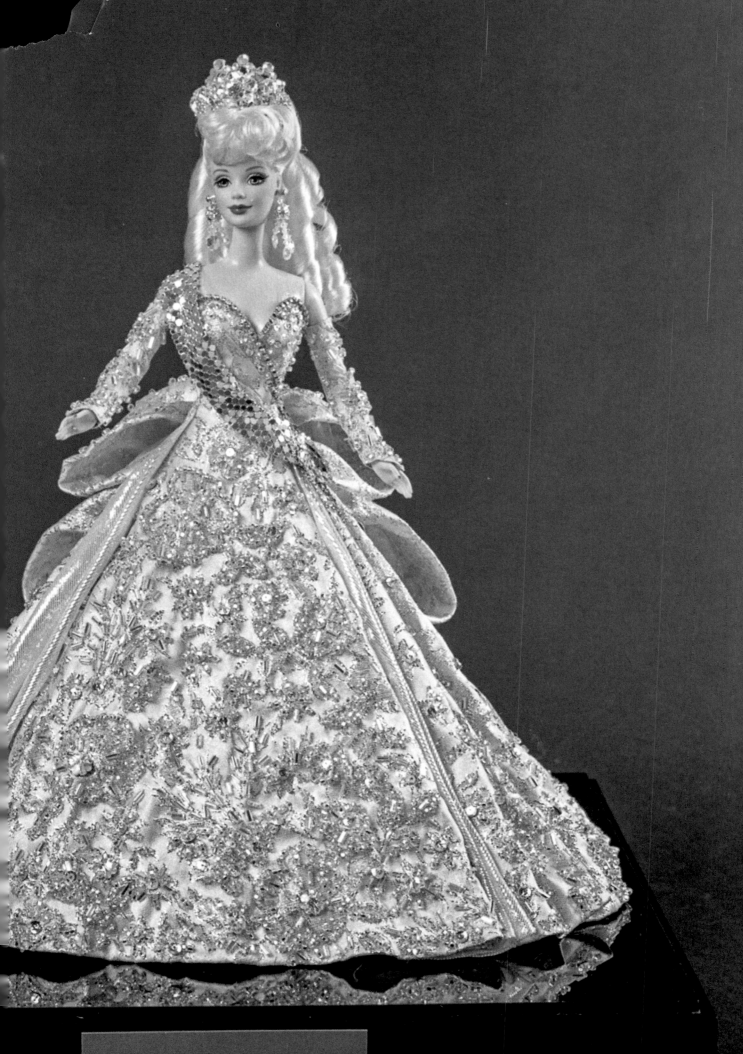

The Costume Society of America
CSA SILVER ANNIVERSARY BARBIE DOLL
designed by CAROL SPENCER

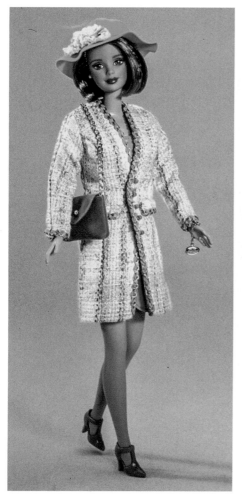

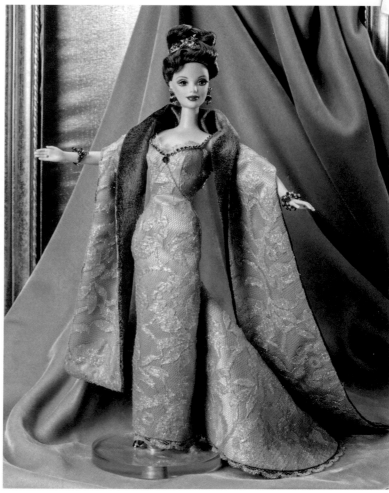

Of course, Café Society Barbie wasn't really my final doll—I just didn't know it yet. On my last day, December 23, 1998, Mattel celebrated my achievements with a lovely going-away party. I had been at Mattel for thirty-five years, eight months, and twenty-eight days. I was Barbie's longest-running designer, with an incredible history of fashions and dolls that are still beloved more than twenty years after my retirement.

The design studio planned a special surprise: a Barbie in my likeness, from my hairstyle and blue eyes to the pink suit my colleagues knew I loved to wear on special occasions. My Barbie was holding a bouquet of flowers and, like the doll created for Charlotte Johnson, a miniature Barbie in plated gold. This small gesture touched me immensely, as it meant my colleagues considered me on equal footing with both Charlotte and Ruth Handler.

Any Barbie fan or collector will tell you that you never really leave Barbie. And she never really leaves you. She was my muse for years, but for those who grew up with her or who discovered her later in life, she'll occupy a special place in your heart no matter how old you get.

In the years since I retired, I've gotten involved in volunteer work and neighborhood politics in Los Angeles and contributed to such projects as helping to redesign Santa Monica Boulevard near my home. But I've also attended a wealth of Barbie national conventions and other events, signing the dolls and fashions I've designed, and always delighting in the questions and the palpable love I've felt from those who consider Barbie such an important part of their lives.

I've been on so many adventures with Barbie. Then again, with more than two hundred careers over the years, she's always been an adventurous girl, filled with independence and an amazing spirit. We have that in common, Barbie and I. Learning that during all my years with her, well, that's been the best gift of all.

Above: *The last outfit I designed, Gallery Opening* (left). *Café Society Barbie, the last doll I created, had my favorite things, including red hair* (right). ✳ **Opposite:** *When I retired, Mattel surprised me with my own special Barbie.*

CAROLINE SPENCER

1998
HAPPY RETIREMENT
From your Friends at Mattel.

POSTSCRIPT

With Barbie Love

IT COMFORTS ME TO HEAR COLLECTORS AND people who played with Barbie tell me that she brought joy, friendship, and love to them as well as many hours of fun. I sincerely hope that my designs played a role in this.

The origin of Barbie stemmed from paper dolls, many drawn by cartoonists. As a child, I loved to play with paper dolls that I cut out of the comic section of the newspaper during WWII. I often wonder if Milton Caniff's *Miss Lace*, a cartoon that appeared in the *Stars and Stripes* during the forties, inspired the German cartoonist who created Lilli, a cartoon for the newspaper *Bild*. Later, Bild Lilli became a German doll and the model that Ruth Handler used to explain her idea of the three-dimensional paper doll that became Barbie.

I truly fell in love with Barbie from the first moment I created her clothes and accessories all those years ago. The sixties was a time of change, and I loved being a part of the fashion scene. But then again, I loved being part of the fashion scene no matter what decade.

I also have witnessed many changes at Mattel since retiring. Technology has become increasingly dominant in the production process. During my years, everything was done by hand, with the designer creating a 3-D fashion prior to approvals. Now designs are sketched—often on computer—and approved before a 3-D model is produced. Patterns are digitized, while a machine cuts the fabric for sample makers to sew. Patterns are transmitted electronically to an overseas factory in an instant. Accessories designed on a computer are quickly printed out in actual size on a 3-D printer. It's a very different, yet no less exciting, environment. But I wouldn't trade it for the memories I have of the hands-on labor of designing beautiful dolls and stylish fashions for anything.

To show the Barbie family of dolls created during my tenure in perspective with other dolls throughout history, I began donating dolls from my personal collection to the United Federation of Doll Clubs doll museum in Kansas City, Missouri, in 2008. My first donation included one hundred dolls and fashions I'd designed through the years. Since then, I've donated close to one thousand.

I was inducted into the Strong Museum of Play emeritus program in 2017 through the Women in Toys (WIT) Wonder Women Awards program and donated both dolls and design information for their archival cultural history section. WIT is a global organization offering professional mentoring and networking for women and men within the toy, entertainment, and licensing industries.

Because I've been in the toy industry for so many years, I can't help but worry about future generations. As play becomes more centered on the virtual world, will children miss out on the real-life experiences and imagination that playing with Barbie dolls offered? As one of Barbie's biggest fans and the creator of so many adventures in Barbie's world, I sincerely hope not.

—Carol Spencer

Acknowledgments

I dedicate this book to the child in all of us, especially those who played with and loved Barbie; to the editors of HarperCollins, whose playtime memories encouraged them to publish my dream book on Barbie; and to the memories of Charlotte Johnson, the first Barbie designer, and especially Ruth and Elliot Handler, the founders of Mattel, Inc., and, in Ruth's case, the creator of Barbie doll.

I would like to thank my good friend Gwen Florea, author of *Barbie Talks*, for introducing me to Lenore Kletter. Lenore's faith in my story as a designer for Barbie inspired me to write a book proposal with her help, and along with Murray Weiss, my attentive book agent, guided me into the world of publishing. I am particularly grateful to Laurie Brookins, who stepped in at the last minute and wrote my story as I told it.

Gracious thanks to my friend Ed Bolkus for guidance and faith in my story; to Pat McGovern, Ric Markin, Cheryl Nelson, and Leslie Bote for lending me rare vintage dolls and fashions; and to Joannie Parker and Parker Alison for finding Astronaut Barbie in the Smithsonian Museum.

To my friends at Mattel, Inc: Vickie Cerritos, who helped every step of the way; Matt Repicky and Michelle Chodini, who approved my book proposal; and Maggie Snow, Bill Morey, Amanda Searles, and Sammie Suchland, who made my book a reality.

For the photographs I did not take myself, I'd like to thank the following people: Shannon Donnelly, Tara Scoville, Dennis Dilaura, Jean Chu, Eliana Ruiz, and Melissa Huntington.

Above all, I want to thank my sister, Margaret Mackie, and my nephews, James and Paul Mackie, who supported me throughout the years I spent reliving moments in my Barbie book.

Last and not least, I beg forgiveness of all those who have been with me over the course of the years and whose names I have failed to mention.

Photo Credits

Photos by Carol Spencer: Pages 8, 9, 21–23, 32–33, 37–43, 50, 52–53, 56–57, 65, 67–69, 72–73, 82, 84, 86–89, 97–98, 102–103, 106–107, 109, 111–112, 114, 132–133, 135, 139, 142, 143, 145, 152 (right), 153
Photos by Jean Chu (Mattel, Inc.): Pages 34, 45 (top), 51, 99
Photo by Paul Mackie: Page 44 (right)
Photos by Shannon Donnelly and Tara Scoville (Mattel, Inc.): Pages 30–31, 44 (left), 45 (bottom left), 46–47, 49, 54, 66, 136–137
Photos by Dennis Dilaura (Mattel, Inc.): Pages 61, 62–63, 70–71, 74–80, 85
Photo by Scott Miles Photography: Page 128
Richard Haffey (Mattel, Inc.): Page 155 (caricature)

Mattel Archival Photographs: 18–20, 28–29, 36, 48, 55, 64, 81, 83, 90–91, 95–96, 99, 100–101, 104–105, 108, 113, 121–127, 129–131, 138, 140–142, 144, 146–152

Used with Permission
Pages 14–15: Standard Color Reference of America, 9th Edition, 1941–1981
Page 16: Rand McNally map c. 1960; *Women's Wear Daily* ad, November 1962; *California Apparel News* ad, April 1963
Pages 56–57: The '57 Chevy is a body design by the Chevrolet division of General Motors. Trademarks used under license by Mattel.
Page 146: *Gone With the Wind*, its characters, and elements are trademarks and © 1994 of Turner Entertainment Co. and the Stephen Mitchell trusts.
Page 147: *My Fair Lady*, Eliza Doolittle, and Henry Higgins are trademarks of CBS Inc. and are used under license. ©1996 CBS Inc. All Rights Reserved.

Resources

BOOKS

Handler, Ruth, and Jacqueline Shannon. *Dream Doll: The Ruth Handler Story*. Stamford, CT: Longmeadow Press, 1994.

PERIODICALS

Johnston, David Cay. "Arthur Spear, Who Led Mattel Through Fiscal Crises, Dies at 75." *New York Times*, January 4, 1996.

Mattel, Inc. *Annual Report*, 1992, page 20.

Mattel Toy Catalogs, 1959–1999.

ONLINE SOURCES

https://barbie.mattel.com/shop/en-us/ba/barbie-signature-gallery

Barbie.Mattel.com

"Dolls of the World," accessed January 12, 2017, https://barbie.mattel.com/shop/en-us/ba/barbie-dolls-of-the-world#facet:&productBeginIndex:0&orderBy:&pageView:grid&minPrice:&maxPrice:&pageSize:&contentPageSize:&.

"Hollywood Legends Collection," Barbie.Mattel.com, accessed December 27, 2017, https://barbie.mattel.com/shop/en-us/ba/hollywood-legends-collection#facet:&productBeginIndex:0&orderBy:&pageView:grid&minPrice:&maxPrice:&pageSize:&contentPageSize:&.

"The Great Eras Collection," Barbie.Mattel.com, accessed February 7, 2018, https://barbie.mattel.com/shop/en-us/ba/great-eras-collection#facet:&productBeginIndex:0&orderBy:&pageView:grid&minPrice:&maxPrice:&pageSize:&contentPageSize:&.

"Fast Facts About Barbie," BarbieMedia.com, March 15, 2018, http://www.barbiemedia.com/about-barbie/fast-facts.html.

"Barbie Signature Gallery," Barbie.Mattel.com, accessed May 11, 2018, https://barbie.mattel.com/shop/en-us/ba/barbie-signature-gallery.

"Handler, Ruth. Papers of Ruth Handler, 1931–2002: A Finding Aid," Harvard University Library, accessed January 9, 2018, http://oasis.lib.harvard.edu/oasis/deliver/˜sch00324.

Mattel Corporate Timeline, Mattel.com, accessed March 13, 2018, https://corporate.mattel.com/about-us/history/mattel_history.pdf.

YouTube.com

"1992 Totally Hair Barbie Doll Commercial," accessed January 24, 2018, https://www.youtube.com/watch?v=jlsk2xACwqc.

"Barbie 1985 Commercial Featuring Mary Lou Retton," accessed January 17, 2018, https://www.youtube.com/watch?v=3ZgDj3LH9vs.

"Hello Dolly," Eye to Eye with Connie Chung, CBS, October 27, 1994, accessed February 13, 2018, https://www.youtube.com/watch?v=cleZIXu4PXM.

ONLINE ORGANIZATIONS

California Institute of the Arts (calarts.edu)

Los Angeles County Museum of Art (lacma.org)

Minneapolis College of Art and Design (mcad.edu)

Smithsonian National Air and Space Museum (airandspace.si.edu)

FURTHER READING

Augustyniak, Michael J. *Thirty Years of Mattel Fashion Dolls: Identification & Value Guide, 1967 through 1997*. Paducah, KY: Collector Books, 1998.

Blitman, Joe. *Barbie Doll & Her Mod, Mod, Mod, Mod World of Fashion: 1967–1972*. Photographs by Kevin Mulligan. Grantsville, MD: Hobby House Press, 1996.

DeWein, Sibyl St. John. *Collectible Barbie Dolls, 1977–1979*. Edited by Harold J. W. DeWein and Tommie Neely. DeWein, 1980.

DeWein, Sibyl St. John's and Joan Ashabraner. *The Collector's Encyclopedia of Barbie Dolls and Collectibles*. Edited Annemarie Dunzelmann. Paducah, KY: Collector Books, 1994.

Eames, Sarah Sink. *Barbie Fashion: The Complete History of the Wardrobes of Barbie Doll, Her Friends, and Her Family, Vol. 1: 1959–1967*. Paducah, KY: Collector Books, 1990.

———. *Barbie Doll Fashion: The Complete History of the Wardrobes of Barbie Doll, Her Friends, and Her Family, Vol. 2: 1969–1974*. Paducah, KY: Collector Books, 1997.

———. *Barbie Doll Fashion: The Complete History of the Wardrobes of Barbie Doll, Her Friends, and Her Family, Vol. 3: 1975–1979*. Paducah, KY: Collector Books, 2003.

Florea, Gwen, and Glenda Phinney. *Barbie® Talks!: An Unauthorized Exposé of the First Talking Barbie® Doll*. Lincoln, NE: iUniverse, 2001.

Lord, M. G. *Forever Barbie: The Unauthorized Biography of a Real Doll*. New York: Walker, 2004.

Melillo, Marcie. *The Ultimate Barbie Doll Book*. Iola, WI: Krause, 1996.

Olds, Patrick C., and Joyce L. Olds. *The Barbie Doll Years: A Comprehensive Listing & Value Guide of Dolls & Accessories, 3rd ed*. Photographs and captions by Myrazona R. Harris. Paducah, KY: Collector Books, 1999.

Doll Index

Page 81: Prince dog ©1984, #7928; Day to Night Barbie Doll ©1984, #7929

Page 82: Promotional SuperStar Barbie Doll ©1977, #9720

Page 83: Romantic White fashion ©1977, #9836; SuperStar Beauty Boutique ©1977, #2328

Page 84: SuperStar Ken Doll ©1977, #2211; Promotional SuperStar Barbie Doll ©1977, #9720

Page 85: A Very Deluxe Tux ©1977, #9745; Brocade Dream Steals the Scene ©1976, #9740

Page 86–87: (L–R): Pumpkin Partners ©1983, #4873; Sleek 'N Chic ©1978, #2667; City Sophisticate ©1979, #2671

Page 88–89: Masquerade ©1977, #9472, courtesy of Larry and Cheryl Nelson

Page 90–91: Fashion Photo Barbie Doll ©1977, #2210

Page 95: Golden Glamour drawing 1979: Barbie #1412; Ken #1413

Page 96: Barbie booklet © 1984

Page 98: (L): Typical My First Barbie fashions (clockwise) Dress © 1986, #7920; Sleepwear OOAK Summer Dress ©1987, #1895; Casual Separates ©1987, #1976; Exercise © 1990, #2691; (R): My First Ballerina Barbie Doll ©1987, #1788

Page 99: My First Barbie Doll ©1980, #1875

Page 100–101: Dolls of the World series (L–R): Royal Barbie Doll ©1980, #1601; Russian Barbie Doll ©1989, #1916; Second Mexican Barbie Doll ©1995, #14449; Second India Barbie Doll ©1996, #14451

Page 102: Great Shape Barbie Dolls ©1983: Caucasian #7025; Black #7834

Page 103: Wild West ©1981, #3577

Page 104–105: Great Shape Barbie Doll, ©1983, Caucasian #7025

Page 106: (L–R) Fur Sighted ©1970, #1796; Weekenders ©1967, #1815, courtesy of Leslie Bote; Trailblazers ©1986, #1846

Page 107: Series V Oscar de la Renta Collection ©1984, #9259

Page 108: Astronaut Barbie Doll ©1985, #32449

Page 109: Dinner Date Fashion in assorted colors ©1989, #1292

Page 111: Astronaut Fashions ©1985 (L–R): Galaxy A-Go-Go #2742, Welcome to Venus #2748, Space Racer #2737, Starlight Slumbers #2739

Page 112: Fashion Finds fashions ©1988 (L–R): #1062; #1012; #1011; #1007; # 1025; #1024

Page 113: Fashion Finds ©1988, #1012

Page 114: Mardi Gras Barbie Doll ©1987, #4932

Page 121: Totally Hair Dolls ©1992 (L–R): Blonde Barbie #1112; Ken #1115; Brunette Barbie #1117

Page 122–123: Dinner Date fashions ©1990 (L–R): #4911; #4938; #4940; #4912; #4937; #4936

Page 124–127: Totally Hair Barbie Doll ©1992, #1112

Page 128: Carol Spencer with her personal display of the Classique Collection fashions ©1992

Page 129: Classique Collection fashions ©1992: Hollywood Premiere #1618; Fifth Avenue Style #1646

Page 130–131: Classique Collection Benefit Ball Barbie Doll ©1992, #1521

Page 132–133: My First Ballerina Barbie Doll (Mock-Up) ©1993, #11294

Page 135–137: Gold Jubilee Barbie Doll ©1994, #12009

Page 138: Jeweled Splendor Barbie Doll ©1995, #14061

Page 139: OOAK in pink color of Jeweled Splendor Barbie Doll

Page 140–141: Baby Sister Kelly Doll in Crib and Party Dress ©1994, #12489

Page 142–143: Southern Belle Barbie Doll ©1994, #11478; Bodice of ill-fated 1812 era proposal

Page 144: Flapper Barbie Doll ©1993, #4063

Page 145: Complete Barbie Dressy Shoe wardrobe per decade; Flapper dress bodice computer print

Page 146: Barbie as Scarlet in *Gone With the Wind*: Green Drapery Dress ©1994, #120145; Barbeque at Twelve Oaks Dress ©1995, #12997; Red Dress ©1994, #12815

Page 147: Prototype of Barbie as Eliza Doolittle, Flower Girl in *My Fair Lady* ©1996, #15498

Page 148–149: Barbie as Empress Sissy of Austria ©1996, #15846

Page 150–151: One-of-a-Kind Barbie Doll made for the 25th Anniversary of the Costume Society of America, Inc., 1998

Page 152: (L–R) Gallery Opening ©1998, #18893; Cafe Society Barbie Doll ©1997, #18892

Page 153: One-of-a-kind Mattel retirement gift Carol Spencer Barbie Doll